Critical Praise for Joe Meno's Fiction

"The power is in the writing. Mr. Meno is a superb craftsman."

—Hubert Selby, Jr.

"For an exasperated subset of literati, the adjective 'quirky' is a red flag signaling that the experience ahead involves missing limbs, trailer parks, broken-down classic cars, baffling non sequiturs, roadside grotesquerie, and a snobbish attitude toward Americana disguised as a celebration of America. So what to make of Joe Meno, whose slender, icepick-sharp books include many elements that might reasonably be described as quirky, but are rather heartfelt, beautifully written and vivid as a bad dream—or a very, very good one?"

—*Washington Post Express*

for *The Boy Detective Fails*

"Comedic, imaginative, empathic, atmospheric, archetypal, and surpassingly sweet, Meno's finely calibrated fantasy investigates the precincts of grief, our longing to combat chaos with reason, and the menace and magic concealed within everyday life."

—*Booklist* (starred review)

"Mood is everything here, and Meno tunes it like a master . . . A full-tilt collision of wish-fulfillment and unrequited desires that's thrilling, yet almost unbearably sad."

—*Kirkus Reviews* (starred review)

"This is postmodern fiction with a head *and* a heart, addressing such depressing issues as suicide, death, loneliness, failure, anomie, and guilt with compassion, humor, and even whimsy. Meno's best work yet; highly recommended."

—*Library Journal* (starred review)

"At the bottom of this Pandora's box of mirthful absurdity, there's heartbreak and longing, eerie beauty and hope."

—*Philadelphia Weekly*

for *Hairstyles of the Damned*

"Meno's language is rhythmic and honest, expressing things proper English never could. And you've got to hand it to the author, who pulled off a very good trick: The book *is* punk rock. It's not just *about* punk rock; it embodies the idea of punk . . . its rebellious spirit is inspiring and right on the mark."

—*SF Weekly*

"Captures both the sweetness and sting of adolescence with unflinching honesty."

—*Entertainment Weekly*

"Joe Meno writes with the energy, honesty, and emotional impact of the best punk rock. From the opening sentence to the very last word, *Hairstyles of the Damned* held me in his grip."

—Jim DeRogatis, pop music critic, *Chicago Sun-Times*

for *Tender As Hellfire*

"Features some of the liveliest characters one is apt to meet in a contemporary novel. Vividly described . . . Meno's passionate new voice makes him a writer to watch."

—*Publishers Weekly*

"Dark and exuberant with a stunning lyrical quality . . . reckless storytelling, both in the audacity of its plot twists and in the nearly sentimental quality of the emotions it plumbs."

—*Chicago Tribune*

for *How the Hula Girl Sings*

"Wow, can he turn a phrase."

—*Entertainment Weekly*

"Meno's poetic and visceral style perfectly captures the seedy locale, and he finds the sadness behind violence and the anger behind revenge. Fans of hard-boiled pulp fiction will particularly enjoy this novel."

—*Booklist*

for *Bluebirds Used to Croon in the Choir*

"A collection of tales heavy with meaning yet light on length. In only a few pages per story, Meno crams in loss, healing, familial bonds, unrequited love, and understatement to spare. Men fall in love with the wrong women, a brother tries to understand why his sibling enjoys stealing airport baggage, and a small girl comes of age on a ride on the city bus to buy an eye patch for her senile neighbor. Although each of Meno's seventeen stories is a sovereign entity in its own right, the collection has the feel of a novel written in installments, where heartaches overlap to form a patchwork of frayed, weathered, yet undeniably comforting humanity."

—*San Diego Union-Tribune*

"Joe Meno creates a fictional world so strange, so absurd that it could almost be real. Despite the stories' eccentricities, however, they rarely seem artificial or overblown. This is because Meno creates each of his characters with a deep and elaborate architecture, one that imbues their eccentricities with meaning and makes them seem vividly—even painfully—human."

—*Virginia Quarterly Review*

Demons in the Spring

stories

Joe Meno

Grateful acknowledgment is made to the following publications, where these stories first appeared: "Frances the Ghost" in *TriQuarterly;* "Stockholm 1973" and "People Are Becoming Clouds" in *McSweeney's;* "An Apple Could Make You Laugh" in *Ninth Letter;* "The Sound before the End of the World" in *Make Magazine;* "Animals in the Zoo" and "The Boy Who Was a Chirping Oriole" in *THE2NDHAND;* "Architecture of the Moon" in *Mule Magazine;* "Ghost Plane" in *The Art of Friction;* "Miniature Elephants Are Popular" in *Demo;* "What a Schoolgirl You Are" and "I Want the Quiet Moments of a Party Girl" in *Other Voices;* "Art School Is Boring So" in *Verbicide;* "Oceanland" in *Swink;* "Airports of Light" in *LIT;* and "Winter at the World-Famous Ice Hotel" in *Collage.*

Book design by **struggle** inc.®

Cover art by Chris Uphues

Published by Akashic Books
©2008 Joe Meno

ISBN-13: 978-1-933354-47-7
Library of Congress Control Number: 2007939617

Printed in Singapore

First printing

Akashic Books
PO Box 1456
New York, NY 10009
info@akashicbooks.com
www.akashicbooks.com

Also by Joe Meno

Tender As Hellfire

How the Hula Girl Sings

Hairstyles of the Damned

The Boy Detective Fails

Bluebirds Used to Croon in the Choir: Short Stories

Some of the author's proceeds from this book will be donated to 826CHICAGO, a nonprofit tutoring center, part of a national organization with branches in San Francisco, Los Angeles, New York City, and Seattle. Founded by Dave Eggers, best-selling author and the creator of *McSweeney's* and the *Believer* magazines, 826 is an organization dedicated to supporting children ages six to eighteen with their creative and expository writing skills, and to helping teachers inspire their students to write. From 826's mission statement:

> *Our services are structured around the understanding that great leaps in learning can happen with one-on-one attention, and that strong writing skills are fundamental to future success. With this in mind, we provide drop-in tutoring, after-school workshops, in-schools tutoring, help for English language learners, and assistance with student publications. All of our programs are challenging and enjoyable, and ultimately strengthen each student's power to express ideas effectively, creatively, confidently, and in his or her individual voice.*

For more information on 826CHICAGO and what you can do to contribute, please visit 826CHI.org

TABLE OF
CONTENTS

Frances the Ghost.... *illustration by Charles Burns* 13

Stockholm 1973.... *illustration by Evan Hecox* 25

An Apple Could Make You Laugh.... *illustration by Geoff McFetridge* 45

It Is Romance.... *illustration by Ivan Brunetti* 55

The Sound before the End of the World.... *illustration by Kim Hiorthøy* 69

Animals in the Zoo.... *illustration by Jay Ryan* 85

People Are Becoming Clouds.... *illustration by Nick Butcher* 91

Ghost Plane.... *illustration by Jon Resh* 99

What a Schoolgirl You Are.... *illustration by Kelsey Brookes* 109

Miniature Elephants Are Popular.... *illustration by Todd Baxter* 121

The Boy Who Was a Chirping Oriole.... *illustration by Archer Prewitt* 131

I Want the Quiet Moments of a Party Girl.... *illustration by Caroline Hwang* 135

The Architecture of the Moon.... *illustration by Souther Salazar* 153

The Unabomber and My Brother.... *illustration by Cody Hudson* 167

Art School Is Boring So.... *illustration by Steph Davidson* 191

Oceanland.... *illustration by Anders Nilsen* 205

Get Well, Seymour!.... *illustration by Paul Hornschemeier* 225

Iceland Today.... *illustration by Rachell Sumpter* 241

Airports of Light.... *illustration by kozyndan* 253

Winter at the World-Famous Ice Hotel.... *illustration by Laura Owens* 263

About the Contributors.... 274

Demons in the Spring

FRANCES THE GHOST

illustration by
Charles Burns

Frances the ghost is going to school: She is dressed in a white sheet with two holes for her eyes and that makes the people who see her riding in the passenger seat of her mother's station wagon smirk. Of course, Frances becomes a ghost whenever her mother does not know what else to do. Today was too much already so her mother decided, fine, fine, if she was going to behave like this, fine. The phone would not stop ringing and the baby was colicky again and Frances was pretending she could not buckle her shoes, so Janet, her mother, began to shout, and Frances threw herself on the ground and would not get up. She started holding her breath and crying and the only way to get her to calm down was to pretend she was a ghost again, draping the white sheet over her face and humming, Janet placing her soft lips against the fabric where Frances's forehead was crinkled up, and slowly, slowly, the tears began to stop. Too many minutes later they are all piled in the front seat of the brown station wagon, the muffler dragging as they drive, and Janet suddenly remembers the baby's car seat is once again unbuckled.

* * *

An ice cream truck has collided with a van at the intersection up ahead. The station wagon slows to a crawl as Frances sits up and stares at the damage. The vehicle is white and green and lying on its side. All over the road are melting popsicles, Dilly Bars, and Nutty Buddies, growing softer by the moment in the April heat: every kid's best dream. A hundred bumblebees, excited by the prospect of so many melting sweets, hang above the ice cream truck in a glittering cloud. From beneath the white bed sheet and from behind the two small holes her mother has cut so she can see, the little girl stares at the mass of bees suspiciously. Frances does not like bees. She thinks they are her enemy. One day last summer, she was stung inside her mouth when she surprised a bumblebee hiding under the rim of her soda pop can. Frances places her hand against the outside of the sheet just above her lip remembering. She watches the truck grow smaller and smaller until it is just another strange, uncertain memory.

Oh, oh, oh. Come and see:
See the girl. See the boy. See the pony.
Come and see:

Beneath the ghostly white sheet, Frances is very pretty. She has soft brown eyes and a face shaped like a dandelion: Her hair is blond and curly. For some five months now, Frances has refused to speak. She is reading her school book which is all about horses. In the book, a black mare nestles with a small white pony. The baby, in the car seat behind her, is blowing spit bubbles and smiling at her. While her mother is fooling with the radio, Frances turns and pinches the baby for absolutely no reason.

In the station wagon, in front of the school, Janet turns to face her daughter. Slowly, making sure Frances can read her lips, she says, "Okay, honey, it's time to take off the sheet."

The ghost does not move.

"Frances."

The ghost is silent.

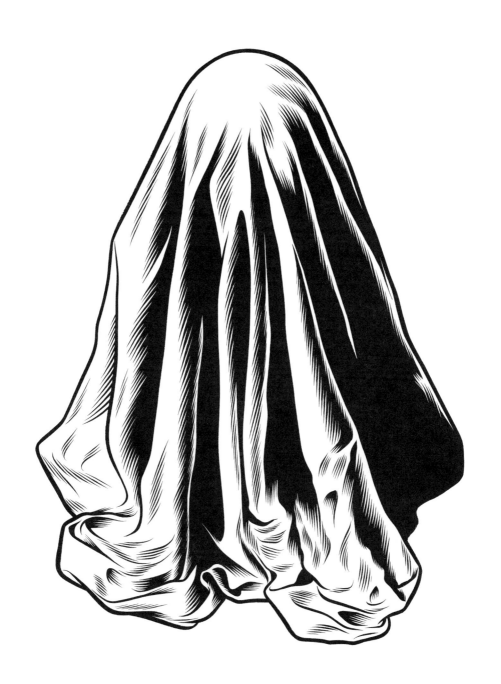

"Frances, I want you to take off that sheet right now."

The ghost makes a small move and Janet can see that Frances has folded her arms in front of her chest, pouting.

"It's time for school and it's time for you to take off that blanket."

The ghost shakes its head.

"Frances, right now."

The ghost shakes its head again.

"Frances, take off that blanket or you're going to be on punishment."

The ghost does not move. Janet quickly makes a grab for the flimsy fabric, but Frances, small, ruthless, quick, is already gripping it too tightly.

Janet is exhausted and it is not even 8:00 a.m.

"Okay, okay!" Janet shouts, letting go of the white blanket, sheet, whatever it is. "If you want to go in there like that, fine, be my guest."

The ghost is still for a moment, then one solitary pink hand reaches up and finds the door handle. Frances hurries from the front seat of the station wagon across the empty schoolyard, before her mother can change her mind, the white sheet still covering the girl's head. Janet does not even protest. It is now 8:01. It is totally out of her hands. Janet sits and watches the schoolchildren all standing in line, clapping, singing, shouting. Frances is doing well at school, mostly. She has known how to read ever since she was three. Frances loves to read but struggles to speak, or to make many sounds at all due to her hearing impairment. She can say a few words: *No, Yes, Hello, Goodbye,* but she's gotten lazy and does not really try to talk anymore. Janet can't remember the last time she heard her daughter mumble anything like a word. Frances is good at spelling and her vocabulary comprehension is very high. She has a hearing aid but doesn't like to wear it in her ear. She does not like to wear it because it makes the other children stare.

Sitting there, like every morning, Janet wonders if they are doing the right thing, letting Frances go to the regular public school. There is a special ed school but it is an hour and a half away and the school here has been very accommodating. The biggest problem is Frances, because she gets frustrated and she can be pretty, well, mean.

* * *

In line, the first grade class is whistling. Frances whistles along, hers a bright dizzying sound like a small bird doing figure eights in the sky. Frances knows how to whistle. She does not exactly hear the sound but feels the small, bright vibrations along her lips. She measures the sound and pitch using her fingertips. Some of the kids laugh, staring at the deaf girl dressed as a ghost, trying to whistle along. An older girl from the fifth grade who wears a green dress and a small, coy smile, points and laughs at Frances and says her name in a way which Frances hates. She can tell by the looks their mouths are making how terribly they are saying it. But soon all of the fifth graders begin to chant it. *Fran/ces. Fran/ces. Fran/ ces*. Frances lunges at the closest fifth grader, a dark-eyed boy, and tries to bite his arm through the sheet. Miss Dove appears and asks what the commotion is, and very soon Frances is, once again, crying.

In the station wagon, Janet pulls away, the baby now asleep. Her fingers are aching for a cigarette. She allows herself only two a day, one after Frances has been dropped off at school, and one when both children are in bed. Their daddy is now only a photograph of a young man with boyish good looks, blond hair, soft eyes, who is holding a machine gun at his side, a mosque rising behind him in a sand-colored background. *Liberator, my ass*, she thinks. *How about "big, dumb target"? How about "imaginary husband"?* When the cigarette lighter in the dash pops out, Janet struggles to find her package of menthols in time. The traffic light changes too quickly and the jerk in the Volvo behind her begins to honk. The baby dozes behind her. Janet is thinking. She has decided Frances is too old to be hiding under that sheet. She inhales the minty smoke and composes an imaginary letter to her husband in her mind: *Your daughter is acting up again. She scratched another kid at school last week and today won't go anywhere without her blanket. Where are you, you jerk? Do not get killed or I will never forgive you.*

Often, Frances must sit in the time-out corner at school. She must sit in the corner for drawing pictures of horses on her worksheets or for leaving her seat without permission.

Up and down. Up and down. Go up, up, up. Come down, down, down, Miss Dove is saying.

Frances, once again in trouble, sits in the corner of the room. She sits on a small wooden stool. There is a great silver spiderweb hidden in the silent angles of the classroom where Frances finds two dead flies. She names one Fritz and one Ferdinand. She decides they are soldiers. She decides they are her dear friends, but unhappy at war, and far, far away from their homes. What adventures the two of them will soon have. Look: Fritz has found a motorcycle with a sidecar. Ferdinand does not want to ride in the sidecar; he is afraid of riding in it. Ferdinand is afraid of everything. Fritz and Ferdinand are now arguing. They better hurry. The enemy is drawing near. The enemy's evil feathered helmets are getting dangerously close. They fire their muskets in the air, and Ferdinand, suddenly finding the courage, hops into the motorcycle's sidecar, and the two brave soldiers speed off. The duchess has been kidnapped! Fritz has decided they will rescue her and become heroes. Fritz is the brave one. Ferdinand likes looking at flowers and is not so brave.

Before work, Janet drops off the baby at her mother's. Her mother is watching a TV game show and puts the baby in his crib, answering the question the game show host has asked. "Jayne Mansfield," is all her mother says to her that morning.

Parking behind the VA hospital, Janet digs her hand beneath the driver's seat and searches for a small cigarette case, which contains four tightly wound joints and a small roach, which she lights and inhales from deeply. She checks herself in the rearview mirror, decides she has somehow become her mother overnight, squeezes some eye drops into her eyes, and straightens her nurse's uniform once she is standing.

Janet is falling in love with a patient named Private Dan. He is a vet from the first Gulf War, around thirty-five, and is missing most of his left leg. He is handsome in a dull way, like an unpolished stone or the sheer face of a cliff. He suffers from PTSD and may have a Gulf War illness. He is in and out of her wing of the VA like a celebrity. He served four years in the reserves and was discharged as a private, which does not say much for him.

Today Private Dan is complaining about a rash. And chronic diarrhea.

"You have to wait like everybody else," is what Janet tells him, though when he frowns, pretending to pout, he makes her heart feel small and quivery.

If you look, you can see Frances dressed as a ghost, sitting alone on her grandma's front porch: The bus has dropped her off early and Grandma, not expecting her so soon, has gone to the store to get diapers for the baby. Frances is sitting on the top step of the porch, waving to you as you ride past in the backseat of your parents' minivan. It is only a glimpse of a girl dressed as a small white phantom. You smile and wave but already she is a blur; already she has disappeared. Frances picks up her pink bicycle from the driveway and rides as close to the curb as she can without crossing into the street. The front wheel dangles dangerously close to the gray concrete edge and Frances imagines crossing the road while no one is looking. She has been warned never to ride her bike in the street. She edges the front wheel on the black pavement but does not go any farther. She slowly turns and sees her grandmother arriving home now, the old blue car teetering up the road from the other direction. Frances hops off her bike. She pulls the white sheet from her head and waves hello. Grandma kisses her cheek, almost forgetting the baby who is still buckled in the car seat. Frances points across the street and Grandma nods after checking for traffic. Frances hurries across to go play with a neighbor girl named Allie. Allie is not really Frances's friend: She's three years older and likes to think she is something of a mother to the small, strange girl. Allie is weak-shouldered and skinny, with stringy blond hair and yellow teeth. She will try to carry Frances around like a baby, but Frances will fight, biting the older girl's shoulder if she does not put her down quickly.

Allie has decided they will go into the woods and throw rocks at a beehive she has recently discovered. Frances does not think this is a good idea. She hates bees. She is completely terrified of them. She stops walking and holds her hand to her mouth at the spot where she had been stung. She decides she is not going into the woods. She is going to head back to Grandma's and sit and watch TV. Allie stares at Frances and calls her a baby, then walks off toward the woods by herself. Frances decides she does not like being called a baby. She decides she is not a

baby and so she hurries to follow Allie. The two small girls gather all the stones they can find and begin pelting the side of the papery brown honeycomb. Allie laughs. Frances thinks maybe there is nothing to be scared of, all they are is dumb bees anyway. Frances throws another rock, then one more. Almost immediately, a string of glittering bees descends, stinging Frances on her face and hands. Allie, a little older but not much brighter, turns and runs away, leaving her small charge to fend for herself. Frances tries to cover her face but they are on her now, the whole hive, stinging her through her blue dress and pink tights.

At the VA, Private Dan insists on a physical exam. Janet draws the curtain as Dan unbuttons his blue shirt.

"How's your husband?" he has the gall to ask.

Doesn't he know the way I look at him? Is this his way of letting me off the hook? "I get e-mails from him every few days," Janet says. The e-mails are sometimes single lines like:

> —*Found a kid hiding an explosive device under a Humvey.*
> —*Ate candy all day.*
> —*Think our children will no longer recognize me.*

"I'm sure he's fine," Private Dan says. "Six months over there and I never fired a round. It was a different war, though," he mutters.

"So tell me about the rash," Janet says, trying to establish some decorum.

"Here," Dan says, pointing to a red mark on his chest. "It really burns."

Janet pulls on a latex glove and carefully pokes the vet's chest. *Still in shape,* Janet thinks. *Which is why he took his shirt off. The showboat.*

"What do you think?" Dan asks.

"I'm not a doctor," is Janet's reply.

"So?"

"So you'll have to wait to see Dr. Grant."

"Is it serious?"

"I don't know," she says.

"You don't know? You just wanted to see me with my shirt off then?" Dan smiles. He has a big toothy grin that makes Janet laugh.

"The doctor will be right in."

"Nurse?"

"Yes?"

"If you ever want to talk, I mean, I know it can be pretty lonely, waiting for somebody."

"I have to go," she says.

"Nurse?"

"Yes?"

Private Dan winks, then, before Janet can turn in mock disgust, he blows her a kiss. It hits her, the invisible kiss, it is as real as a real kiss, and exiting from the exam room and rushing back to the nurses' station, Janet knows she is blushing.

Grandma is looking for Frances, holding the baby in her soft, flabby arms. She sees Allie sitting alone on the other side of the street and calls out, "Have you seen Frances?"

Allie, alarmed, looks up and shakes her head. *No* is what her head is saying, but Grandma has raised three kids and knows damn well when they are lying.

In the parking lot of the VA, Janet sits in her station wagon beside Private Dan. They do not touch. They do not talk. They light up one of her joints and watch the front seat fill with smoke. Finally, Private Dan begins to speak.

"I can feel my toes wiggling when I get high sometimes."

"Hmmm?"

"On the missing leg. I can feel them wiggling when I get high sometimes."

"Oh, that's weird."

"It's okay."

The pair is quiet for a while. Then Private Dan speaks again.

"I would sure like to kiss you, Nurse Janet."

"I've got a guy," she says.

"I know."

Janet is pleased with herself suddenly. She feels like an adult, like a television actress on a soap opera, like someone's real wife. She begins smiling, thinking of Mickey the Jerk on the other side of world and the way he looks when he is on the couch sleeping.

"I should head back in," she says.

Meredith, the other nurse from the same wing, comes hurrying out into the parking lot, looking panicked.

"It's the phone. Your mom. Something's happened."

Okay, first of all, Frances is okay. She is as swollen as a newborn, but she'll live. Janet looks at Frances's face and arms and hands and counts nine stings. Grandma has, as usual, completely gone overboard. Frances is lying on the corduroy sofa and every visible part of her is coated in pink calamine. Frances has arranged her small hands over her waist like a photograph of someone beautiful lying in a casket.

"What happened?" Janet asks, but knows her mother has no answer. She turns to face Frances, who is pretending to be asleep. She pats Frances's hands and asks Grandma where the baby is.

"Oh, I almost forgot! I left him with Allie across the street." Grandma gets up and moves briskly through the front screen door.

At home now, Frances wears the white ghost sheet at the table. It is dappled with dots of pink calamine lotion from all of her stings. Janet looks up from the TV dinner, unsure what kind of wet brown meat she is eating. She wipes her mouth on the paper napkin and stares directly at Frances.

"Frances, we are going to have a talk."

Frances blinks, becoming suddenly still.

"Frances, that sheet of yours has got to go."

Frances does not move.

"Frances. Do you want to be a big girl like Mommy or a baby like the baby?"

Janet cannot see the expression Frances is making beneath the white blanket.

"Do you want to be a big girl? Big girls don't carry their blankets around with them."

Frances does not move.

"You can keep it in your bedroom. But no more wearing it to school. Or at the table. Today is the last day."

Small dots of gray begin to form around the ghost's eyes: Frances has begun to cry. Janet can already hear it, the soft gumming of her teeth, the tightening of her small lips.

Janet gets up from her chair and puts Frances in her lap. She places her mouth right beside her daughter's ear and begins to sing: *"Frances / Frances / please don't cry / please don't cry . . ."*

Of course, it is true: If you cover your ears, a whisper does not feel the same as a kiss. A laugh does not make the small hairs around your neck startled the way it does when someone is shouting. When someone cries, it feels like you are waiting for the rain. When someone sings, it feels like the shape of a heart is being traced along the center of your chest.

Frances lays her head against her mother's neck and slowly stops crying.

By the time the baby is asleep, Frances is ready for bed too. Janet sits beside her and reads her a story that has a horse and a princess and a castle in it. She dabs calamine at the sting above Frances's left eye and then switches on the nightlight. She goes downstairs and waits a half hour, flipping through the channels. When she thinks Frances is asleep, she climbs back upstairs and sneaks into her room, carefully, oh so carefully, tugging the white sheet from beneath her daughter's head. She does not know what she is going to do with it, and sits on the couch composing another imaginary letter to her husband:

I did a bad thing tonight, one of the most terrible things ever: I waited for her to fall asleep, then stole the sheet from under her head. I am missing you or maybe just the idea of you. I have begun seriously thinking about other men. I am afraid I am not strong enough or tough enough for this. I am afraid all the time. I have not slept well in months. When are you coming back, you

jerk? We are all trying to be brave without you and doing a real crummy job of it. I do not want to have to be brave anymore without you.

Janet holds the white sheet against her face and feels like crying, but she doesn't. She pulls it over her head and sighs, sitting on the couch like that for a while, a ghost staring through the small eyeholes at the TV. Then she carries the sheet downstairs and hides it with the rest of the laundry, once again afraid she is not doing the right thing.

The morning begins with the phone ringing nonstop. First it's her mother, then Meredith at the VA asking about Frances, then some annoying guy from the military selling life insurance. By the time Frances is awake, the baby has already been fed. Soon Janet has everyone the station wagon. She turns the key, adjusts the rearview mirror, and throws the vehicle in reverse. Frances immediately begins fussing. She has forgotten something. She has forgotten her white sheet. She kicks her legs and begins sobbing. Janet puts the station wagon in park and takes a breath, then turns to her daughter, lowering her chin so Frances can read her lips.

"Frances, I need your help. I need you to help me get through this today."

Her daughter's face is stony-white. Small beads of tears hang at the tips of her black eyelashes.

"Frances, we are going to try to get through the day without the sheet. If we make it, we will have ice cream sundaes after dinner. But if you throw a tantrum, I think I am going to quit right now, honey. I think I am going to go back inside and never get out of bed again."

The station wagon sounds like it is going to die. Janet stares at her daughter, ready to cry herself, waiting for her daughter to begin screaming. But Frances turns, still pouting, staring straight ahead. She is mad, she is angry, but she does not cry. Janet decides this is okay, this is fine. Angry she can handle. Angry sounds great.

STOCKHOLM 1973

illustration by
Evan Hecox

Out on parole, Jan Olsson walks into the Kreditbanken at Norrmalmstorg, located within the central banking district of Stockholm, Sweden; he has a small pistol in the pocket of his jacket. He does not think the pistol actually works as it has been stolen out of the glove compartment of a stranger's car. Since the car was a rusted-out American model with a broken windshield, Jan instinctively believes the pistol will be unlucky. Jan has recently taken a large dose of amphetamines; because of this, he mistakenly thinks he can see things other people can't see.

Within the revolving glass doors of the Kreditbanken, Jan Olsson decides now is as good a time as any and pulls the pistol from his pocket, raising it above his head, his dark eyes wide and menacing. He sees his bearded face and unwashed hair reflected in the glass of the revolving door and is terrified. He looks like a character from a children's book, someone who has sold his soul to the devil and has become a wolf. He begins shouting even before he has exited the revolving door: This is the beginning of a long series of amateurish mistakes. Bank patrons watch the young man in the dark leather jacket waving the small pistol above his head and immediately start to panic. A woman in a black dress and white furs sees the weapon and faints, falling stiffly to the marble floor. A black toy poodle, coddled within its owner's arm, begins to bark. A child holding her mother's hand wails loudly. Her tiny lungs collapse and expand with such terrific urgency that her screams become more frightening than Jan's shouts.

At this moment, I am making a terrible mistake, Jan thinks, though it is already too late. He declares, We are having a bank robbery, but his words are muffled by the revolving door's thick glass. By the time Jan finally enters the marbled anteroom of the bank, a security guard with a brown mustache and thick

sideburns has telephoned the police. The security guard, at this moment, holds the telephone in his right hand: It is bright yellow and as obvious as a screeching alarm. Jan sees the yellow phone and thinks of a bird lying in a cage shrieking, its tiny reptilian feet having been pulled off. He thinks of a large fish being torn apart by silver hooks, its innards milky-yellow, struggling to breathe through red gills that no longer work. He thinks of a yellow hive full of bees, crashing together and stinging one another angrily; the buzz of their death rattle mimics the sound he now makes, grinding his teeth nervously. Already two policemen are charging through the glass doors of the bank—one is short and brave-looking, the other is taller and seems quite frightened. Jan Olsson raises his pistol and fires one shot, which hits the first policeman in his right hip, knocking him to the polished floor, though the gunshot does not mortally wound him.

Jan does not know what to do about the other policeman: The bank is intolerably silent now, even with the child crying and the dog barking and the wounded policeman moaning. All of the bank customers have fallen to their knees and are praying quietly. The noise of their whispers is frightful; they sound like sorrowful, disembodied spirits. Jan commands the second policeman to drop his weapon, which the patrolman does, thankfully, his large hands shaking with sweat. Dreading the sounds of these terrified prayers, Jan asks the unarmed policeman to please sing something.

—Sing something? the policeman asks. His eyes are wide and trembling.

—Sing something, anything, Jan says plaintively.

—But I have a very terrible singing voice.

—It's no matter, please sing something for us.

The nervous policeman, staring at his injured partner who lies there entirely prone on the black-and-gray marble floor, closes his eyes and begins to sing. He does not recognize the words even as he begins to shout them. To him, they are only sounds, the anxious catch and pause of his alarmed breath. The echo his mouth makes is the exact beat of his heart in time with his wounded partner's fading pulse. Moment by moment, everyone's hope is now disappearing. Everyone's heart has become an anvil, a boulder, everyone feels as if they are now drowning.

Jan faces the singing policeman. The man's face is young and thin; he is handsome with hazel eyes and a contemptuous-looking mouth. By staring at the policeman's face like this, Jan can see that the officer has a wife he thinks fondly of, as well as two kids—a boy who loves to ski and a girl who writes poems about sad horses. Jan knows this as surely as he knows the song the policeman has chosen to sing. It is "Lonesome Cowboy" by Elvis Presley.

Jan Olsson looks around. The bank patrons are all lying on the ground now, weeping. Their trembling hands cover their oily heads. Even with the policeman singing, he can still hear their prayers. He can still hear the child crying and the tiny dog barking. Just then a telephone—the yellow one sitting beside the security guard's desk—begins to ring.

—Do you want me to answer it? the security guard asks.

—Please do, Jan says.

The security guard speaks into the yellow phone for a few moments and says, It is the police. They would like to know your demands.

Jan looks around the disrupted bank. Everything is now still. Even the tiny dog seems to be listening.

—I would like . . . Jan mutters. I would like my best friend, Clark Olofsson, brought here.

—What? the security guard asks.

—I would like my best friend, Clark Olofsson, brought here.

—That is your first demand? the guard asks.

—It is, Jan says. He is my best friend. He will know what to do.

The security guard repeats this demand into the yellow phone, which quivers in his large white hand.

—Anything else? the security guard asks.

—Yes. I would also like three million kronor.

The security guard adds this, his teeth chattering as he speaks.

—I would also like two guns. The best guns they can find.

—What kind of guns? the security guard asks.

—Any kind. As long as they are loaded.

The security guard relays this, his words whispered and weak.

Kreditbanken,
Stockholm

—I would also like two bulletproof vests. And two helmets. One for me, one for my best friend, Clark. And also a very fast car.

The security guard mumbles each of these requests.

—What kind of car would you like? the security guard asks.

Jan Olsson turns, staring out the immense glass windows. It is just past 1 in the afternoon. The afternoon itself has no idea what is happening: Automobiles hurry past, shoppers shift their bags from hand to hand, a girl on a bicycle pedals along, her skirt yellow and flimsy, flirting with the breeze.

—I don't care what kind of car it is as long as it's fast. And as long as it's not yellow. Jan says this and then waits for the security guard to transmit the information.

The guard mumbles this final demand and then looks up.

—They said they will do their best. They said they will call back when they've gotten everything.

—Good.

Jan looks around the bank, suddenly very pleased with himself.

—What do you want us to do until then? the security guard asks.

Jan has no idea what the answer to that question might be. He thinks for a few moments and then has an idea.

—You will all stay here. I am going to take a hostage now.

—A hostage? Don't be ridiculous! the wounded policeman shouts. There is no need to involve anybody else in this.

Jan peers at the customers lying there, scattered across the marble floor. They all appear sad and white and pasty, like animals who have been skinned, then turned into rugs. Behind the large glass and marble counter, there are four bank tellers, each of them women, each young and bright and pretty. In colorful turtlenecks and blouses and skirts, they look like far-off planets Jan would like to visit.

—The four of you will come with me, he says, pointing his gun at the tellers. You will stay with me until my partner arrives.

—What about the rest of us? the security guard asks.

—The rest of you are free to go, Jan says.

He points his pistol at the first teller, Kristin Ehnemark, a thin blond girl with a striking pair of blue eyes.

—Where is the best place to hide? Jan asks the girl, pressing the muzzle of the pistol against her fluffy orange sweater.

—The main vault.

—We will go to the vault to wait for my friend Clark to arrive. Does anyone have a transistor radio with them?

—I do, one of the bank tellers, Elizabeth Gullberg, whispers, meekly raising her tiny right hand.

—Perfect. Bring it with you and we will see if any of you can dance.

Jan marches behind the four tellers, his pistol aimed at Kristin's back: There is Kristin, blond, with stunning good looks; the mousy but charming Elizabeth; and two identical twin sisters, Sandra and Diane Ekelund, who have dark eyes and straight brown hair. The four young women walk in single file, silently disappearing down the long white corridor while the rest of the bank's patrons pull themselves to their feet and rush through the front glass doors, screaming.

The tall policeman stops singing and lifts his partner to his feet, dragging him as best as he can through the revolving glass door. A dark smear of blood follows the wounded police officer out, his rubber-soled shoes squeaking against the floor. Within a few moments, the bank lobby has become entirely empty, a still life of despair and quiet.

In the main bank vault, which is dark and rectangular, filled with tiny shelves and silver deposit boxes, Jan commands Elizabeth to turn on the radio. There is not much on besides disco and the reception inside the vault is quite terrible.

—Who among you can dance? Jan asks.

—I can dance pretty well, Kristin says.

—Anyone else?

The other three girls all shake their heads.

—Okay, then you dance.

Kristin nods and begins to dance, very slowly at first, moving her feet and hips from the right side to the left. Jan points at the radio with his pistol and asks Elizabeth to please turn up the music. Kristin closes her eyes; she pretends that

she is all alone, back in her tiny apartment. She pretends it is Saturday night and she is waiting for her date to telephone her.

Jan finds the light switch and begins to flick it on and off: light effects. The two sisters, Diane and Sandra, smile at the exact same moment, surprised by the bank robber's strange sense of humor.

—What about you? Jan asks the twins.

Together, they shrug their shoulders and begin to dance, mirror reflections of one another's stiff movements. Even their long dark hair seems to flip and swish at the same time.

—Good, Jan says. Okay, now we are getting somewhere.

Before the long disco track ends, Jan can hear the police shouting at him through a megaphone outside. He motions to Elizabeth with the pistol; she quickly shuts off the radio, looking worried once again.

—*Jan Olsson!* comes the amplified voice. *We have located your friend, Clark Olofsson! He is now going to enter the bank!*

Jan points the pistol at Kristin and says, No monkey business, then leads her back toward the bank lobby. Before he crosses into the afternoon's blank sunlight, he pauses. He suddenly imagines a police sniper depositing a single bullet into the front of his brain. He begins to tremble a little. He holds onto Kristin for support. Then he takes another two amphetamine capsules, offering one to Kristin first. Kristin kindly refuses. Together, they slowly step into the sunlit lobby. Through the glass doors and windows, Jan can see a battalion of blue police uniforms, of drawn weapons, of blue helmets, of black bulletproof vests, of police cars and vans, of flashing blue lights.

—I did not want this to happen the way it is, Jan says sadly. I really did not.

From behind the police barricade, Jan spots his best friend, Clark Olofsson. Clark is wearing a tan leather jacket, a loud flowered shirt, and bell-bottoms. He looks as if he has been rousted from a discothèque. Jan slowly raises his hand to Clark, who, behind his dark brown beard, smiles, rolling his eyes, as if to say, *What crazy mess is all this, my friend?*

—He is my best friend in all of the world, Jan confides, whispering the words into Kristin's neck. He will know what to do.

Clark walks across the tiny avenue, then opens one of the bank's heavy glass doors. Jan stares at his friend's wide face, and from the shape of his dark eyes and the unruliness of his shaggy beard, he at once knows the entire story of Clark's troubled life. Even though he can see that his best friend Clark is one equally destructive mess, that he will be arrested over and over again, that nothing good will ever come of their friendship, Jan still begins to weep with gratitude. Clark has two bulletproof vests with him as well as two formidable-looking assault rifles.

—You came, Jan whispers.

—Of course, Clark says with a wide grin.

They hurry back into the safety of the bank's long corridor, Jan gently placing the pistol against Kristin's ribs, leading his friend toward the main bank vault. He stops suddenly, his eyebrows raised in worry.

—What about the helmets? Jan asks. Where are the helmets?

—We don't need them. We have hostages, Clark says. The police assured me they would not try and open fire as long as we didn't hurt the bank tellers.

—What about the fast car?

—It's parked around the corner.

—What color is it?

—Yellow.

—See! Jan shouts. See, they are fucking with me!

—We can ask for another car, Clark says.

—Of course. I'm sorry I lost my temper, Jan says.

Clark steps inside the bank vault and smiles. He has the smile of a television spokesman, of an insurance salesman, of your favorite dentist. You trust it though you know you should not. He grins at brown-eyed Elizabeth and the two sisters.

—If I may please ask a question: Is anyone in this bank vault worried about anything? Clark asks.

The four women are silent, unsure how to answer.

—Because you can tell me. I would really like to know, Clark adds. It will be helpful for us to know your fears. You, he says, singling out shy Elizabeth. What are you afraid of?

—Certain snakes. And spiders. All kinds of spiders, I guess.

—Good. Anything else?

—Stories about witches.

—Okay, that is what I'm talking about. It's important that we are open with each other. That is how we are going to get through this.

Clark itches his beard knowingly, then nods at the twins.

—What about you two, what are you afraid of?

—We are afraid to be alone, they both say in unison.

—Of course, like anybody. And you, what is your name? Clark asks, motioning toward Kristin. Kristin blinks at him bravely. She thinks she may have danced with him once at some disco downtown, or maybe not. Maybe it's just his eyes, or his wiry beard. Maybe he looks exactly like every young man she has ever fallen in love with only to have her heart broken later. The boy who bought her a kitten for Christmas, with a red bow around its neck, who then slept with her best friend, Monica. Or the boy who made her a painting—a scene of them happily living on the moon together—and then asked for it back so that he could sell it. Or the other boy who named each freckle on her body, only to disappear a month later. This man has the same kind of charm, the kind that suggests weakness, the kind that indicates how sad he will always make her feel. There is something dependable, unfailing in this sort of sadness. Kristin immediately finds herself taken with him.

—Go on, what's your name? Clark shouts.

—Kristin Ehnemark.

—Okay, Kristin Ehnemark, what frightens you?

—I am afraid of nuclear war.

—Good. Anything else?

—And fireworks. I don't like loud noises.

—Good. Anything more?

—I am also afraid of the police.

—Wonderful. I'm afraid of the police too. Why are you afraid of them?

—I'm afraid they will try to storm the bank. I'm afraid they will accidentally kill us all.

—It's as if you could read my mind, Clark says, winking. That is exactly what I most fear right now. We must make sure that does not happen.

—In 1999, you will be arrested in Denmark on drug charges, Jan suddenly blurts out.

Clark stares at his friend. Jan is slimmer than he is, with a longer nose and an untrustworthy face. Clark pats his friend on the shoulder and whispers, Please try and relax, Jan.

—I think we need to leave, Jan says. We need to leave as soon as possible. Or we will all die here. They will send things to harm us through the electricity.

—Listen to me. There is a car waiting for us, Clark whispers. The problem is that they said we could not take the hostages with us.

—Then they will shoot us! I told you we needed helmets. If we had helmets, we could escape!

—No, no, no, no, Clark says. You are trying to think rationally about all of this. You must try and think irrationally. I am going to call the Prime Minister and tell him we want to be able to leave with the hostages. That he must get us a different vehicle. And that we want a flight out of here, to Switzerland, and then when we get there, we want another car to take us to a secret location, some mountain somewhere, where all of us can live together for a while. We want a place that has a lot of trees. And birds, so we can go for a walk in the woods, all

of us, and listen to the different birds and talk about what we liked about their different songs.

The girls all look at Clark questioningly.

—If anyone has a problem with that, they should say something now, he says.

The young women are all still silent.

—You, Clark says to Kristin, smiling his soft, unreliable smile. You come with me.

Slinging the rifle over his shoulder, he carefully takes Kristin's wrist and leads her down the long corridor to the bank's lobby. He picks up the yellow telephone and dials the police, then hands the phone to Kristin.

—Tell them who you are. Tell them you want to speak to the Prime Minister. Tell them you are going to be shot if they don't let you.

Kristin speaks quickly into the receiver.

—What did they say? Clark asks.

—They said you can speak with the Prime Minister whenever you want.

—Good.

Kristin hands the telephone back to Clark.

—Is this Prime Minister Palme? he asks.

The voice on the other end of the line is formal and shaky.

—Yes. Whom am I speaking to? the voice says.

—Whom are you speaking to? Whom are you speaking to? You are speaking to Clark Olofsson. I have a rifle. I am sitting here pointing it at a pretty girl. I am about to blow her head off.

—Yes, I apologize. I wanted to make sure I was talking to the right person.

—I am definitely the right person.

—Good, the Prime Minister says.

—You bet it's good. Now, I want you to know something. If you don't let us leave with the hostages, we are going to begin shooting them. Do you understand this?

—Perhaps, Mr. Olofsson . . .

—No, I want you to listen. I want you to hear what you are doing.

Clark grabs Kristin tightly, his right hand gripping her thin throat. He holds the phone up to her pink mouth, her lips curling as she struggles to breathe.

—You have one hour to clear the street of police. Or else we start shooting.

Clark slams down the phone and releases his grip on Kristin. She looks up at him, holding the red spot where his hand has just been.

—I am sorry I had to do that, Clark says. I had to make him think we're serious. I want you to know that no harm will come to you.

—Why are you doing this? You don't have to . . . I mean . . . why are you here? Did you even want to rob this bank?

—No, Clark says. But Jan asked me to help him. He is my only friend in the world. The only one who isn't in prison. I had no choice.

—He's not your friend. A friend wants to help you, wants to make you happy. You can't be friends with someone who doesn't want you to be happy.

—We are all going to be happy. Together. On the little mountain. We'll get some animals: some goats, some cats maybe. You can name one after me and then I'll name one after you.

—They'll never let you. They won't let you leave the building with us.

—They have to.

—But they won't let you. And then we'll all be killed.

—Listen, if we are to be killed, then there's nothing we can do about that. For now we must return to the safety of the vault.

But Kristin does not move. She holds her throat, staring at him, her eyes wet with tears. Clark recognizes the look: She thinks she has been betrayed by something.

—I told you about what I was afraid of, she says. And I don't want you to die either. You didn't come here to do anything wrong. You're like us. Why should you be killed too?

—Listen, he says. I am very sorry. Look, look, he whispers, digging through his jacket. Here, look, look at this. He takes out a small silver ring. This is my mother's, it's hers. It's her wedding ring. I want you to have it. It's good luck. It's my good-luck charm. I'm giving it to you. Nothing bad will happen to you if you have it.

He takes Kristin's small white hand and places the ring against her palm.

—Now, let's hurry back to the vault, okay?

Kristin nods, marching ahead of Clark, who gazes at the impossible smallness of Kristin's ankles and feet. Years later, while imprisoned for drug charges, he will think of those tiny feet and know he is forever doomed for having lied to her, for having harmed something so delicate, so defenseless, so small, so weak.

By the end of the day, the police have decided they will not leave. The bank robbers try and phone the Prime Minister once again. By then, Jan Olsson has nearly given up. He sits in the corner of the enormous bank vault, sobbing, the police assault rifle resting uselessly at his feet. Clark, unsure how to proceed, ties up the four young women with electrical wire. He knots a loop around their necks so that if they try to escape, or try to untie the wire, they will end up choking themselves. He searches the empty bank offices and finds a phone behind the information counter with a very long cord, then drags it into the vault with him.

When Elizabeth's transistor radio runs out of batteries, Clark sings Roberta Flack's "Killing Me Softly" over and over again. After that, there are a few hours of marked silence. Outside it must be midnight. Clark crawls out of the vault again and down the long corridor. He stares into the unlit lobby, where the marble floor reflects the night and the bright searchlights of dozens of police vehicles. Clark hisses, then quickly moves back to the vault. He picks up the telephone, asks for the Prime Minster, and then begins to shout.

—Why are there police still on the street?

—They said they were unable to withdraw until the hostages have been released.

—You are fucking with us, man! Clark screams. Don't you want these girls to live?

—I do.

—Well, it doesn't seem like it. We want to leave now. We are going to take the hostages with us. We want a car that is fast and not yellow. We want a flight out of here and a mountain for ourselves in Switzerland.

—I don't think I can arrange all that, Mr. Olofsson.

—Well, you better try! Or these girls are going to start getting shot. Now, I want you to listen . . .

Clark looks around the vault, then drags the telephone over to Kristin.

—Tell him, Clark hisses. Tell him we are going to kill you if they don't let us take you.

Kristin closes her eyes as Clark places the receiver against her ear and mouth.

—Sir, she whispers. Sir, you are putting us in great danger. These men, they don't want to harm us, but they will.

—We are afraid for your safety, the Prime Minister says. We're afraid they will try and kill you once they escape with you.

—Sir, Kristin says, I am very displeased with your attitude. Please allow us to leave with the robbers.

—My dear girl, the Prime Minister responds quietly, you are in all our thoughts and prayers. We will get you out of there safely, I promise. But we cannot let them leave with you.

—What is he saying? Clark asks.

Kristin shrugs her shoulders.

—He says he won't let you take us.

Clark slams the phone down. It rattles with a weak ring, which then reverberates throughout the large vault.

—What now? Jan asks, looking up from his hands. His face is red, his bottom lip quivering uncontrollably. What will we do now?

—We must wait until they change their mind, Clark says.

Jan shakes his head. He begins to sob once more.

—In 1996, you will be arrested outside a bank in Oslo, he whispers.

—If you say so.

—We will no longer be friends by then.

Clark clucks his tongue and pats Jan on the shoulder.

—That is enough of that.

Clark picks up the assault rifle and begins to pace back and forth, thinking. During this time, Jan Olsson does not try to stop himself from crying. Kristin

39

Ehnemark watches Clark, wondering what kind of birthday present he might give her if they were close friends. Elizabeth Gullberg has fallen asleep, mumbling to herself. Sandra and Diane Ekelund blink at each other silently, in a secret code no one else can understand. When Clark stops pacing, it is as if they have all given up. He sits down in front of the vault door and, using the muzzle of his rifle, traces the shape of a Swiss mountain along the dusty floor.

By the third morning, the bank robbers have become thoroughly depressed. Clark has begun to pick at his fingernails, while Jan refuses to even lift his head. At around 9, they hear a far-off song, like a bird captured within the dark cell of the vault. Soon the plaster above their heads cracks, shaking and trembling in place.

—What in the world is this? Clark asks, grabbing his rifle.

A tiny hole appears and slowly begins to expand.

—They are using magic on us! Jan screams, pointing. I knew they would if we weren't careful!

Clark stands beneath the hole, smiling.

—They are drilling.

Just then the telephone begins to ring. Clark hurries over and places the phone against his ear.

—Hello?

—This is the police. We are drilling through the roof of the vault. We are going to insert a small camera in the hole. We want to be sure the hostages are still alive.

Clark laughs. He turns and stares up at the hole, and at that moment a small black device appears through the tiny opening. Clark stands beneath it, smiling. He places the phone beside his ear again and says, So what do you see?

—It looks like everyone is still alive.

—Just as we promised. Now, will you let us all leave?

The phone goes dead. The tiny black device disappears.

—Hello? Clark says. Hello?

He hangs up the phone, then walks across the vault, staring up through the tiny hole. At that moment, another sound, something unfamiliar, something lacking any music or melody, begins to hiss. Elizabeth Gullberg starts to cry frantically.

—Snakes? she shouts. Is it snakes?

Clark peers up into the tiny hole, laughing.

—No. It's . . .

He suddenly frowns. The sound grows louder and louder.

—Gas.

He throws down his weapon and tears off his shirt. He wraps it around his face and mouth, but it's too late. His throat has already begun to close up; his nose and eyes are watering furiously. He decides he must free the four young women. While he fumbles with the tiny knots, he begins to choke on his tears. He unties Elizabeth, who collapses to the floor, then the two twins who have been lashed together. He is only able to untie Kristin's neck and wrists. She is coughing and choking, reaching out through the smoke for Clark's shirt. They fall to the ground together, covering their faces, her hand tightly grasping his flowered shirt. In the corner of the vault, Jan Olsson continues to sob, the gas making his tears bright silver. He folds his head into his arms, wishing now he had not stolen the unlucky pistol from the American car. By the time the riot squad throws open the door of the vault, Jan has decided to surrender. He

crawls out with his hands over his head, his face red, in a posture of certain, final defeat.

Olsson and Olofsson will be charged and sentenced for kidnapping and robbery. Jan Olsson will choose to represent himself in court. During the court proceedings, he will ask several important eyewitnesses if they will please sing for him. All but Kristin Ehnemark will refuse. She will sing "Frère Jacques." Jan Olsson will then place his head on the defense table and slowly fall asleep. The judge will quietly try to wake him. Olsson will apologize to the court. All of this will be later stricken from official court records.

Clark Olofsson will shave his beard during the trial. He will receive a number of marriage proposals from lonely women, some of whom are already married to other convicted criminals. After being sentenced, Olofsson will claim that he had nothing to do with the robbery and was only there to prevent his best friend from hurting the hostages. A Swedish court of appeals will eventually find him innocent, and his friendship with Jan Olsson will come to an end shortly thereafter. Clark will be released and then arrested again within a year.

Criminologist and psychiatrist Nils Bejerot will coin the term "Stockholm Syndrome" in a news broadcast, referring to the hostages' evolving sympathy with the robbers during the ordeal. He will comment on how the girls stated that they were more afraid of the police than the robbers themselves, and he will write a number of papers on the subject. He will then buy a yacht and have *Stockholm Syndrome* etched in silver lettering along its colossal bow. No one will ask to go sailing with him. Not ever.

After he is acquitted, Clark Olofsson will begin a lifelong friendship with Kristin Ehnemark. On holidays and birthdays, when he is not in prison, they will exchange presents with one another. One year, for Christmas, Olofsson will give Ehnemark a white rabbit in a perforated box. It will have a blue bow around its neck. It will smell of violet perfume and will be stolen from a local pet store. It

will be the best present Kristin ever receives. Clark and Kristin will visit each other whenever they are upset about something: This is made more difficult by the fact that Clark will be incarcerated quite frequently. Often, when they have a dream in which the other person appears, they will telephone to discuss what they have just witnessed in their sleep. In her dreams, Kristin sees Clark as a hand made of ice. In his dreams, Clark imagines Kristin as a lovely white dove.

AN APPLE COULD MAKE YOU LAUGH

illustration by
Geoff McFetridge

Apples are kissing other apples. Gray cats are kissing other gray cats. Trees are kissing trees. You and I are not kissing. We work in an office together. We are both married to other people. It is okay because we only have ideas, you and I, about whether we should kiss or not. These ideas are both good and bad, probably. At work, we do not say these ideas out loud but make elaborate diagrams for one another using pink phone-message sheets. You write these words: *Kissing you would be like this*, and draw a picture of two butterflies being struck by lightning. You hand me the note over the gray cubicle wall. I stare at it and wonder if you may be right. I do my own drawing and write, *Kissing you would be like this*, and sketch a picture of a man made of ice kissing a woman who is actually a stove. We have made hundreds of these drawings. We do not actually do any work in the

office anymore, other than trying to imagine what it would be like to kiss each other. We have been thinking about it so long we have forgotten what it is we should be doing.

Your husband is a man I have met once or twice. He always looks sad. His chin is weak. His eyes are dark and he is always carrying a black umbrella. I have seen you climb into his black automobile, watched the mesmerizing flash of your white ankle disappear into a world I do not want to imagine. I have seen you crying and I know he is the one who is making you cry. I have seen you smile while you are speaking to him on the phone, your voice becoming soft and girlish, someone else, someone who I want to kneel before, and then lift her gray flannel skirt above the safety of her knees. I do not know if you still love him, your husband. I don't know if you know, but I have a wife who I do not speak to anymore. She is living with someone else, somewhere in Germany. I do not have a photo of her but I remember her face as angrily aglow, her short blond bangs framing eyes fixed in a stare of complete resignation. Other times, I remember her as being tall and lithe and having narrow white fangs. We were young when we got married though neither one of us now, you or I, are so very old.

At work, you make paper airplanes. For these airplanes you have a number of names: the *two-spinner*, which flies in two complete circles before its inevitable crash; the *submarine plane*, which goes underwater; the *perpetual drifter*, a plane you have devised which, through aerial locomotion, can stay airborne forever. We make two of each of these and send them out the office window, watching them take to the air, wing in wing, disappearing over the city. When they crash, giving in to the luxury of gravity, I think of kissing you and know that is exactly how it would feel.

One day, we go to lunch together. On the way, you find an eyelash on my cheek.

You hold it on the tip of your white finger and I close my eyes and blow and ask someone somewhere to turn us into pilgrims, one hundred years ago and one million miles away, all alone in a jungle somewhere, naked. At lunch, you only order food that is green. When you finish yours and begin to eat off my plate, it makes me very happy suddenly. I do not like how happy it makes me. I watch you touch the white napkin to the corner of your mouth and imagine how easy it would be to kiss right now, how we could disappear into the bathroom or an empty motel room or the backseat of a taxi and I could feel your mouth on my mouth as we fumble for simple buttons, easy zippers, the desperate waistbands of our unhappy clothes. I could take you and place my hands under your arms, lifting you onto the edge of a marble bathroom sink. Your blouse would part like a crème-colored curtain and your shoulders would be as white and stunning as antelopes made of snow, your breasts two sloping diamonds which would disappear under my hands, my fingers, my tongue. I could tug your flannel skirt up over your legs, the soft nylons stretched tight against your narrow thighs, slipping them down your knees, leaving them to rest at the end of your bare feet, then not thinking, neither one of us thinking, never thinking. I would fall to my knees before you and gently kiss the dimples of your thighs, working my fingers beneath the soft stitches of your pale pink panties. What else would I do? What might you do? What might you say if I was kneeling before you? You would laugh. You would laugh and say what we are doing is okay. It is nothing, really nothing.

Your hair is blond. Your neck is like a giraffe's. You hands are small but wrinkly. You wear your gray flannel skirts and black nylons. I touch your skirt sometimes and say, You look nice today, though we both know that is not what either of us is thinking. I am thinking about the shape of your hips, which remind me of a harp, and how these hips would fit into mine, naked, your weight under my weight, as everything is knocked to the ground around us. I am thinking how your clavicle might sound when you breathe, how your ankle might feel, your wrist, your

earlobe, the base of your neck, your elbow, the perfect soft places other people probably do not ever think to kiss. At work, I have made a very complicated flowchart depicting all of the body parts I could kiss, hundreds, thousands, before ever touching your lips. (If I began kissing your fingertip then I would move to your palm, the inside of your elbow, your shoulder next, then your breast. If I began kissing your foot, I would kiss each toe before moving along the bridge of your leg to the inside of your thigh.) I decide to fax this chart to you. You fax back a document that takes me some time to discover is a price list. Each toe, each earlobe is several thousand dollars, and as you know, I can't afford any of it.

At work, we have begun inventing reasons to brush past each other, reasons no one, including us, would ever believe. You ask to use my telephone because your phone is too cheerful-sounding. When you're done with it, the phone has suddenly become lovely: a phone from a dream I once had about you where we were both made of soap. Later, you borrow a pen because your pen is haunted. When you hand it back, you leave the perfect indentation of your teeth along its end. Touching these spots, I understand you have left these teethmarks as a letter, a warning, an invitation to me.

At work, I am sitting across from you in a meeting when you sneeze. I say *gesundheit!* and you say *thank you* and I say *you're welcome* and it is like we are talking about something else. You are saying, *I would like to but I could never forgive you or myself.* I am saying, *If you let me kneel before you once, I can live without forgiveness for a very long time.*

We go for walks in the park during our lunch break. We are suspicious of ourselves so we don't do anything but hold hands. We sit beside each other and look at the world, suddenly seeing what we are feeling: Bicycles decorated with noisy tin cans are steering down the street arm in arm; dogs are chasing other dogs wearing long white veils; rocks are whispering words of lust to one another in secret.

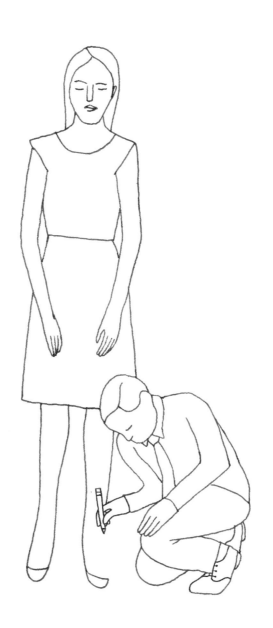

You do not ask what I do when I am not with you. You do not tell me anything I don't want to know, like how the two of you fit each other's bodies together in bed. Does he sleep facing you? Do you have your back to him? Does he mumble something secret to you? What do you sound like when you are about to come? How do you move? Do you close your eyes? Do you make jokes or do you become very serious, ignoring everything? I have asked these questions and you have not answered. I should not ask. I do not want to know any more than I already do.

An apple could make you laugh: You are so charming. On our lunch, we find our way along the crowded boulevard. You stop abruptly and pluck two green apples from someone selling them on the street. You look at them and decide they are in love, these two apples. You make them whisper to one another. You make them dance: The kinds of dances they do are dainty, spontaneous. At the end of the dancing, the apples get married in a little ceremony. After the two apples kiss, you and I laugh. It'll be okay going for the two apples, they will get on fine, anyone can tell. Together, we walk back to the office and hate each other for how easily we can laugh about this.

One day I cannot take it anymore. I throw my shoes over a bridge. I tear off the blossoms which have begun to bloom. I ride my bicycle into a tree and howl on the telephone to you. Your husband is on some trip. Maybe you are thinking about him being gone for good. I tell you things I later regret. I tell you my ideas about the flannel skirt, your nylons, me on my knees, my hands in your lap. I ask you to move to London with me. There is silence and then you hang up the phone very angrily.

You are as young and as lovely as you will ever be. You are at the office. You are on the phone but not listening. You look up at me and ask if it is okay to kiss me right now. Why not? I say. It is something, you say, you have been seriously

considering. We wonder what might happen. We might kiss and the world would end just as we have always imagined. Buildings might fall over and streetlights might turn into silvery glass. A cathedral might become shiny red candy and break apart under its own weight. Children and pigeons might come and eat up all the pieces and then we might disappear quickly. We are not going to find out.

We are not going to kiss, are we? I ask.

You stare at me and tell me your awful news: You have decided to leave your husband. You have decided you are leaving him, the city, and everything.

Really? I ask.

Really, you say. Today. I am leaving everything today.

Oh.

You are going back to wherever you've come from and now you will not even look at me.

I ask if I can come along. You tell me, No, sorry. I try to touch your shoulder but your back is turned. I sit on the edge of the desk and watch you pack up your things. You have a little brown box. I wonder if there is some way I can make myself disappear. I ask if you will write me a postcard. You tell me you will try. I convince myself to tie you up but I find I lack the courage. You take everything from your desk and fit it inside the box, not wanting to waste any time. You look around the office for what you might have missed: Oh, yes. Your green mittens. You put them in the box. I hear you sigh but do not say anything. I watch you button the buttons along your coat. I say your name but you don't look up.

IT IS ROMANCE

illustration by
Ivan Brunetti

It is romance whenever the Model United Nations of Flossmoor High School begins to argue. Mr. Albee, their faculty advisor, tries to pay attention to each of the students as they state their opinions, all of them seated in a half-circle in the corner of the library's meeting room, but in truth, he does not hear what they are actually saying. In his burgundy blazer and tan slacks, he is happy watching the shapes their mouths make as they all politely disagree. Margaret Hatch, in her black turtleneck, the girl who represents China, is standing up, pointing across the fake wood table at Hector, who is supposed to be the ambassador of Argentina. Hector is wearing a formal gray tie and is pointing at Sasha, who, in her yellow skirt, is a very lithe Great Britain. All of them are quarrelling about the unfairness of international interest rates. Their words are like music, an impossibly beautiful concerto, a piece of unbearably eloquent composition played by the secret tympanis of Mr. Albee's tiny ears. Mr. Albee does not get involved in today's discussion; today he only watches his wards, mesmerized by the sounds of their

formal intonations. When their young and unsure voices begin to tremulously shake, to explode, to rattle with multisyllabic words, with complex ideas, with imperious intentions, when one of his students begins to raise a hand, when one of them begins to raise a point, when one of them begins to raise a protest in their adopted country's defense, Mr. Albee feels as if he could love them all forever. He could love all of them, even Quinn Anderson, the dour boy in the tweed sweater representing Russia, an adolescent who refuses to learn anything about his assigned country, a boy Mr. Albee forced to join Model United Nations in order to make good on a number of missing or incomplete assignments for his history class. Even then, when Quinn decides to participate, interrupting Margaret, rolling his eyes at the other kids, pointing out that the other boys and girls have got it all wrong and that "People are just greedy animals, after all," when all of their thoughts are like yellow buds blossoming from behind their white teeth, only then does Mr. Albee finally find what he believes to be true love.

"I don't see how your proposal for economic sanctions against non-Communist countries is even legal," Nigel, a freckled senior and the secretary of the Model UN, is saying.

"Oh, believe me, it is," Margaret responds. "I spent all last night on the Internet. It is now time for the capitalist nations to bow to the power of post-isolationist China. We will not wage war with bullets. We will wage war with loans that none of you will ever be able to repay."

"Well played," says Gwen, the French ambassador. "But aren't you concerned about possible military reprisals?"

"Not with the largest army in the world. Not to mention a few nuclear bombs. In my estimation, China is pretty much invincible."

"Unless it's against South Korea," says Walt, the South Korean ambassador. "We invented tae kwon do as a way to attack Chinese soldiers mounted on horses. We could fight them to a standstill in hand-to-hand combat. Plus, we have the U.S.'s support. Do you have any idea how many U.S. military bases are stationed in South Korea? Thousands. Like a hundred thousand."

"I don't know if all of that is entirely accurate," Mr. Albee interrupts. He glances about the room, all of their faces flush, Margaret squinting victoriously

across the table. A vote is being raised. Someone seconds someone else's motion. Someone says something completely serious about world affairs in a voice that is wracked with the crackle of prepubescence.

In moments like this, Mr. Albee could announce that he is in love with each and every one of them. In moments like this, he could gather them up, like a bouquet of precious crystal animals; like a bundle of brilliant Fabergé eggs, and run off, hiding them all in his coat.

In other quarters of his personal life, Mr. Albee is not so very lucky. In his apartment, alone, Mr. Albee tries to dial up a personal or two from the back of some free newspapers. He tries gay chat lines. He searches websites, he looks in the back of awful porno magazines for a variety of telephone numbers, but he does not find any joy in the conversations he has. When those gay men—who invariably sound much older, much lonelier, much more desperate than their beatific photos in the glossy advertisements (young, tinted, eyes glowing brightly like Jupiter, coy looks on soft faces)—when those men speak, their voices slow, dumb, without any kind of resonance, without any kind of melody, when they begin to mutter their stupid, obvious words, their unkind phrases, their tragic euphemisms which Mr. Albee so hates to hear, when their dialogue is no longer bold, no longer one of ideas and ideals, when the other man's tongue and teeth accidentally click too loudly against the phone's mouthpiece, Mr. Albee will thank the other gentleman for his time and quickly hang up. It is not the fast heartbeat and nervous flurry of desire he is after. It is not the awkward mumbling, the imprecise heavy breathing, the fumbling hands against fumbling hands. It is hope. It is naïveté. It is the tremor of unseen possibility. What he most wants in the world is to hear Jessica Chin point out why she believes colonial deconstruction is responsible for the ongoing conflict in the Middle East, her large eyes narrowed with conviction. What he fantasizes about has little or nothing to do with the complexion, firmness, or nearness of anyone else's flesh. What he would like to have is Matthew Ankle standing beside his bed each evening, reciting the German national anthem, which the scruffy-haired boy has memorized in his spare time, in the few moments when he is not studying for his AP classes and not winning

another fencing match. What Mr. Albee most desires is for the Model UN, the entire group of them, all eleven, even the scoundrel Quinn, to be there waiting when he gets home each dreary night, and there again when he awakes in the morning, all of them politely debating one another with their resplendent voices, their hearts—which have not yet been broken by anything more serious than an unrequited crush or an unfair grade—quietly aglow with everything.

What Mr. Albee finds when he gets home tonight is not a chorus of fresh-faced future ambassadors, however. It is only a phone message from Barry, his ex: *I hope you haven't forgotten how to have fun without me. I hope you're getting out. I'm worried about you. Give me a call when you get a chance. Here's my new number.* Mr. Albee quickly erases the message without writing down Barry's new number. He looks up and stares at the odd space above the black sofa where an enormous Henri Rousseau print—a scene depicting a tiger wrestling a water buffalo—used to hang. It has gone with Barry. Now there is only the dusty outline of its frame and a perfect white space within its rectangular shape. Mr. Albee decides he has always hated that print and stands, staring at the blank spot on the wall, suddenly pleased at its absence, imagining the perfect loneliness of that unsullied space. The empty rectangle makes him think of his wards. *Where are they right now?* he wonders, almost out loud, staring at that blankness. *What are they doing, for the first time, this very night?*

That fall, the Model UN begins to meet twice a week, on Mondays and Wednesdays, at Mr. Albee's request. He mentions it vaguely, as if it is an after-thought, at the end of a meeting one afternoon. He has already made permission slips. In the corner of the mimeographed sheet is an illustration of the United Nations building, its narrow, square shape flanked by a curve of indecipherable flags. The illustration is something Mr. Albee has spent an entire weekend perfecting. There are twelve flags in front of the drawing of the UN building he has made, one for each of the students and one representing him. No one seems to notice this, which is fine, but the twelve flags are there if anyone cares to look. The children do not question the addition of a second meeting. Although it is odd that an extracurricular activity

like Model UN should meet more than once a week, all of the students involved, all but Quinn Anderson, of course, will return with signed permission slips from happy parents thanking Mr. Albee for his support and ongoing commitment to their children. One such parent, a district judge, Emily Banner's eloquent father, writes this line at the bottom of the mimeographed page in fussy penmanship: *You, dear sir, are an example of the most wonderful kind of teacher, the likes most of us as students never had the chance to have. Let your rapturously intelligent heart beat on, let it beat bravely on.* In the pale gray fatality of the teacher's lounge, Mr. Albee smokes a Dunhill and stares at the handwritten note, almost crying. He is so overcome with conflicted emotions, mostly joy and guilt, that he cancels the meeting of the Model UN the very next day. Canceling the Model UN, however, causes Mr. Albee to miss his wards' vibrant voices, their gleaming eyes, their foreheads radiant without creases, their profiles alight with both intelligence and charity, which, in turn, causes so much anxiety that Mr. Albee goes out the very next day and buys an appropriate regional accoutrement for each member of the Model UN.

At the next week's meeting, Mr. Albee presents the children with his tokens of esteem: For Margaret Hatch, there is a Communist's gray worker's hat; for Hector, a beautifully woven belt; for Sasha, a black bowler; and for Quinn Anderson, a furry Ushanka cap. Quinn, predictably, refuses to wear his. It sits in front of him like a wounded animal as he glares suspiciously at its square shape, then up to Mr. Albee's pallid face, back and forth, back and forth again.

For most of this particular meeting, Pablo, the ambassador of Mexico, in a festive sombrero, has the floor. He is accusing Jerome, Spain, who is now wearing a dashing black neckerchief, of iniquities and persecution during Mexico's colonial period. He is asking for compensation. He wants Spain to build a new bridge somewhere within the capital city. He wants the bridge to be made out of gold and wants it to be engraved with an enormous apology. The rest of the junior ambassadors, of course, vote in Mexico's favor. Jerome concedes and imaginary plans are quickly drawn up.

At the end of their meeting that day, Mr. Albee suggests they all take a picture

together with their new garments. Gwen, who represents the nation of France and who happens to be junior editor of the high school year book, always carries her Polaroid with her. She excitedly poses the group. She takes off her beret and then snaps a shot. Each of the children is wearing their regional garment, even Quinn, who sneers, then begins laughing as soon as Gwen takes the picture. As the photograph finishes developing, the Model UN stands staring down at it. In the photo, Mr. Albee is incandescent. He does not look like a man in his late thirties. His face, paunchy, bruised, the color of gooseflesh, is beaming. His thinning hair looks coiffed. He is as hopeful, as spirited, as an adolescent boy. "I'll get copies made," Mr. Albee promises, and places the photo inside his suit vest pocket, close to the radiating circumference of his beating heart.

Once again, Mr. Albee receives a message on his answering machine from Barry: *I stopped by but you weren't home. Are you actually* seeing *someone? Just wanted to make sure everything is okay. Give me a call when you get a couple of seconds.* Mr. Albee erases the second message and stares at the blank space on the wall—the ghostly space of the departed Rousseau print—then reaches into his vest. He finds a thumbtack in his utility drawer and tacks the Polaroid of the Model UN in place, directly in the center of the empty white space.

When he wakes in the morning and stares at the photo in his pajamas, Mr. Albee is deeply shamed. He untacks the photo, looks at it once more—all eleven of their faces brilliantly glowing—then places it in the trash. He stands there, over the garbage can, for an hour or more, staring downward, his eyes gleaming with tears.

On the following Wednesday, the Model UN takes a strange field trip to the dangerous part of the city. It is Mr. Albee's plan that they should all be killed together. It is the only way he can think to resolve this very dire situation. Under the feigned assignment of an activity which he has invented, "Understanding Foreign Relations as It Pertains to Contemporary Life in Major American Cities," Mr. Albee borrows a Ford Econoline from the now-defunct badminton club, and drives the children downtown. Somewhere on the west side, across the street from

a crumbling passel of housing projects, where Gwen takes a wonderful photo of three black girls jumping rope, double-dutch style, which she will use for a photo essay in this year's yearbook to be titled "The Most Beautiful Kind of Poverty," Mr. Albee informs his students that the van will not start. All of the children have cell phones, but Mr. Albee asks them to please be patient. He pretends to turn the key over and over again, but the engine does not roar to life. Quinn Anderson, sitting in the last row of the enormous van, rolls his eyes. Mr. Albee can see the shape of his pale face sneering from back there in the farthest seat. He pretends to turn the key again, feeling the surly boy watching him all too closely.

"This is bullshit," Quinn mutters audibly. "I have homework I got to do. I'm calling my mom."

"Only a moment more!" Mr. Albee shouts, terrified by the thought of having to meet Quinn's mother, or worse, the boy's certainly churlish father. Out of the corner of his eye, Mr. Albee suddenly sees two young black men appear, very interested in the stranded van; they wear shapeless hooded sweatshirts, their gold teeth are frowning, and their earrings glimmer with diamond-studded light. Together, they walk over to the driver's side where Mr. Albee is seated and tap on the window. Mr. Albee closes his eyes and hopes it will all be brief. He hopes he will faint before anything truly violent happens. Most of all, he hopes that they will kill him before they kill the children.

"Open your window," one of the men says. His face is wide and pockmarked, though quite handsome as well.

Immediately, Mr. Albee places his hand over his ears. He imagines death will be like the end of a wonderful evening at the opera, when the baroque bronze doors are slowly opened by the bedecked ushers and the gentry—noisy, tired, overexcited—come hurtling out, their best coats and furs lightly brushing each other with the static of unfamiliarity, the opera's musical reprise still hanging in the air, repeated here and there by a husband or wife helping their spouse out into the cold, the audience, having seen what there was to see, finally crossing into the dark night to simply return home, no blood, no pain, only a kind of sadness, a kind of disappointment at the songs that weren't sung, at the actors' kisses that weren't actually kissed, at the scenes that were unknowingly cut.

The men outside are pounding on the window now, their gold teeth cruel in the half-light of the streetlamps. Sasha has begun to scream. Gwen is praying. Nigel and Pablo and Matthew and Hector are trying not to look terrified, but their trembling lips and uncharacteristic silence have already begun to betray them.

"Open the window, man!" the hoodlum outside is shouting. "Just open the window!"

Mr. Albee imagines Margaret Hatch disemboweled, her skirt undone. He sees Jerome bleeding from his large hairy ears. He sees Jennifer Chin lying lifeless in a dark alley somewhere, her math homework blowing up and away from her still body, the lined notebook paper rising and falling like a specter searching for some sort of solace in the echoless night. Mr. Albee finds the key is still in the ignition, still in his hand, and gives it a turn, pulling the gearshift into drive, speeding off, narrowly avoiding a head-on collision, confidently blowing a red light. The children all happily cheer, clapping their advisor on the shoulder, hugging one another without embarrassment. Margaret Hatch, in a moment of true inspiration, starts singing "The Internationale." The rest of the children listen thoughtfully for a while, then slowly, one after the other, they begin to sing along.

The Model UN will not meet for many weeks after that. Mr. Albee informs the children that he has personal business he must attend to. He invents a sickly mother with a mysterious fatal disease, something akin to shingles. The children do not complain or put up a fuss. Quinn Anderson, at the end of their last meeting, offers his condolences, quoting Tolstoy: *In spite of death, he felt the need for life and love. He felt that love saved him from despair, and that this love, under the threat of despair, had become still stronger and purer.*

Mr. Albee stares at the pale boy, strangely moved.

"That's from *Anna Karenina,*" Quinn adds.

"I didn't know that," Mr. Albee says.

"It's one of the most important books in Russian literature."

A flame of gratitude leaps along Mr. Albee's white cheeks. He watches the boy exit, knowing his life will never be more full than it is at this moment, dreaming of a brain aneurism to end it all right then and there.

* * *

Once again, Mr. Albee returns to the gay chat lines. He reimmerses himself in the fraudulence of pornography. He revisits many singles bar, he spends hours in disreputable bathhouses, he buys a membership to a gym. When none of this works, when Mr. Albee finds himself sobbing on the treadmill machine, when a beautifully burly accountant named Gary says he doesn't know anything about the war in Darfur, when the Model UN advisor discovers he is circling the high school alone in his Toyota Corolla at 4 in the morning, he finally gives in. The Model UN will have to resume its meetings. An announcement is read at lunch and all eleven of the Model UN show up promptly at 3 o'clock that Wednesday afternoon. Nigel has drawn up an agenda and he and Margaret Hatch are already arguing about something.

On and on, into a contented winter, then into a delightful spring, Mr. Albee and the student ambassadors of the Model UN meet unfailingly, twice each week. Near the end of the school year, the students are all invited to the National Model United Nations summit in Cincinnati, Ohio, where Mr. Albee does what he did not think he could do. He purposely books a single hotel room for himself and his wards: one hotel room and only one hotel room. After a chartered bus ride of several hours, the students are exhausted and giddy. They stand anxiously in the motel's chintzy lobby, all flecks of gold and mirrored glass. When Mr. Albee explains that there has been some kind of mistake, that there is only one room and that all of the other hotels in town are booked, that the eleven of them are going to have to share a room, the students do not immediately disapprove. Or he does not believe they immediately disapprove. Standing in the hotel lobby, gathered about their suitcases and traveling bags, some of the children groan a little while others sigh.

Quinn Anderson shakes his head, crossing his eyebrows, muttering. "What bullshit. My parents paid sixty dollars for this trip."

Gwen, always the optimist, so much the bon vivant, announces that she thinks it's a wonderful opportunity. "It will be like a slumber party," she says. "We'll be able to talk all night and really come to an understanding with each other."

Some of the children agree, while the rest are unsure, staring down at their belongings in silence. Once inside the luxurious room, however, all of the Model UN representatives are quite happy. They fling their clothes about, put their sleeping bags and blankets on the floor, and ask if they can order room service. Mr. Albee, in a flush of emotion, quietly consents. The girls do each other's hair. The boys sit watching the girls and wonder if, during the night, there will be a secret entanglement of unfamiliar limbs. All together in their nightgowns and pajamas, the children sit in a half-circle and begin to tell each other secrets: Jennifer Chin has a birthmark in the shape of a boat on her stomach. Hector was the one who pulled the fire alarm last year. Jerome fears he might be gay. Margaret Hatch doesn't know how to swim. Nigel has eczema. Pablo is failing Latin. Gwen had a twin who died when she was three. Matthew doesn't know who his real father is. Quinn is afraid of heights. Suddenly, when it is her turn, Sasha begins to cry. No one knows why. She tells them, holding her hands over her eyes, that she's just so happy to be here, right now. She says she's the luckiest person in the world to have friends like this. Mr. Albee feels like he is going to die all of a sudden. He does not know if he should pull himself to his feet and hurry out the door, out into the street, away, away, or if he should tell them, if he should just say it to them now, here, while they are all together: *I love you. I am in love with all of you.*

"You didn't tell us any of your secrets, Mr. Albee," Margaret says, her blue eyes marvelous with both sincerity and mischief.

"I think it might be time for another game," Mr. Albee says. He stands up, then turns off the lights. "Let's use our imaginations," he says. "Let's pretend there's been a terrible accident of some kind."

"What kind of accident?" Nigel asks.

"Like a world war. Or a plane crash. Let's imagine we're the only survivors. It is up to us to decide the future of civilization."

"Where are we?" Hector asks.

"The arctic?" Margaret offers.

"No, a desert island. We've been evacuated here," Mr. Albee says. "Everything you know is far away. Everyone you've ever loved is dead. We are on this island together, all of us. The ocean is pure brightness, blue with waves of foamy white,

depositing the trash and debris of a ruined world upon the beach. The palm trees move in the breeze like cripples. Who would you turn to then for comfort? Who would you ask to hold you? When it begins to rain, when the monsoon season comes and the bodies of your family begin to wash ashore, their eyes plucked out by seagulls, whose arms do you seek?"

The children stare at each other in the dark, unsure, unnerved, uneasy.

"Does anyone else want to put the lights back on?" Nigel says.

Mr. Albee does not move. He is only a voice now. No one knows where he is standing or if he is still actually in the room.

"Imagine we are trapped on this island, the last survivors anywhere in the world, all of us diseased with grief, far away but together. We build our huts. We sew our clothes out of plant life. We invent new rules. We fish, we hunt, we forage for food. Hurricanes come and go. The remaining nations of the world annihilate each other and it only looks like fireworks to us. At night, we sit on the beach and watch and point out the pretty explosions because we are safe where we are. Imagine how we would name them. What would we call the red ones, the white ones, the ones that look like blue daffodils? Imagine the songs we would invent. Imagine the new civilization we would make. Imagine the secrets we would tell each other. Imagine how happy we would be."

One of the children, maybe Quinn or maybe one of the girls, switches the lights back on. Mr. Albee, in his navy satin pajamas, has begun to cry. He is sitting in a corner of the motel room, his wet face folded into his small hands. When the light flickers on above him, Mr. Albee lets out a sob and pulls himself to his feet. He throws aside the drapes and shoves the window open. He is trying to crawl out onto the fire escape, but the window will only go so far. He keeps trying to force it open wider yet the window won't budge. He is sobbing uncontrollably now. He gives the window one more push before letting out a strange-sounding moan, suddenly collapsing onto the untidy beige carpet. One of the children nervously says his name several times. One of the children is dialing the operator: Her voice sounds like an adult's as she explains the situation as best as she can. One of the children doesn't know if she should feel upset or ashamed and worries that she doesn't feel something decisive either way. One of the children is already

imagining what he will tell his parents, whom he knows will automatically blame themselves. One of the children runs from the room, out into the hallway, and doesn't return for a long time: He spends these lonely hours in the desolation of the motel's video arcade. One of the children wonders what this moment would be like if it was a movie and what famous child actor might play him. One of the children thinks this is certainly a sad turn of events and is curious what Mr. Albee will do now after he is certainly fired: Will he be an insurance salesman or a manager at the new supermarket, perhaps? One of the children can't bear to look away: It is a moment he will later write about on his college applications as the first time he realized that the world had all but forgotten the necessity of beauty. One of the children busies himself eating a chocolate bar he has kept hidden in his coat pocket. One of the children can't stand to watch any more and covers his face with his hands, though he continues to peek through the soft pink web of his fingers. One of the children begins to pray.

THE SOUND BEFORE THE END OF THE WORLD

illustration by
Kim Hiorthøy

Being decent is the only thing that matters in a terrible world like this, where secret, destructive bombs are being dropped on the heads of innocent children in strange, unnamed lands and citizens are being lied to by the awful, greedy men they have no choice but to elect and outraged students get shot by arrogant Ohio National Guardsmen and the President, well, he can cheat and steal as much as he pleases, and a rich girl like Patty Hearst decides to become a liar and a criminal and a thief. Because of the events of the last couple of months and the disappointment of the last couple of years, Ron does not like to think of himself as part of "the establishment." He does not even like to think of himself as a cop: a patrolman, fine, but when he is in the squad car alone, parked in the empty NowUGo convenience store parking lot, listening to rock and roll on the radio, he sometimes imagines he is a famous record producer instead. Ron will ignore the disabled, heartbroken vets shooting at each other in front of the VFW hall. He will ignore the young mother holding her baby upside down at the bus stop, her eyes cracked yellow on angel dust. He will ignore the children shooting fireworks at the American flag rising above the grammar school, and instead he will imagine himself in a darkly lit studio, surrounded by intense bearded musicians and party girls who cheer him on as he decides to add a violin section to an untitled Aerosmith song. Listening to top forty, Ron can always tell, like someone with ESP, which songs are going to make it and which ones aren't.

"Da Ya Think I'm Sexy?" by Rod Stewart sounds like a serious hit to Ron, who loves rock and roll more than anything. He taps out the beat on his dashboard, watching two hippie girls who are not wearing bras strut across the parking lot. It is almost April but still frigid and they are not dressed properly. Ron can see their knees are pink from the cold. A song by Gloria Gaynor suddenly comes on and Ron, disapproving of disco, turns the radio way down.

A group of teenaged kids, dressed in their older brothers' raggedy army jackets, stumble out of the convenience store. Ron sees they are high on something as they amble about like baby-faced phantoms. Ron recognizes most of them from church: They are mostly high schoolers, some still in junior high. One of them, a greasy-looking kid with dark eyes and a peach-fuzz mustache, stops ambling and

turns, giving Ron a dirty look. Ron glances up from the squad car's dashboard, closing his eyes. *Oh, please don't do it, kid,* he thinks. *Oh, please don't do it.*

But the kid does. "Fuck you, pig," he whispers, and lifts up his middle finger and flips Ron the bird and then takes off running. Ron is out of the squad car before he knows what he is going to do, and even though he is well into his middle to late thirties, even though he has very nearly failed the physical the last three years, the weight around his middle being heavier and more awkward than the gun belt he is now wearing, Ron manages to chase down the kid, cornering him by a wire fence. The kid looks scared, his friends hollering as they hurry off down the street, leaving him. Ron fights to catch his breath, which is white fog in the cold night. He raises a finger and says, "Okay, okay, I'm not gonna hurt you or anything, but listen, just listen."

The kid tries to dart away, but Ron sticks out his large arm, stopping him.

"Okay, just listen. Just listen."

The kid lowers his head, the hair covering his face.

"I want you kids to know something. I am not a fascist. I am not a pig. I did not become a cop to oppress anybody. I became a cop because I like helping people. I thought I could either become a policeman or school teacher, but I am not any good at math or history or English, and I thought, *How great would it be to be a cool cop, one kids could relate to, one kids could go to with their troubles?* I'm not out to get you or your friends. I want you guys to be safe and make it past high school so one day you can do the things you want to do with your life. I don't want to hurt anyone. I just want to do my job and listen to some Alice Cooper and keep you guys out of trouble."

The kid glances up, pushing the hair from his eyes, and mutters, "Fuck you, pig," before he darts off, past Ron, his friends laughing with him in the dark.

Ron, though a cop, is still an active member of the KISS Army. He goes to meetings and conventions with other fans of the band KISS, and they trade stories and gossip about what the band members might look like under their hideous makeup. They talk about their favorite KISS moments, the one where

Peter Kriss's drums levitated, the one where Gene Simmons spat blood.

Ron shows up to the KISS Army meeting late. He is still in his patrol uniform and the other members laugh, shout out, "Ron!" and grin from behind their modest, awful-looking glitter makeup. Each member of this unit of the KISS Army has his own favorite KISS member. Ron is very much into drummer Peter Kriss. He argues that the ballad "Beth" may be the greatest KISS song ever, which is upsetting to the rest of the guys. Bobby, a grade school teacher, wears the face paint of Paul Stanley, the star child. Glen has on the demon makeup of Gene Simmons, and Bruce, the poorly done spaceman design of Ace Frehley, which is streaking down his bearded face. Ron barely had enough time to put on his black cat whiskers in the squad car and even the makeup on his nose looks rushed. When Ron enters, Glen is showing off his signed *KISS Dynasty* record again.

"Well, what someone told me was that Peter and Ace didn't even play on this record."

"What?" Ron asks, cracking open a beer.

"I was talking to that guy Lawrence, the guy who owns the record store, and he heard that the producer, Vini Poncia, said that Peter and Ace were too doped up to play. They said they called in different musicians to play their parts."

Ron sets down his beer, pinching the spot between his eyes. He forgets about the black grease paint there and frowns, seeing it glisten at the end of his fingertips.

"Why would they do that?" Ron asks. "Why wouldn't they just record it when they were sober?"

"Maybe they had to get it done," says Bruce, the overweight spaceman. "Maybe like they had no choice."

Ron stands up, leaving his beer untouched. "I can't even hear this right now," he says, and hurries out.

Ron's wife, in bed last night, said she was thinking of trying out a separation. That's exactly how she said it. "I'm thinking of trying out a separation."

"What?" Ron said.

"I'm thinking I need to explore other avenues. I'm thinking about going back to school."

Ron sat up and switched on the lamp beside the bed: It shook from how quickly he had jerked the switch and made shadows that moved along his wife's smallish face. Beth itched her nose, but lay in bed, staring straight ahead.

"Honey, what are you talking about?"

"I don't think this marriage is working right now and I think maybe we should spend some time apart."

"How can you say it isn't working?"

"I am not satisfied. I don't feel okay with myself. You, you have a job. The kids, they have school. Everyone has something to look forward to but me."

"Honey, we're supposed to look forward to each other. That's what couples are supposed to do. Look forward to spending time together."

"But I don't. I don't look forward to spending time with you."

"You don't?"

"No. I feel very disappointed in you right now."

"You do?"

"Yes."

"Why?"

"Because we don't spend any quality time together. When you're home, you go down in the basement and get high and listen to your awful records."

"Beth, that isn't true."

"Where were you all night tonight? The kids and me, we were watching TV, and you were downstairs listening to your records."

"Honey," Ron said, smiling, condescending, "I'm a cop. I have a very stressful job. Sometimes I just need to decompress. I'm not expecting you to understand what it's like, but it's something I need to do."

"It's always like that. I feel like you and I are stuck. We're not growing as people. We're the same people we were five years ago."

"What?" Ron asked, turning to face her.

"You refuse to take the detective test. You don't want to move up in the world."

"I am not going to discuss that with you."

"Don't you want to get ahead? Don't you want to get a nicer place? Don't you want to be somebody different than you are now?"

Ron switched off the lamp. "No," he said, and turned on his side. He lay in the dark and could hear his wife crying. He felt ashamed of himself and turned back over, taking her head and holding it against his large chest. He began to sing softly, his voice baritone but sweet. *Oh, Beth what can I do? Beth, what can I do?"*

Ron's wife is named Beth. Like the ballad sung by Peter Kriss of KISS. It was how they met, actually. It was the reason Ron wanted to meet Beth in the first place. His friend's girlfriend Suze mentioned she had a college roommate named Beth, and Ron, imagining the kind of girl he had always dreamed about in the song, quickly agreed to go on a date with her. They fell in love right away when Ron admitted he was scared of heights, at the top of a Ferris wheel, holding hands, that very first evening.

Tonight Beth is not home: In fact, Ron notices that many of her personal items— her shoes, coat, makeup bag, suitcase—are all gone. There is Ron's dinner sitting in the fridge beneath aluminum foil, which he heats up and eats, staring at the three empty seats around the table.

Ron cleans his dish and heads downstairs to lift some weights. He is feeling out of shape and a little blue, so he decides some physical exercise may help. As he climbs the basement stairs, he sees Gary, his son, sitting in the dark, playing Pong.

"Gary, pal, you're sitting too close to the TV," Ron says, now standing beside his son.

Gary does not move, his eyes following the digitized white ball across the black screen.

"Gary, how long have you been down here, buddy?"

"Six hours."

"Six hours is a long time."

"Yeah."

The boy, whose dark hair is cut in a mop shape, does not stop playing as he speaks.

"Do you know where your mother is?" Ron asks.

Gary shakes his head. "She said she was going to Grandma's."

"Oh. Did she have a suitcase with her?"

Gary nods, twisting the game knob furiously. "That was close," he whispers to himself.

"Did your mom have a suitcase with her, pal?"

Gary nods, the bleep of the game acting as an answer.

"I'm going to go lift some weights. You want to spot me?"

Gary shakes his head in the negative.

"Gary, how old are you?"

"Twelve."

"Okay," Ron says, and pats his kid on the head.

A couple of hours later, Ron is sitting in his blue boxers watching *All in the Family* on TV. Gary is upstairs doing science homework. Beth has not called or returned. Ron sits up abruptly when he hears Lindsay, his daughter, arriving home. He leaps from the soft, orange reclining chair and huddles beside the window as a yellow Camaro idles outside.

"That dickhead again? Come on, Lindsay," he mutters. "God, I hate that kid."

Ron watches, squinting his eyes, as the boy in the yellow Camaro grins at Lindsay, who blushes and tucks her long, feathered brown hair behind her ear. The boy whispers something. Lindsay whispers back.

Ron frowns, mumbling to his daughter who cannot possibly hear him. "You don't have to do anything you don't want to do," he says. "Just shake his hand and climb out of that fucking go-cart."

Lindsay giggles, covering her mouth with her hand.

"Just say goodnight and get out of the car."

Lindsay closes her eyes when the boy places his hand along her cheek.

"Don't do it. Don't you do it."

The boy flips off the headlights as he turns, grinning. Lindsay's head begins to drift beneath the horizon of the dash. Ron's stomach plummets as the Camaro's engine dies. The streetlight above the car masks what is going on inside, the

windshield a shimmering glare of light and movement. Ron curses and hurries toward the side kitchen door. He darts from the big oak tree to one of the cars parked in a neighbor's driveway. By the time he's at the driver's side window of the Camaro, Ron can see Lindsay has unbuttoned the boy's pants.

Ron pounds on the window once and the boy jerks up, surprised, turning his head toward the sound. Lindsay, also startled, sits up, shocked at seeing her father in the cold, with no shirt on, standing in the dark, smiling. He nods, motioning to the boy to unroll his window, which he does. The boy's face is ghastly white as he struggles to pull his flannel shirt down over his unbuttoned pants.

"Hi there," Ron says. "I'm Lindsay's father."

"Oh, hello, sir."

"What's your name? Because I don't think we ever met properly," Ron says, smiling.

"Parker."

"Parker, I'd like you to say goodnight to my daughter now."

The boy nods, his face bright red. "Goodnight."

Lindsay lurches from the Camaro, red-faced, swearing at her father.

"I fucking hate you! I do! You are such a fucking jerk!"

She storms off toward the house, and watching her, Ron realizes she is not wearing any shoes. He turns back to look at the boy.

"Parker, I want to show you something," he says. He leans in close to the window and shows the boy his large, hairy bicep, on which is placed a small, almost indecipherable tattoo. "Do you see what that is?"

"No," the boy says.

"That's a tattoo. Do you know what it says?"

"No."

"It says, *KISS Army*. Do you know about the KISS Army?"

The boy, confused, nods slowly.

"Do you know what it means to be in the KISS Army? It's a brotherhood, like the regular army, but with people who are fucking crazy, like bikers and drug addicts and everything. You didn't have any idea, did you? No. I bet you didn't. Did you know that guy Bill Warner, who works in the morgue downtown, is KISS

Army? Did you know if I asked him to forge some documents for me, he would? Let's say I went and got my gun and shot you right now. Bill Warner would, without a doubt, file your death as a suicide. Why? Because that's what we do for each other in the KISS Army. Do you get what I'm saying here?"

"Yes."

"If I ever see you driving down the street again or anywhere near my daughter, I will have you murdered. You and your fancy car together. Now go and don't ever come back here again."

The boy nods and turns the car on, then peels off. Ron smiles again and waves at the vehicle. He turns and his smile fades as he stares back at his house. He can see that Lindsay is upstairs and he thinks she's packing a suitcase.

Ron stands in the doorway, trying to apologize.

"Lindsay, stop it for a moment, okay?"

"I'm not speaking with you. I'm going to go live with Mom at Grandma's. She said I could if you started acting like a jerk."

"I was not acting like a jerk. I was trying to help you. That boy, well, he was going to hurt you. He was going to use you, and I, well, I'm here to help you."

Lindsay stops and turns, staring at her father. Her blue eye shadow is runny.

"You were going to help me? That's a joke. You don't even know what I do when I'm not here. You have no idea who my friends are or what kind of person I am, like at school or whenever I don't have to be here."

"Lindsay . . ."

"Mom is right. It's like you don't even exist."

"Lindsay."

She closes her small yellow suitcase and picks up the pink phone. She dials a few numbers and Ron watches silently, bracing himself against the door frame.

"Mom? It's Lindsay. Can you come pick me up right now?"

As Ron is patrolling 98th Street in the squad car alone the next day, he sees a strange black shape, like a cloud of some kind, glowing in the middle of the road.

Some kids with bicycles are kneeling beside it, poking at it with sticks. Ron flashes his lights and pulls the car over.

"What's going on here, guys?" he asks as he climbs from the vehicle.

"We don't know. Something happened to Teddy."

"Well, where's Teddy?"

The kids all look downward, toward the strange black shape that Ron notices is slowly growing. It is like an enormous hole, an absence of space, steadily expanding.

"That's your pal? He's in there?"

"He fell in there. Him and his bike," says a kid with green eyes, who is poking into the black hole with a tree limb.

"He fell in?"

The kids all nod.

"Okay, nobody touch anything. Everyone just back away." The kids nod again and watch as they realize their friend, fallen into the strange black mass, is truly gone. Then the cloudy formation begins to sparkle, as if it is made of the night sky. Several small stars appear as the mass keeps expanding outward. The kids jump back, but one of their dirt bikes is too close to the mass and gets swallowed up: The frame begins to twist and collapse, and then it is gone, then it is nothing. Ron hurries to the squad car and radios in to Angie at the call desk, fighting for his breath.

"Angie, it's Ron. There's something weird happening at the intersection of 98th and Homan. There's some sort of hole or chemical cloud or something. I need a fire truck or chemical clean-up crew or something."

"Ten-four. Roger that," Angie says.

Ron looks up and watches as the black hole continues to grow. A parked car, a blue Nova, teeters inside the blackness, disappearing into the sparkling, star-lit mass. Ron hops out of his vehicle and yells to the kids who are all still standing nearby, staring. The children pedal in lazy figure eights around the circumference of the thing, some of them still calling out for their missing friend.

In a moment, Ron can hear the clang of the fire truck speeding down 98th

Street toward the scene. He takes a deep breath and stares in terrible confusion as three streetlights topple inside the hole.

After four hours, the black hole stops growing and Ron is temporarily dismissed. He heads home to change his shirt, which is soaked through with sweat, and to grab himself something to eat. Beth has been home while Ron's been at work: She's cooked him dinner and left it covered in aluminum foil in the fridge. She's also cleaned apparently: There are vacuum lines on the carpet around where Ron had spilled a bag of barbecue potato chips the other night. Ron sets the plate in the oven to warm it up and hears the strange, computer-simulated boops and beeps of Gary's video game echoing from the basement.

Ron sighs and heads downstairs. Gary is once again playing Pong, alone in the dark, his eyes a deep red and a drool stain of some kind visible on the collar of his blue shirt.

"Gary?"

"Yeah, Dad?"

"Gary, do you ever worry about being cool?"

"No."

"Well, I think you should."

"You do?"

"Yeah, I really think you should be concerned about how other kids look at you."

"I really don't care if they like me or not."

"That's my point, pal. I think you should. Don't you ever want to have friends?"

"In the future, people won't have friends. We'll have computers to interface with."

"Maybe, pal, but I'm talking about right now."

"Well, you're my friend. And so is Lindsay."

"Lindsay is your older sister. And I'm your dad. We're not your friends."

"Why not?"

"Because. Because you can't be friends with someone you're related to."

"But Dad, I don't like anyone I go to school with."

"Well, you have to fake it then. You can't just stay down in this basement playing that game. It's going to make you into a bad person."

"Really?"

"I think so. I think it might make you into a weirdo."

Gary nods. Ron pats his son on the shoulder and heads upstairs to take a nap.

When he wakes up, the basement is silent. There is no beep-boop-beep of Gary's video game. He smiles and pulls himself up from the couch and heads down to find that his son and the video game are both gone. They are both missing. Ron scrambles up the basement steps and sees a small white note left on the kitchen counter. It says, *I went to go live with Mom.*

On patrol that night, Ron watches as the black hole swallows all of Turner Avenue. The whole block is suddenly gone—the homes, the trees, the parked cars, a dog which was barking and ran straight into the strange mass. Parents stand down the street with their children, gasping in horror, as the fire department evacuates the next block. The black mass seems to stop growing for a moment, and then, as if making up its mind, it continues to expand once again, swallowing a fire truck whole. Someone from the mayor's office is making a speech on the radio and the governor is sending in the National Guard.

Ron squeezes a family of six people in the back of his squad car, with their pet canary, and drops them off at a relative's house. When he drives back to the scene, the yellow wooden barricades have already been swallowed up. He calls in on his radio to report the situation, and Angie at the call desk just says, "I know. We're evacuating the whole town now. If you want, Ron, the chief said you can go by and pick your family up."

"That's a ten-four," Ron says, knowing they are already gone. They are already on the other side of the interstate and probably watching it all on TV. They are far away from him but they are safe and sound, for now at least.

After most of the east side of town is evacuated, Ron is dismissed from duty. He

argues with his sergeant about staying on until the job is done, but the sarge can see lines of exhaustion crossing Ron's face. Scared, tired, alone, unsure what to do, but not wanting to go back to his empty home, he heads over to Bobby's house, which is a safe distance from the catastrophe and where the KISS Army was supposed to be meeting that night. He does not bother to put on his Peter Kriss cat makeup. He walks around the side of the small brick house and knocks on the kitchen door. The lights in the kitchen are dimmed and the other three guys are all sitting around the small linoleum table, none of them wearing their makeup, each looking confused and distressed.

"What's going on here?" Ron asks, standing in the doorway. "Beth," Peter Kriss's solo song, is playing quietly on the stereo, and when Ron looks into Bobby's eyes, he thinks he sees the guy is crying.

Bobby sniffles a little and then looks up. "It's bad news, man. Bad news."

"The worst news," Glen says.

"The worst news ever," Bruce adds.

"It's Peter Kriss. He . . . he quit the band."

"What?" Ron whispers. "What are you talking about?"

"He . . . he quit KISS."

Ron slowly backs out of the door and then hurries into his squad car as fast as he can.

Ron circles the town in his squad car for an hour, listening to the radio. Every few minutes the deejay mentions the terrible news: Town hall has just been swallowed by the black hole. The mayor is now missing. The grammar school looks like it will be swallowed next.

Ron finally pulls up in front of his empty house. He stumbles inside and decides to call his mother-in-law's. He is terrified. He does not know why, but his hands are shaking as they hold the receiver against his ear. In the distance, he can hear sirens screaming. He takes a deep breath. The phone rings and rings and rings, then he hears his mother-in-law Judy's voice, old, confused, angry.

"Judy, it's Ron. I need to talk to Beth."

"Well, Ron, I don't know if she wants to talk to you." There is a long pause. *"Beth? Beth, do you want to talk to Ron?"* There is some commotion and then Judy whispers into the phone, "Ron, she says she doesn't want to talk to you."

"Will you tell her it's an emergency, please? Tell her it's life or death."

Ron hears her whisper the message and then add, *"He sounds really upset, dear."* The phone changes hands and Ron can hear his wife's breathing on the phone: He knows it's her breathing. He could recognize it anywhere, soft, unsure, a little sad, but her breath, her breath which is really, really lovely.

"Hello?" she says. Ron thinks of everything he wants to say, of everything he's ever wanted to say, of all the times he was wrong and never said anything, of all the times she has somehow saved him, maybe without her even knowing, and how he has never even thanked her. "Hello?" she says again, and he can feel the phone trembling in his hand as he tries to think of the perfect thing, the right thing to say, the one thing that will save him in this moment. What is the one thing he can tell her right now that will let her know how she is his everything? How, without her, he does not want to do anything, that none of it matters? "Hello? Ron? Are you there or not?" she is saying, and Ron closes his eyes and feels something like tears coming on and decides to just say something, even if it is not perfect, even if it is not good enough to be a line in a hit song, even if it is just him blundering, he does it anyway, he does the best with what he has, and says, "Beth, oh Beth, without you or the kids, I'm nothing. I'm absolutely nothing." Then her voice which comes again, answers, "It's okay, Ron, it's okay, I'll be there soon. I'll be there soon."

ANIMALS IN THE ZOO

illustration by
Jay Ryan

The zookeeper's heart is broke. His wife has left him and gone on an airplane with some stranger to Peru. In his grief, the zookeeper has opened all of the animals' cages and thrown away the keys. He has left a note and flung himself into the exhibit of the poisonous African bees. The rest of the animals, sleepy-eyed and lacking courage, do not escape at first. They only stand in the open doorways of their confines and stare, sure this is a trick of some kind. *Ha, ha, ha,* they think. *Very funny, Mr. Zookeeper.* The elephants, using their lovely trunks, feel around the openings, their limbs twitching, their hearts secretly waiting to be shot with

the precision of a well-oiled elephant gun. The monkeys, smarter than most of the other animals, convince their neighbors, the gullible but charming pandas, to open their cage doors, sure the clumsy bears will be immediately tranquilized for trespassing. The tigers and lions moan in unison, and also in disbelief, then give up and go back to their grooming. A brave little antelope named Eeka finally marches out of its holding pen. Together, all the animals wait and watch, then are dumbfounded when nothing happens, the antelope simply disappearing into the forbidden expanse of the nearly empty park. *Have the doors really been thrown open?* their small animal hearts all ask. Their small animal hearts all answer: *Yes.* The animals hurry toward the entrance of the zoo, still half-believing they will be exterminated before they make it to the parking lot.

At that moment, Emily Dot, a third grader, is sitting on her front porch, waiting to be punished. She is in trouble, serious trouble. It is the first day of summer and her

final report card has just arrived. It seems Emily has not done so well this year. Her teacher's comments claim that Emily was quite unruly and refused to stop interrupting class. Apparently, she once even yelled, "There cannot be a God! If there is a God, why are there no dinosaurs anywhere in the Bible?" Emily Dot has been known to misbehave like this ever since her mother went back to work. What does her mother do? She is a stewardess. Her days and nights away from home have had some unhappy consequences for Emily. For instance, in religion class, Emily Dot's teacher warned her to please keep her comments to herself, but it was of no use. Emily is very, very sad. Like the zookeeper's, like the world's, Emily's heart has been broken a little bit too.

Mr. Dot, her father, tall and handsome, takes off his tie and sits on the porch beside her. He is in sales, a project manager. He has been known to manage a project or two in his time, you better believe it. "What are we going to do about this report card, young lady?" Mr. Dot asks seriously.

"I refuse to be talked to like a child," Emily says. "I know there is no such thing as God and I won't be forced to think there is."

"No, certainly not, dear. No one can make you think something you don't want to think."

"I tried to be polite and ask questions, but Mrs. Shields only got angry whenever I spoke."

"I imagine you must have tried her patience quite a bit."

"Mom always answers whatever questions I have. She never loses her patience with me."

"Yes, she's very kind and very patient."

"She never talks to me like a child."

"No, she doesn't."

Emily Dot and her father, Mr. Dot, look up just then and see an amazing sight: It is a beautifully massive, ivory-horned rhinoceros, quietly hurrying down the middle of their street. It slows to a halt, seeing them, then huffs through its great gray nostrils. It looks from daughter to father, blinking its enormous black eyes, then continues on its way, lumbering behind a small yellow house on the corner, disappearing from their sight. In a moment, an African red deer and a spotty-orange tiger follow, then a silvery crocodile, one after the other like a very strange parade, the animals making their way aimlessly down the street. Several lovely white reindeer pause a moment to taste the Dots' hedge, then sprint past, scraping their great antlers along the elms that line a neighbor's small blue house.

"We ought to phone the police," Mr. Dot says, and scurries inside the house. Curious, Emily Dot climbs down off her porch and hides behind the great green hedge, watching as a massively round hippopotamus strolls toward her, lolling its heavy tongue over its pearly teeth. It takes a large chomp out of their azalea bush, ignoring the small girl, who curls into a shadow at its feet. In a moment, the hippo is wailing. Two cheetahs have sprung from nowhere and are making short work of this, an enormous meal, pouncing upon the hippo's great, wide back, snapping its preposterously large vertebrae. Emily Dot stares up into the twin mewling jaws of certain death, stunned, until her father pulls her to her feet and up onto the safety

of the porch. The cheetahs ignore the father and child, however, quite content with the shambling feast breathing its last breath before them.

"We'll be safest up there," Mr. Dot says, and they hurry up the rose trellis to the second story. From their slanting shingled roof, Mr. Dot and his daughter watch the animals maraud their tiny neighborhood: The Fosters' duplex becomes a temporary snake house as their prized poodles become strange bulges in the digestive tracts of several anacondas; the Hamiltons' front lawn becomes a makeshift savannah as ibex and zebra gracefully feed on their magnolias; two camels wander into the Halloways' backyard and demolish their luau, tipping over a tikki torch which ignites a series of fireworks; worse still, Dickey Peterson, the neighborhood bully, is accosted by several gorillas, who carry him up into the dense shadows of his family's maple trees.

"There's a little gray monkey on the corner there!" Mr. Dot exclaims, pointing.

"That's a bush baby," Emily says. "We read about them in science class."

"Oh, yes. A bush baby," he says. "Where do they come from?"

"The rain forest."

"Oh, yes. Of course."

They both observe the tiny, furry animal preening itself, as it hangs nimbly from a street sign. They are quiet for a while, the unfamiliar chatter and prattle of jungle creatures reverberating in the twilight.

"I am sorry for shouting at school," Emily says.

Mr. Dot nods and replies: "Yes, you'll have to stop doing that."

Emily huffs and then looks down. "I really miss Mom," she mumbles. "I think about her all day."

"I miss her too, pumpkin. I miss her too."

Emily itches her nose and sighs, then says what she has been thinking for quite a long time: "Nothing's been right since Mom's been gone."

"Yes," her father says, taking off his glasses. "You're exactly right."

PEOPLE ARE BECOMING

CLOUDS

illustration by
Nick Butcher

People are becoming clouds nowadays. Each time John goes to kiss his wife, Eleanor simply laughs politely into the palm of her hand and immediately turns into a puff of soft white vapor. The vapor is quite odorless and can assume various sizes and shapes. It can still understand when it is being spoken to, the vapor. It can understand whenever John begins wordlessly crying. One time, while holding hands at the airport, John, without thinking, kissed Eleanor's soft cheek and immediately she turned into a puff of charming whiteness that resembled a young pony leaping over a fence post. It seemed that the pony was neighing from the way its long neck was stretched and raised. Someone took a picture of the cloud and it ended up on the second page of the next day's newspaper. Eleanor's parents called right away. Her father was quite unhappy while her mother seemed quite pleased.

* * *

As a cloud of vapor, Eleanor will remain transparent for upwards of an hour or more. Her appearance may vary greatly, depending on various strange, unknowable factors such as the weather, what she has eaten that day, what she happens to be wearing, etc. When she is not a cloud of white smoke, Eleanor is a first grade schoolteacher who is greatly loved by her students as well as almost everybody else, including strangers who pass her on the street. She is that type of striking young woman. She has short red hair and bright eyes like a pixie. She laughs the way you imagine a toy dog laughing. It should be noted that Eleanor had never turned into a cloud before the couple was married and this unplanned development has been a source of silent frustration for John.

A partial list of the strange shapes Eleanor has taken as a cloud of vapor: a dove with enormous wings blowing a large trumpet, an intricate snowflake with castles for feet, a swan with an impossibly long neck sewing a blanket, a fairly accurate representation of an angel with rings of spoons for a halo, and a gigantic apple being swallowed by a ghostly white tiger.

Eleanor claims that turning into a cloud is totally beyond her control. John does not entirely believe this. Right before she transforms, she seems to be laughing, and her laughter is what leaves John unconvinced. But he refuses to argue about it. He loves her and he thinks she loves him and he believes it's just one of those things that will have to work itself out. *Couples go through these kind of things*, he thinks.

John and Eleanor will still sometimes try to be intimate. They will turn off the lights and put on some soft music, it will maybe be jazz music, sometimes not. John will lay there in their white bed and close his eyes and wait for his wife to touch his body, and when she does he will try to stop himself from running his fingers through her hair and he will be able to resist her for a little while, but if she is wearing the pink-and-brown nightgown, he will eventually grope at her, and within moments she will be drifting high above him. He will lay in bed then

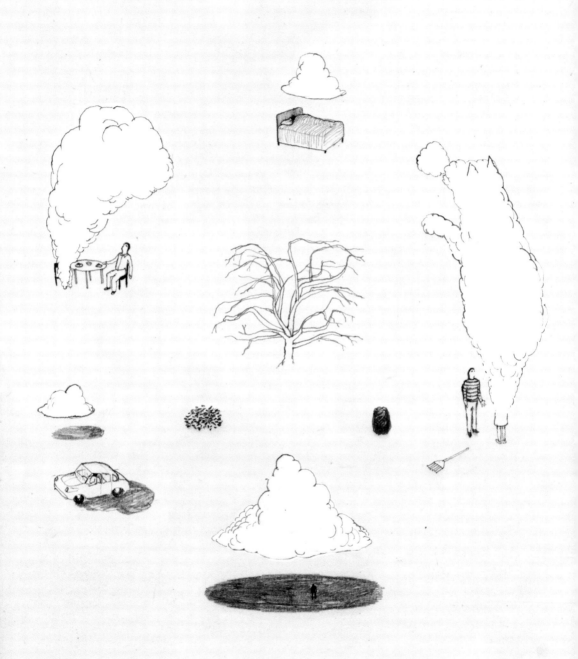

and stare up at her, a white cloud of happiness, condensing and expanding. He will reach his hands up to grab her but he will be unable to. He will try to breathe her in, to take her into his lungs, but his face will only become red until, finally, he gives in. He will turn on his stomach and want to cry into the pillow but he will not. He will be too embarrassed to cry. When he finally turns over, he will see Eleanor has become a snowy-white falcon eating a peach or a series of lovely hills decorated with a miniature cloud town. He will wait, laying there in bed, and fumble with her discarded nightgown until she drifts back down.

John will sometimes call Eleanor from his office, where he works as an accounts representative for an aluminum company, and he will ask her, "Are you a cloud right now?"

"No," she'll say, laughing. "Of course not, honey."

"What about now?"

"Um, no."

"What about now?"

"Nope."

Other times, John will go on business trips to sad places like St. Louis and Cleveland and he will call Eleanor from his motel room and they will try and talk dirty, like they are only dating.

"I am climbing in the window and sneaking up on you," John will say. "I am dressed like an old-time bandit with a striped shirt and a mask."

"Okay. What am I doing?" she will ask.

"You are doing the dishes. You are wearing a white frilly apron, like a maid."

"How about I'm wearing the apron but I'm not a maid?"

"Okay, that's good. You're doing the dishes in your apron and I am sneaking behind you and touching your shoulders and arms and the backs of your legs."

"Then what?" she will ask.

"I dunno. Um . . . I am carrying you off into my jet and we are flying away now. I have kidnapped you maybe."

"You're a bandit with your own airplane?"

"Yes, I'm independently wealthy. I chose a life of crime to relieve my boredom."

"I see," she will laugh. "What are you doing to me now?"

"I am . . ." Someone will be listening to the television too loudly in the motel room next to his and John will whisper into the phone softly, "I am blindfolding you. I am blindfolding you and feeding you a lot of frosting and candy."

There will be a pause where John will be unsure if his wife has hung up or is still listening, and after some time he will whisper, "Are you a cloud now?" and then there will be silence, there will only be the sound of air, which is no sound at all, which means yes, she is a cloud now, and John will imagine kissing his wife right then and he knows he will be unable to, so instead he will kiss the phone, and it will be the closest he can get to the actual thing, the kissing of his wife, and then he will say goodnight and place the receiver back in the small plastic cradle before closing his eyes and fighting to go to sleep.

The couple finds a weather/relationship specialist in the phone book and makes an appointment to go see him. He has glassy blue eyes and a white beard and holds Eleanor's hand. He has many charts and maps and graphs marking cold and warm fronts overlaid with sketches from an anatomy book. He blows his nose with a white handkerchief and asks the couple very personal questions like, "How frequently do you each masturbate?" and, "Do you still find your mate sexually attractive?" John holds his hands over his eyes as he answers, feeling the heat of his embarrassment glowing along his eyelids. When, toward the end of the session, the specialist asks Eleanor her favorite shape when she is a cloud and she responds, "I like just being a general kind of cloud the best," the old man nods and sets down his pen as if he has found the answer to something. He asks for a check for seventy-five dollars and tells the couple to come back next week. They do not. They go to the movies instead. During the film, John boldly reaches for Eleanor's bare leg, kissing her with wild abandon, until suddenly she is an enormous black cloud, her gold earrings now strips of zig-zag lightning. An usher sees the cloud and shines his flashlight at it and John imagines the lightning flashing back is her smiling.

At work, John finds himself searching the Internet for clues, hints, suggestions,

stories of similar weather-related problems happening to other normal, red-blooded men, but no, there is nothing. There are only endless pictures of girls in wet T-shirt contests and site after site of affordable radar-tracking devices which give three-dimensional depictions of storm clouds hovering above far-off cities. He comes across a photograph of a gulf-stream hurricane tearing the roof off a small white house and thinks he recognizes Eleanor as one of the clouds drifting in the nearby gray sky. He stares at the photo for a long, long time.

Often, when Eleanor is a cloud, she will make a strange sound like this: *Ooooooo oo oo oo oo ooo.*

Eleanor sometimes phones John at work. Sometimes they talk while John is busy sorting through his files.

"I want you to know that it's okay to be angry with me," Eleanor says. "I would be if it was the other way around."

"I'm not angry with you," he replies, typing something boring.

"I know, but sometimes I wish you were. Sometimes I wish you would shout at me and tell me you hated me or something."

John holds the telephone receiver against his chest. He feels as though he has fallen from a great height and is clutching at the air around him, only to find that the air is laughing spitefully. He stands up and watches the zipping rattle of the office around him and begins shouting: "I can't fucking stand this anymore! I can't fucking stand this!" He holds the phone above his head and howls and then places it against his ear and says, "Eleanor?" breathing heavily.

"Yes?" she whispers.

"I'm sorry. I'm sorry I yelled like that."

"Do you feel any better?" she asks.

"Yes," he says. "I guess I do."

"Well, then good. I'll see you when you get home."

"Okay," he says.

On the bus ride home, John fantasizes about the lips of various nondescript strange women. He imagines what he would do with a pair of hot lips if given a chance. He stares across the aisle and a question forms from nothing in the vessel of his mind. *Would I still love my wife so badly if she wasn't so impossible to claim? Would I still want her if I could have her whenever I wanted?* He does not know. He isn't sure. He does not think so, suddenly. But maybe kissing her might be worth all the boredom in the world as well.

When John arrives home from work, he finds Eleanor has become a large sparkling building. She is as tall as a skyscraper and is made entirely of a strange silvery material, like a cloud, both precious and transparent. The building is standing in the yard, rising high and mighty into the infinity of the evening sky like a futuristic needle. John sets his briefcase down and sighs, then takes off his jacket, folding it over his arm. "Great," he says, looking up. "This is just great." He finds the entrance to the large silver building, spins in through the revolving door, takes an elevator up to the highest floor, and stands staring out at the stars glowing above the rest of the world.

The horizon is so big and dark and sad that John can barely lift his head. In the silence of that very great height, he can hear the echo of his own breathing.

"Eleanor?" he asks, and then leans against the silver railing. Somehow he knows his wife is listening. He loosens his tie, taps once on the railing, and says, "It looks like you had a bad day."

ghost plane

illustration by
Jon Resh

The airport was eerie—it was almost entirely empty. Billy looked the ticket agent in the eye, took a deep breath, and tried to explain once again that the girl he was with was having a really serious nervous breakdown of some kind. It was the reason they were late and the reason they really ought to be let aboard the plane, did she understand any of this? No, it did not look like she did. He tried to say all of it slowly, in his most informal, most over-enunciated English, but the small Belizean woman behind the counter only nodded and shrugged, then pointed to her watch, which was already a half hour past their original departure time.

"This girl is totally f-ing unstable," Billy argued. Nicole only shrugged, yawned, then covered her mouth with her hand. She blinked twice dumbly and Billy looked at her hair, which she had cut yesterday in a fit of madness—it was long on one side, while the rest was dangerously short. Her forehead was still red

with small scissor marks. "This girl is seriously losing her marbles and we need to be out of your country as soon as f-ing possible."

The ticket agent's reply was this: They would have to wait until the next available flight, the earliest of which would be the following morning.

Billy did not like that at all, no, he did not. He adjusted his mirrored sunglasses and smoothed his tropical flower shirt. "Okay, look, this young woman needs help. She needs to return to her homeland where people, her doctor or whatever, know why she is crazy. Now, why isn't it possible for us to be on the flight that is sitting at the gate right now?"

The small woman shook her head and said, "No, no, tomorrow, thank you." She offered them two seats in economy class for the morning flight, checked their passports again, and advised them to please be on time, thank you very much, goodbye.

The couple stared in horror as the great blue metal door to the boarding area closed suddenly. In the next moment, the enormous white airplane was taxiing away. Billy held the girl's hand, not out of any affection, but out of a sense of camaraderie in having missed what would have been the quickest, easiest way to end a miserable five-day trip. Watching the plane depart, the girl let go of his grip, both of them becoming immediately hopeless.

"We'll have to get a hotel room for the night," Billy said. "We'll go get a taxi and find a place nearby. Don't worry. It'll be fine."

"It doesn't matter either way," the girl whispered. "I'm already on that plane. I'm flying away from here. I'm gone and never looking back at this terrible place or you ever again."

"We should go get a room," he repeated.

"As far I'm concerned, you and everybody else are dead to me now."

"Excellent," Billy said.

"I am doing everything I can not to start screaming at you," she whispered.

"Bonus," he said. He took their bags and began stumbling uneasily toward the exit. In a moment, a smiling Belizean man in a dark suit stopped them both, showing them a bright silver identification badge.

"Good afternoon. We have been alerted that your companion here may be

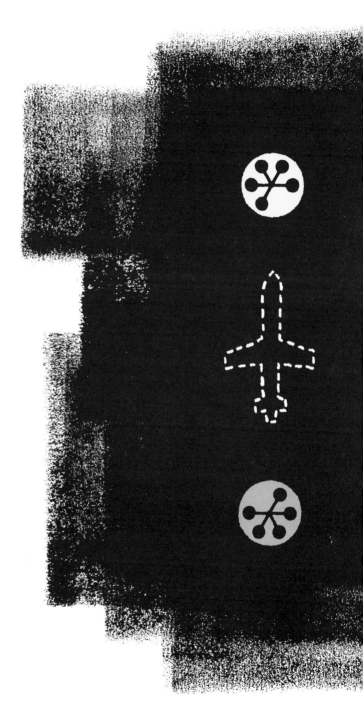

suffering a mental illness of some kind. We must be sure you will not injure yourself or other passengers on the flight." The man said all of this very quickly while smiling at the girl. "If you are to fly tomorrow morning, we must give you a short psychological test before you can board the plane."

"Man, is this for real?" Billy asked. "Because it doesn't seem like you can just do that."

"Yes, we can, and we should not wait, if you want to make arrangements to leave here as you plan."

Nicole looked at Billy and rolled her eyes. He nodded and said, "I shouldn't have said anything, huh?"

"No, you shouldn't have, you dick."

"Do you want me to come with you?"

"No, I do not."

"How long will this take?" he asked the man with the badge.

"One hour."

"Okay, I'll meet you here in about an hour." He pointed to the airline counter. "Good luck. You know, just say whatever you think a sane person would say."

"Very funny." The girl smirked and followed the man in the dark suit down a corridor, then disappeared into a small office. Seeing her scared, stepping down the shadowy hallway, Billy remembered why he liked the girl so much: She wasn't strong. She was truly the weakest human being he had ever met. She was young and rich and spoiled and had been in a video which documented topless girls on spring break. She had been in two different volumes of this particular series. She was about ten years younger than him but much, much smarter. She read. Books. All types of books. She once gave him a book for his birthday. He looked at it as if it was a glowing rock fallen from outer space. He had met her the first time at a party and immediately noticed she was not wearing a bra. She had on this very thin white T-shirt and there was something about the shape of her astonishing breasts, small, like teacups, that made Billy follow her around all night in a daze. In the taxi, which they agreed to split even though Billy was heading in the absolutely wrong direction, they began to make out. Nicole was an amazing kisser, she kissed with total abandon, like it was the most fun ever, making out, and she even took

his hand and placed it under her pink skirt, his fingers moving down to the soft lines of her panties. She reached into the front of his pants and just as her fingers were unbuckling his belt, she stopped. She looked at him quizzically and frowned, then said, "I've got to stop acting like this," but kept making out with him anyways. When they finally did it, a couple of days later, she was shy at first but then laughed the whole time. She seemed to be the only girl Billy had ever met who actually enjoyed sex. Which was great. Which was why he had asked her to come with him to Belize in the first place. She was more fun than anyone he knew, but sometimes, more often than not, he discovered, a certifiable cuckoo.

It happened when they were unpacking in their small hotel room after arriving the first afternoon. Nicole discovered she had forgotten all her antianxiety medications. Mistakenly, Billy told her that it was probably the best thing that could ever happen to her. He told her not to worry. He told her she probably didn't even need all those pills anyway. Billy, of course, had been wrong about everything in his life, and this poor medical advice was absolutely no exception.

The girl's breakdown, when it happened, looked exactly like this: After three days of sitting under an umbrella crying, arguing with him about why she wasn't eating, Nicole locked herself in the bathroom of the hotel room and refused to open the door for about four or five hours. Billy paced the room and knocked on the door every ten minutes or so. All he could think to say was, "Nicole, this is not very cool. If you're mad at me, open the damn door so we can talk. Don't leave me out here like some kind of asshole." The girl, hearing all of this, sitting in the small, claw-footed bathtub, grabbed her hair dryer, plugged it in, and dropped it into the tub with her. Nothing happened. The hair dryer was a new model that prevented anything serious from happening. Out of frustration, she decided to cut her hair, which was long and soft and blond. After she finished, half of it was still shoulder-length while the rest was molted and jagged. When the girl finally opened the bathroom door, Billy found her naked, submerged in the water, her skin pruning, the hair dryer floating beside her like an expensive bath toy. Suicide, he decided, was more than he could handle, and immediately booked the flight home.

* * *

Outside the airport was a taxi stand, a military outpost, and an old green-tinted factory. It was July and the heat made everything look silver. He had planned on getting a cab back to Belize City, securing a modest room for the night, and then returning to the airport to pick Nicole up. When he stepped out into the sun, though, he realized it would be better to wait for Nicole than drive there and have to come back again.

A dark-skinned boy was sitting on an old red bicycle, resting his feet on the curb near the taxi stand. The boy watched Billy carefully and then, pointing to a wire basket attached to the front of his bike, asked if he was interested in buying any fireworks. As it turned out, Billy was damn interested in buying some fireworks. In fact, he couldn't remember the last time he had wanted to buy fireworks so badly. He gave the kid a buck, American, and the kid offered him his choice of a variety of rockets, noisemakers, missiles, and Roman candles, all with strange names like *Widow's Laundry* and *Sparkly Flying Fish* and *Blooming Fire Mansion*. At the bottom of the basket was another kind, small paper animals on crude paper tricycles, and Billy selected one of those as well, a monkey with a red fez riding an antique-looking bike, and then two nameless blue rockets. He patted the kid on the head, then felt bad for doing that and gave him an extra buck.

Nicole, unbelievably, was given a clean bill of health. But, of course, she was not waiting where she was supposed to be. Instead, she was outside smoking right under a *No Smoking* sign and itching her armpit feverishly.

"What in the hell is wrong with you, Nicole?" Billy asked.

"I've got a mosquito bite in my armpit. It's pissing me off big-time."

"No, I mean, why are you smoking right there? These people are very serious down here. There's a goddamn sign right there."

"Fuck off, Billy. If I can't smoke, I'm gonna fucking murder somebody."

"Okay, fine. We're gonna go back into the city and get a room. Finish your cigarette and let's go."

"Billy, you are not allowed to talk to me for the rest of the trip."

"Fine."

When he heard
that sound,
that snorting laugh...

"Fine, and fuck you," she said.

Billy got her into a taxi and they drove back through the wide, dense grasslands toward Belize City. The landscape was brittle and empty, dotted every so often with aged, aqua-colored Coca-Cola signs and billboard warnings against drunk driving. The girl was quiet, thinking maybe, then at some point looked at him and squinted with her small, hateful eyes.

"That airport guy asked me if you were my dad." She said this with a sneer that showed some of her small white teeth.

Billy nodded but didn't say anything.

"I realized that's why I came here. Because I really hate my dad. I hate my dad and I'm living like this to punish myself."

"Awesome," is what Billy said, staring out of the window of the taxicab. "That is fucking great news."

Nicole complained that the room they got, the room they would only spend like six or seven hours in, was both trashy and cheap. It was, though, really. The water in the bathroom stopped working while Nicole was in the shower and so she came out, her hair wrapped in a small white towel, the rest of her tall and thin and naked. She laid in the small bed beside him and sighed, then said, "I'm sorry for ruining your trip, Billy. I am not very happy right now, in my life. I'm realizing people really don't like me. I feel very shitty about myself inside." She sniffled a little bit, then turned over, covering her face with her hands. "I'm not expecting you to understand, but I am sick of being treated like shit by people. I can't stand being treated like shit anymore."

"Then maybe you shouldn't act like shit," he said.

"What is that supposed to mean?"

"Nothing. You act like a dumbshit so that's how people treat you."

Nicole glared at him, her bottom lip trembling. "I fucking hate you, Billy," she said, and started crying again. "I really do. I came down here because I thought you were nice. I thought you were the one person who really liked me for who I was and everything."

"Oh Jesus, Nicole."

Billy sat up and put his feet on the floor. He buttoned his pants and decided this would be a good time to take a last look at the tropical sunset. He grabbed his backpack and stepped outside. Most of Belize City was lit up with colored lights by then, the small bodegas and corner stores peopled with skinny kids laughing and drinking soda pop from glass bottles. He sat down on a narrow curb, searched for his smokes, found his lighter, then remembered the fireworks. Oh yes, the fireworks in his bag. He placed one of the blue rockets on the ground, lit the fuse, and backed away carefully. It simply burned up, never leaving the earth, totally soundless, exploding into a small white fire which he stamped out angrily with his sandal. He tried the other rocket, which again simply caught fire and fell on its side, another bust, another dud, ugh. He took the paper monkey with its fez, its small legs attached to the pedals of the bike, and set it on the street. He glanced up at the motel room window and frowned. He suddenly felt bad for what he had said to her. He felt awful for forcing her to come with him, knowing exactly how she was, *crazy*, and expecting her to be anything else. He had not been very nice to her the whole time. He had definitely screwed up by telling her it was okay not to take her medication. He felt maybe now might be a good time to apologize. He put his hands to his mouth like a megaphone and started shouting for the girl. There was no response. He called and called and called her name, the Belizean kids on the corner staring at him, their small dogs joining in, until Nicole opened the door and came out onto the balcony. Her hair was still in the white towel and she had a white sheet wrapped around her middle. She was really lovely, like a princess; even in the dirty motel sheets, you could tell there was something very intelligent and refined about her, from the length of her neck and the way she carried herself. She was somebody smart, but she was used to acting very, very dumb. She was pretending to be bored now and smoking, her body lithe and narrow as it leaned against the railing.

"What do you want now?" she asked, staring down at him.

Billy kneeled and lit the fuse, then hurried away, the small monkey exploding with white fire, shooting across the street, disappearing into a small field, jumping from the ground, and vanishing into the night sky. The girl was surprised, for the first time in a long time maybe, and began clapping, her mouth wide and open.

Billy started making monkey sounds, hopping back and forth. Her face went red with mirth, a terrible snort echoing from her nose.

When Billy heard that sound, that snorting laugh, he thought, *Oh no, oh God, oh God, I am falling in love.* He stood there blinking at her on the balcony, then dashed up the motel stairs, chasing her into the room as, just then, she began laughing and screaming.

What a Schoolgirl You Are

illustration by
Kelsey Brookes

What a schoolgirl you are. You read *Choose Your Own Adventure* books and novels about teen romance with cheerleaders on the cover. You believe in the idea of true love. People in your classes call you withdrawn, shy. When your back is turned, they call you lame. You tell yourself how you don't care and go on reading Judy Blume, even though you're a sophomore now and still trying to comprehend why you don't quite fit in at your high school.

Your hair is the same as it was in fifth grade. You have no idea what to do with an eyebrow pencil or lip liner. Your armpits are hairless and so are your legs. You are fifteen and waiting with much dread for your first period to come. Your

body is a green twig, full of knots and unattractive bumps and angles. You have decorated all your folders with the same drawing of the same Pegasus leaping over the same castle.

What a schoolgirl you are.

You do not pay attention in class. You'd rather be reading a horror novel. You find yourself spending most of your summer in summer school.

Ditching your algebra class one day, you go to watch your best friends smoke in the green woods beside the highway. You never smoke. Your father died of cancer two months ago. When you were small, your father would read a book to you, kiss your head, then switch off the light. In that moment, he would become a shadow. That is how you think of him now, a shadow, quiet and lonely in the dark corner of your room. Now you imagine everyone you love dying suddenly. You are sure somehow your father's death has something to do with you.

That afternoon, you are told a secret that changes your young life. Jessica Bennet, the dark-eyed, rosy-cheeked captain of the high school cheerleading squad has, without reasonable explanation, committed suicide. Your closest friend, Patrick Van Buren, whispers this gossip to you as you sit on a wet log. Patrick is one year younger and has small, delicate features. He stutters frequently. He is in summer school for failing gym. He is what other kids call queer and wears his blond hair in one long series of cascading bangs. There was a moment where you thought he was going to kiss you and you were terrified of what was going to happen if he got an erection. You think he saw the fear in your eyes and made a decision to never try and kiss anyone ever again.

Patrick offers you a cigarette, which you decline. You then ask, "How did she kill herself?"

Corey Phillips, your other friend, picks at her braces and answers: "She stabbed herself thirty-nine times." Corey is tall and is often called "Horse-face" while walking down the hallway. She has failed chemistry on purpose. She is in love with the teacher, Mr. Brandt, and wanted to take his class over the summer again. "Can you believe it?" Corey asks. "She stabbed herself thirty-nine times?"

You are impressed. You are impressed because you have often imagined stabbing yourself to death. Strangely, the number in your head has always been

exactly thirty-nine. You have imagined putting on the soundtrack from *The Sound of Music* and taking a kitchen knife to your midsection, counting out blow after blow, one, two, three, up to thirty-nine, until you collapse and the record finally ends. You now imagine Jessica Bennet doing this and what you feel for her is an untold amount of respect.

"Why did she do it?" you ask.

"Brad Armstrong broke up with her."

You think of Brad Armstrong: tall, square-jawed, dark eyes, captain of the football team, the Romeo in every school play. Knowing Jessica Bennet has stabbed herself thirty-nine times because of unrequited love forces you to consider that you may have been wrong about her and everything.

Corey finishes picking at her braces and frowns. "Jessica was, like, totally evil," she says. "The world is, like, much better without her."

A cloudy question storms your mind then. You say it before you have had a chance to actually consider what is being said.

"Who's going to replace Jessica on the cheerleading squad?"

"They're holding emergency tryouts tomorrow afternoon," Corey replies, snapping a small rubber band back in place somewhere within the darkness of her mouth.

You stand abruptly, as you have now made a decision, and say, "I'm going to try out for the cheerleading squad," and begin walking back toward the school in a way you imagine is brave. Your friend, Corey, stands frozen, a statue of a girl with a horse-face staring. Patrick's small mouth drops open. He tries to catch a glimpse of your nonexistent breasts while you are bravely walking away.

If you really do decide to try out for the cheerleading squad, go to page 2.

If you decide to go home, put on the soundtrack to *The Sound of Music*, then stab yourself in solidarity with Jessica Bennet, go to page 15.

You choose to try out for the cheerleading squad because you know that, in its own way, this decision is practically the same as stabbing yourself to death. It is a kind of suicide, you think, and this is both terrifying and pleasing.

As you are walking home, you are trying to remember the cheers your older

sister Melanie used to practice when you shared the same room. This was before she disappeared last year, stealing your small white piggy bank, which contained nearly three hundred dollars, saved from babysitting the previous summer. Melanie is now somewhere in Arizona with an older man named Ron who is no one you have ever met. You imagine him with rough hands and a mustache. Melanie sent you a letter recently telling you she wishes she never left. You carry the letter at the bottom of your school bag and hope she is not dead.

"Ready? Okay!" is about the only part of Melanie's cheers that you can remember, but you repeat the phrase again and again, pronouncing it with each step.

A strange brown station wagon pulls up beside you as you continue to absent-mindedly rehearse, remembering the staged smile on your older sister's pretty face. A good-looking man with dark hair and a black eye patch unrolls the passenger's side window and calls to you.

"Hello!" he shouts. "Can you help me, please?"

You look at the man and know at once that he is seriously troubled. You know at once that he means you harm. The shape of his chin is weak and his mouth is soft and resigned. You approach the passenger's side door and stare down and see his hands are white and trembling. You can easily imagine him strangling you to death with those hands and think perhaps death by strangling would not be so bad.

"I will give you fifty dollars if you'll come sit next to me."

You look down into his face and know if you get in the car, nothing will be the same for you ever again. You think this is one of those moments, this is one of those moments where everything changes.

If you do decide to climb into the car with the mysterious man, go to page 3.

If you decide to turn and just keep on walking, practicing the cheers of your older sister, who may already be dead, go to page 8 instead.

You open the station wagon door and climb inside. With his black eye patch on, the mysterious man looks handsome and daring, a buccaneer from a romance novel you've just read.

"What do you want me to do?" you ask, all out of breath.

"I want you to hold my hand."

His large pale hand reaches out for your small dainty one. You close your eyes and imagine this as the final moment of your life. You are pleased to think people will certainly be surprised when they find your body somewhere in the woods, naked, marked with the signs of struggle, a struggle no one ever thought about until this grave instant, this instant where a strange man took your hand. But he does not try to strangle you. The man folds his chin against his chest and immediately begins crying. You sit beside him and he holds your hand and continues to cry, then he stops, apologizes, and gives you the fifty dollars as promised: two twenties and a wrinkled ten.

"You've kept me from doing something," he whispers, still holding your hand. "I was going to do something awful to myself."

You look down at your feet and see a dirty brown paper bag and suddenly know there is a weapon of some kind, a knife or a gun, resting silently inside, the man's desperate fingerprints smudgy on its shapeless handle. You also realize the man is not a man at all but a boy, seventeen or eighteen at the oldest. This is clearly his parents' car since there is a small religious figure on the dash and a needle and yarn resting beside you on the seat. You see what you thought was a mustache is the same desperate unshaven fuzz of the boys who pass you in the hallway. You let go of this strange boy's hand and now feel like you've forgotten how to breathe.

You fold the money into your pocket and climb out in a hurry. As you're leaving, the boy asks, "May I see you again?" You take out a pen and write down your real name, address, and telephone number on the back of his hand, then walk away without talking.

As you head on home, you wonder what your father would think of what has just happened. You wonder if he is watching over you, or, like everything else you believe, only a dream.

If you decide to go on believing that love continues after death, go to page 4.

If you decide that death is the end of all things, go to page 16.

<div align="center">* * *</div>

You decide to go on believing death is not the end. You decide to keep on believing that love is greater than any mortal divide. You think of the hospital before your father died and the odor you could not place. You would sit beside him, his soft gray eyes closed and sad, the sound of the machine beside him breathing mechanically, his hand resting beside yours, crossed with strange-looking blue veins. Every day after school, when you went to visit, you wore the yellow-and-white striped sweater he had given you for your last birthday. It was too small and was tight in the shoulders but you wore it every time you went to visit anyway.

After your father had been in the hospital for three months, you told him it was time he got a haircut. He agreed. A nurse came in and tied a white smock around his neck and gave him a trim. He looked handsome, like a movie star. He was thirty-nine, only thirty-nine. He looked one hundred. You did not care. You combed his hair and he asked where your mother was. You lied and said she was working.

When he died, you made a promise to yourself not to cry. Not ever. You have not broken this promise yet, but have come very close, and this, this moment now, walking home alone, thinking also of the strange boy in the station wagon, this may be one of those times.

If you decide to go home and practice for cheerleading tryouts tomorrow instead, go to page 5.

If you decide to start crying and finally break that promise, go to page 15.

In the school locker room the next day, you undress before cheerleading tryouts and become terrified of how white your legs look. You notice Hope Chang, a varsity member of the cheerleading squad, slipping out of her jean skirt, her legs like a swimsuit model, her bust womanly and thrumming. You realize that what you are doing now is just as painful as stabbing yourself, worse possibly, because suicide, in its own way, at least has an end. This, this prolonged heartache, this living day to day, it is these moments, these deep, deep, howling moments, these upturned, dark, and woeful moments, these clawing, coffin-shaped moments, these nail-through-the-palm-of-your-hand moments, these every-breath-you-take-is-full-of-baby-spiders moments, it is these moments that are by far much more frightening.

In the gym, in front of the coach, your legs begin to buckle. The coach is a small, dark-eyed woman, her hair long and unbrushed, a silent sign of the grief from having lost one of her own. She is clearly bereaved, clearly struggling to keep herself from crying. She looks over the nine or ten girls there for tryouts and then whispers, the sound of her voice a dull, unanswerable question, "Who among you, like Jessica, has the guts to climb to the top of the human pyramid? Who among you is willing to threaten life and limb, staring into the dark profundity of death, at the screaming height of halftime, just like our dear Jessica?"

You take a small, hesitant step forward, raising your little hand. The coach nods and blows her whistle, and immediately the six living members of the cheerleading squad assemble, young, darling, skin both shiny and scrubbed. They begin a cheer and one by one start to form a gigantic human pyramid. The coach, wiping a flurry of tears from her eyes, nods at you and you walk forward, taking Hope Chang's hand. You climb upward, completely ready for this to be it, your final moment, your often-imagined death.

You don't die, however. Somehow, somehow you manage to stand, only wishing this would be the end.

You are at home now and staring at yourself in the mirror. You do not like what you see. You do not ever like what you see except for your knees. They are the only thing remotely tolerable, but as you know, no one besides you ever notices your knees. You hold the red-and-white cheerleading uniform in front of your small, narrow body and cannot imagine how you will look wearing it: It is the soft, professionally cleaned garment of a dead girl, and like a lost letter, you imagine it carries some of Jessica Bennet's secrets. Along the ruffled wrist is the mark of what may be the remains of a kiss left by Brad Armstrong, the moment before they pressed one another against the rear of Jessica Bennet's red-and-white jeep: the pressure of his hands insistent, his mouth muttering angry requests Jessica would never be able to argue against. There along the frilly skirt is what must be a dewdrop of a tear from when Jessica strained in agony, holding Hope Chang above her head, breathing through the brightest smile she could force, at the head of the Founder's Day parade, the whole town and boyfriend Brad looking on

proudly. Were they already talking about breaking up? Had he left a mumbled phone message or passed some imbecilic note detailing the reason why Jessica was no longer the one for him? Had he even told her or had she seen him laughing at some else's jokes and just known? Searching for evidence, you inspect the uniform carefully and discover a small unwound thread spiraling loose from its spot along the edge of the narrow waist. There, like Morse code, in nearly invisible white knots, you are certain she has spelled out the word *Brad*.

The phone rings and, as no one ever calls for you, you are quite surprised when your mother, from down the hall, shouts out your name. So unsure are you of the call that you stare at the pink sparkle phone at the foot of your bed as if it is another piece of furniture and not a telephone at all. You pick up the receiver and speak, though not confidently, and the voice that responds is the voice of the boy who, just yesterday afternoon, was holding your hand and crying.

"I called to thank you," he mumbles. "And to apologize."

"Apologize?" you say.

"For scaring you. I'm sorry to scare you like that."

"I wasn't scared," you say and realize you are not lying.

"I have been driving around thinking these things for a long time. I have been driving around and thinking maybe I don't deserve to be alive."

You whisper the word, "Why?"

You whisper it quickly and wonder if he is still there listening, and there is a silent beeping on the line before his voice returns and he asks: "What's the worst thing you ever did?" His voice is turning to static and you suddenly feel like you are once again in the car with him.

The answer you are thinking of is this: *I did not love my dad enough to keep him from dying.*

"I don't know," you say. "I haven't done anything really bad, I guess."

"I got in a car accident and killed my friend," he says. "We got in an accident because I wasn't paying attention. We were holding hands. It was this game we used to play. It was a secret, I guess. He let go of mine and I went to grab his and then we got in an accident." He breathes, and it sounds like he might start to cry. "I lost an eye," he adds. "It doesn't really matter—the eye, I mean."

The phone feels like it is a silent hand on your throat and you hold it away from your face, checking to be sure you are still breathing.

"I've been thinking about killing myself," the boy says. "But now I feel okay. I feel like I have a friend."

"Okay," you say.

"I think I'm going to start crying, if that's okay."

"Okay," you say.

If you decide to close your eyes, let the boy cry for the next three hours, fall asleep, wake up, walk down the hall to be sure your mother is still breathing, pick up the phone, and continue to listen to the young man weeping, go to page 7.

If you decide to hang up the phone right then, go to page 13.

Hands on hips, your shoulders back, you stand with the other six cheerleaders before the silent crowd: It's six months later and it's the middle of the big game and your team, the Tigers, are winning. You scan the cheering bleachers for the strange boy's face: handsome, reserved, with the eye patch, a little dramatic, a little scary. You finally find him sitting there in the middle of the sixth row. He is wearing a dark green army jacket and is staring back at you. He looks sad and beautiful, like a watercolor in a hospital room. Just then, a referee blows his whistle and you realize the Trenton Tigers are up 52–46. Tara Armstrong, the shortest of the girls on the squad, tugs the back of your uniform and you discover you haven't heard what cheer has been called. You glance once more over your shoulder at the mysterious boy and then back at your squad, who are all standing patiently, waiting for you to get ready.

Hope Chang shouts, "Ready?" and the squad cries out in unison: "Okay!"

You're on top and you know it!

We're right with you, so let's show it!

You begin your ascent up the human pyramid. You imagine falling and cracking your skull, the crowd dulled to quick silence by your dramatic death. You imagine what they would say, your grainy picture on the front of the school newspaper. You imagine your friends Patrick and Corey staring at the photo and nodding coyly.

When you reach the top of the human pyramid, unsteady, grasping the hem of Tara Armstrong's shoulder, you see the small square of the gym wavering beneath you. You hear your teammates cheering and the crowd clapping and the sound of your heart beating hard against both terror and death. You see how small the world you have known has always been and smile, then closing your eyes, you fall backwards into the arms of the other cheerleaders, their hands gently catching you, falling right past death, just as you have always practiced.

Miniature Elephants are Popular

illustration by
Todd Baxter

Miniature elephants are very popular: There are ads for these tiny pets on the radio and on television and in the pages of a number of up-to-the-minute magazines. Miniature elephants are quite affectionate and the most quiet of all household pets, or so their advertising suggests. Sadly, at this point, miniature elephants are the only elephants left.

Mr. Larchmont, an umbrella salesman and widower, is often lonely: His associates and loved ones sensibly convince him to buy a miniature elephant. There is something about his disposition that suggests he may enjoy a miniature elephant: His face is long and wrinkled and his movements are often quite slow.

 At the pet store, Mr. Larchmont, black umbrella in hand, stands curiously before the tiny tanks of glass. He is searching for the smallest, weakest-looking elephant he can find: He is searching for a miniature animal to match the exact size of his heart. He spots a tiny elephant, more miniature than the rest, in the

corner of the cage: It is sleeping in a nest of old newspapers and is white with narrow, pinkish toes. It blinks its bashful eyes as the pet store employee pinches it by the wrinkly skin behind its neck and hands it to Mr. Larchmont in a tiny white box.

—We're going to be dear friends, says Mr. Larchmont.

—I hope so, the pet store employee says. But it doesn't always work out. These miniature elephants, well, they're very sensitive. They die quite frequently. If you're looking for a pet for your kid, well, we have some miniature horses that are very nice.

—That's okay, replies Mr. Larchmont. This elephant and I, we're going to be dear friends.

So they are: Mr. Larchmont and his miniature elephant often walk thoughtfully through the city, enjoying the summer afternoon, the animal stalking clumsily along the sidewalk, Mr. Larchmont reading that day's newspaper, carrying his black umbrella, his black bowler riding atop his head, as he tiptoes slowly behind his pet.

—Bravo, Mr. Larchmont says, as the miniature elephant splashes through a puddle. Carry on, old friend, he says.

The miniature elephant often sleeps in a bureau drawer among Mr. Larchmont's old ties, underwear, socks, and dress shirts. It drinks water from a broken pipe beneath the bathroom sink. It will only eat miniature vegetables, which Mr. Larchmont buys from a strange foreign store at the end of his street. The miniature elephant enjoys stopping on the sidewalk in front of the city's oldest bakery, where the baker, a kindly old man with a white beard, will often serve him a tiny pink cake.

People will see Mr. Larchmont and the miniature elephant strolling about and will often ask these questions:

—How old is it?

—What's its name?

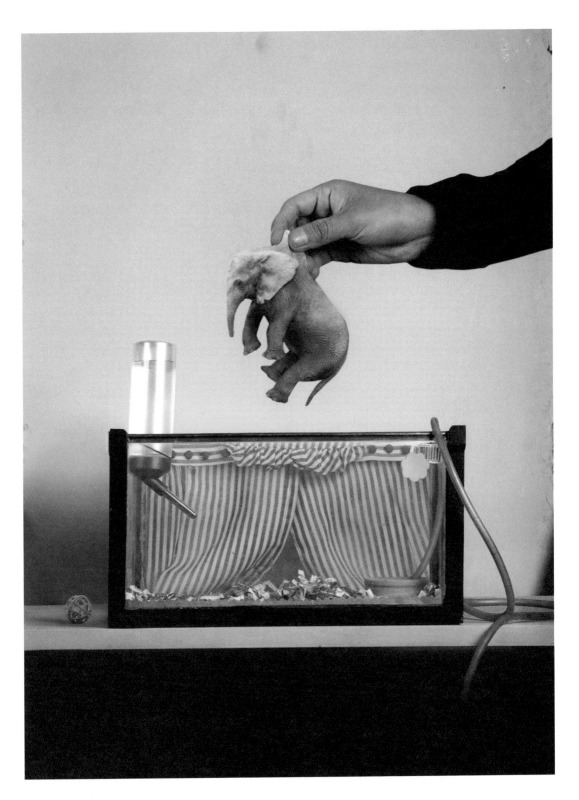

—How does it stay so tiny?

Usually Mr. Larchmont does not answer, pretending to be very busy reading his newspaper.

One day, strolling along the pavement, the miniature elephant stops and refuses to keep walking. Mr. Larchmont smiles and stares down, urging it kindly with the toe of his wingtip. But the miniature elephant does not move. Mr. Larchmont hunches beside it and notices the tiny creature has closed its eyes and its tiny white head is bowed, like a statue of an old man in serious thought.

—What has you troubled, old chum? Mr. Larchmont asks, but the miniature elephant does not respond. It is then, turning, staring down into a sewer grate, that Mr. Larchmont spies a human hand: He shudders as he notices the wrinkles and a pink ring on one of its narrow fingers. Curiously saddened, the miniature elephant stands before the abandoned hand and only bows his head further. Mr. Larchmont, touched by his companion's sympathy, gently lifts the animal into his palm and steps away from the trying scene in a hurry.

On their walks then, the miniature elephant will often stop, sadly bowing its head, whenever they traipse unto the silent shadow of unmarked death. Mr. Larchmont will search about and after some time discover the cause of the elephant's malady: a dead pigeon lying belly-up beside the curb, a yellowed roach motel hidden in the corner of a doorstep, a bouquet of plastic flowers marking the spot where a traffic accident occurred. The miniature elephant's sense of grief is uncanny. Once, the animal stops at a grimy alley which is filled with several dozen bright yellow mousetraps. In each is a small brown or gray mouse, their tawny sides crushed by the aching jaws of the traps. All twelve mice are dead. The elephant blinks its eyes and turns away, ashamed.

Another afternoon, strolling before the shambles of fresh meat hanging in the window of a Chinese butcher shop, the miniature elephant pauses and lets out a long, baleful sound, like a broken trumpet being blown from a very old steeple.

An entirely awful incident takes place when Mr. Larchmont, reading the day's headlines, forgets the direction he is traveling and looks up, finding he is in front

of the city's oldest cemetery. The miniature elephant only closes its eyes and curls itself into a small, compact stone, before Mr. Larchmont picks the animal up and moves away, apologizing.

At a dinner party, a young woman mentions to Mr. Larchmont that her pet cat is lost. It must be hiding somewhere in the apartment, or so the young woman suggests. Mr. Larchmont frowns, staring at the young woman's face. He touches the wrist of the lovely hostess, scurries off, and soon returns with his miniature elephant. The entire party is amused as they travel down the hall to the young woman's apartment. Mr. Larchmont places the miniature elephant on the soft gray carpet and pets its forehead gently. The animal stumbles about at first, happily taking interest in the young woman's white orchids, and then slowly, sadly, it turns, small step after step, drawing closer to the woman's gray sofa. The elephant lifts its trunk for a moment, sniffing about, and then becomes still, an old drawing of itself.

Mr. Larchmont frowns.

The young woman lets out a nervous laugh.

—Of course I looked under the sofa, she says.

Mr. Larchmont says nothing.

—Of course I looked under there.

The young woman takes to her knees and searches beneath the sofa.

—See, there's nothing there.

Mr. Larchmont kneels beside the woman and feels around. It is empty. He turns and stares at the miniature elephant, who sits unmoved, its head sadly bowing.

The young woman, upset now, searches beneath the sofa one more time.

—Oh no. Oh no. Oh no, no, no, no, no.

The young woman feels about and finds a small hole, a tear in the bottom of the sofa.

—Oh no. She used to climb up inside there when she was a kitten. She . . .

Mr. Larchmont frowns, gently lifting the miniature elephant, carefully placing it within his pocket. The young woman begins to sob. The cocktail party is quickly over.

* * *

The miniature elephant may remain sad for many days: After discovering the missing cat, it will not eat for a week. Mr. Larchmont offers it a miniature head of lettuce, but the elephant only frowns, blinking its great blue eyes, turning on its other side in Mr. Larchmont's bureau drawer. After a week of listlessness and a general ennui, Mr. Larchmont takes the animal to the vet.

—He looks very sad, the vet says.

—That's what I thought too, says Mr. Larchmont.

—Did he come across any other dead animals lately? That will put them in terrible humors.

—He did, as a matter of fact.

—Oh no, that's no good at all. It can kill them.

—It can kill them? Mr. Larchmont asks.

—Sure, sure. They're very sensitive, the vets says. You have to be careful not to let them get depressed or, well—here he whispers—it can kill them.

—Then what can I do for him?

—You have to cheer him up. You have to cheer him up or he'll stop eating altogether.

—Okay, Mr. Larchmont says. Well then, how do I cheer him up?

—Here, the vet says. He reaches into his white smock and removes a small red rubber ball. This should do the trick.

The rubber ball does wonders for the miniature elephant: It soon forgets the sadness of death lurking in the quiet corners of every room, every building, every city. Mr. Larchmont is careful when they stroll about town: He avoids cemeteries, hospitals, fancy restaurants where rare steaks are served. The miniature elephant seems to return to good humors and Mr. Larchmont, strolling behind, smiles as it splashes beside a leaky fire hydrant, blowing a trunk full of water into the summertime air.

—Carry on, Mr. Larchmont says. Enjoy yourself, dear friend.

A girl from the city goes missing suddenly: Mr. Larchmont reads the news and

stares sadly at the youngster's picture in the paper. The girl has short brown hair and a white bow above her left ear.

—Oh no. What a terrible world, Mr. Larchmont says, reading the story for the third time.

Strolling about the city that afternoon, the miniature elephant instinctively leads Mr. Larchmont near the apartment building where the missing girl was last seen. The structure is gray brick, the shades of its windows all drawn closed, its façade a weepy face.

—Oh no, my dear friend. We ought to turn now and alter course.

But the miniature elephant pays no heed to Mr. Larchmont's words, stumbling on, slowing with each step, until Mr. Larchmont and his pet stand near a cordoned-off area peopled by policemen, onlookers, and busybodies. The miniature elephant ignores the nervous crowd, trampling right past their feet.

—Oh dear, Mr. Larchmont mutters.

The elephant pauses, its small gray trunk curled in a knot. It begins to fuss and sniff about, its blue eyes blinking excitedly as a well-shined loafer belonging to a police officer hurries by. The elephant pauses again, then takes off at a clip, Mr. Larchmont breathing quickly to keep up.

—Dear friend, he calls. Dear friend, do wait.

But the miniature elephant cannot: With its small, column-shaped legs it canters along, its tiny ears flapping with each miniature gallop. Up the boulevard, down the avenue, around a corner, Mr. Larchmont holds his black bowler atop his head, nearly tripping over his umbrella. He follows his tiny pet about the city until he sees, just up ahead, that the miniature elephant has stopped at the entrance to an abandoned doll factory: The tendrils of strange-looking, angular shadows lurk gravely within. The miniature elephant is standing completely still, its ears drooping sadly.

—Oh no. Oh dear, Mr. Larchmont says.

Through the broken glass and boarded-up doors, Mr. Larchmont quietly climbs: The miniature elephant is trembling in his pocket as he disappears into the fog of the gloomy dark. The widower's best shoes sink in the heavy dust, his hands grasping at the rusted limbs of old machines: Somewhere beneath a thatch

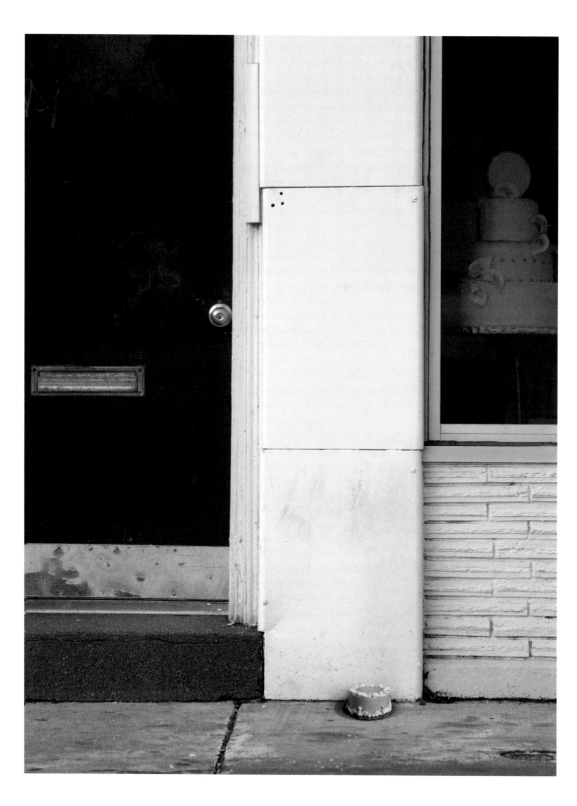

of crossed iron beams, somewhere in the desolate formations of red and green and gray, Mr. Larchmont stumbles upon a pair of tiny black Mary Janes. His breath immediately goes dull. There is a doll beside it missing its head, lying next to a formidable stack of great white boxes. The boxes explode with life as Mr. Larchmont approaches, a flurry of scurrying rats scatter about.

—Oh dear.

Mr. Larchmont's knees are shaking wildly as he trundles on, spotting an enormous vat, and beside it a deep exhaust shaft, which glows and echoes with eerie green light. Mr. Larchmont stops, his heart beating as quickly as the miniature elephant's, one large thump followed by a thump one thousand times smaller in size. Together, however, the thumps muddle on. Mr. Larchmont finds his way to the grimy edge of the shaft, and gripping a metal support beam, he peers down. There is nothing: only black. Too slowly, his old eyes adjust to the light, and several small shapes begin to drift into place. The shaft is filled with hundreds and hundreds of tiny dolls, their blue eyes flashing up in sorrow. Mr. Larchmont places his hand beside his mouth and shouts into the darkness.

—Hello? Hello?

What he hears in response is only the factory watching him quietly.

Perhaps it would be best if we paused here. Perhaps if we consider the sound of the city as it whispers in unfamiliar shadows behind us, we could stand here and become silent, counting the moments of our lifetimes with the heartbeats on our wrists. We could wait, lost in the city, in this quiet, in this silence. We may come to know the sound of one particular second. We may take this moment to stop and wonder what will become of us after our deaths.

The factory begins to grow darker still.

Mr. Larchmont calls out. There is no reply but an echo.

—Hello? he calls once more.

Only silence again.

Mr. Larchmont peers, blinking hard, down into the dark, then holding his breath, he is sure he can hear something whimpering.

—Hello! he shouts. Hello! Is anyone down there?

A pebble moves. A sound rises like a tiny insect trying not to weep.

—Hello?

—*Yes?* comes an eek, from what may be the smallest voice in the world.

—Is someone down there?

—*Yes*, comes the answer. *I am. And I am scared.*

Old Mr. Larchmont, joyous, darting from the well like a madman, is crashing through the factory, his legs and neck aching with panic as he very nearly collapses. Somewhere, oh he must hurry now, somewhere there is help. He staggers out toward the boulevard, the boarded-up doors parting before him, *A policeman, if only I can spot a policeman, if only a policeman,* and as he stumbles about, the city rising before him, he notices that the sound of his pulse in his head, middle, and wrist, is now, sadly, hurrying on alone. He places his hand beside his suit coat pocket and is startled by its stillness. He chokes back a startled sob, unable to breathe. The miniature elephant in his pocket, as strange a weight as the heart in his chest, is dead.

People in the city, reading the newspaper headlines that evening, elect to fund a miniature statue in tribute to the tiny elephant. In the paper later that week, there is a photograph of the monument beside a photo of the girl smiling, her face bandaged, lying in a hospital bed. The monument for the elephant is only four inches high and is placed before the city's oldest bakery, accompanied by a miniature plaster cake. Pigeons nest near the monument and children, often curious, put the miniature elephant in all of their chalk drawings.

THE BOY WHO WAS
A CHIRPING ORIOLE

illustration by
Archer Prewitt

The Boy Who Was a Chirping Oriole Firework was my son first. We do appreciate the cards and gifts and letters. We do not care much for what the scientists have to say. I hate them generally. I hate the scientists who use the word *impossible* like a knot. On our own, we have struck a bargain with Life and are usually pretty happy, as is our boy, so I am here to say once and for all that **FIREWORKS ARE OK: THEY ARE GENERALLY SAFE**. We feel that fireworks are a necessary and important part of American life. We do not blame Starling® Fireworks, who have been my employer for fourteen years, or the fireworks industry in general. Bobby, our son, the boy who is now a firework, still loves fireworks more than anything. It is the only time, lighting them off, that he becomes remotely visible to us.

Here are some of Bobby's favorite Starling® fireworks:

Pearl of the Orient Fountain
Item#: H-106

This fountain, small but loaded, is one of our nicest! It features fiery jewels of color accompanied by loud whistles and lots of crackle. This particular fountain was one of my son Bobby's favorites. He would count each exploding pearl as it turned to purple smoke in the fading sky above our heads. One summer, when he was five, he counted up to fifty. Then he ran to me and thanked me and said he was having the best summer ever. *A Starling® exclusive!*

Giant Cuckoo Fountain
Item#: H-110

A crackling fountain with golden spray and screaming-whistle effect. Six pieces per pack. By the time Bobby was ten, we began to notice a kind of phosphorescence to his pale white skin. Sometimes, when we would stand close together, him staring up at me, watching me light one of these lovely fountains, I could almost see right through him, like he was made of nothing but the night.

Golden Gate Spectacular
Item#: H-105

Voted the best fountain for gorgeous color three years in row. This favorite features red, gold, and silver sparks. Bobby was watching one of these beautiful fountains the first time he began to glow. I put a blanket around him and his mother phoned an ambulance, but by the time they arrived, he looked fine. Still, we should have known better. We should have asked better questions or made them take him to the hospital. It wasn't more than a day or two later that he began to vanish, but slowly, phantom limb by limb.

Golden Pine Fountain
Item#: H-103

Begins with an explosion of golden and silver sparks, which look a lot like pine needles. This is followed by golden pops and long-lasting, tree-shaped sparks. Bobby could not go to school because of his skin, the glowing. So he would come

with me to the warehouse and I would let him light off whatever fireworks he liked, which were usually these Golden Pine Fountains. He would often cover his ears and shout along with the loud, screeching sounds of this award-winning firework, stamping his feet with glee. Soon, parts of him—his hands and feet and knees—would momentarily disappear while he was shouting.

Silver Salute Firecrackers
Item#: F-107
LARGEST *available by law!* 20,000-count strip of our loudest firecrackers. One night, Bobby disappeared completely. His mother was panicked, but what I did was light one of these 20,000 strips of Silver Salutes, and as the tiny explosions echoed in the dark, we could see a faint outline of our boy clapping his hand, smiling back at us, stamping his feet.

Whistling Gemini Missile
Item#: L-101
New, astounding twenty-inch missile with a variety of effects at the highest point of the rocket's path. Ten pieces per bag. We soon figured out that Bobby had become a firework. We also figured out which fireworks he loved and which could bring him back. He is always with us, just not so visible. We are proud to say Bobby's favorite fireworks of all time are these Whistling Geminis. They are the only rockets bright enough to light up the freckles on his fading face.

Chirping Oriole Roman Candle
Item#: C-015A
Eight incredibly noisy screaming meteors with red and silver tails. This one is always a favorite! Bobby, where are you now? Where do you go when you are not here with us? When these chirping comets cry out, we have to imagine they are your voice. We imagine you are telling us that you love us and that you know we love you no matter what.

i want the Quiet, moments of a party girl

illustration by
Caroline Hwang

About then we are going to the movies once a week just to be outraged. We pick the worst-looking film of the bunch, a romantic comedy with some scandal-afflicted star or a z-grade horror pic, whatever Sophie wants, and then, after a few moments of watching, we begin shouting our displeasure before we finally storm out. We ask for our money back. We demand to see the manager. We threaten to write angry letters. We dream up imaginary offenses. We begin carrying on like this everywhere we go—inventing outrages for everything. At a record store, Sophie declares that the vinyl is too overpriced. On the bus, she refuses to pay the fare because we have been forced to wait in the rain. We have fun acting like this, acting like we are incredibly offended. Really, we are just bored to tears with everything.

Which is about when Sophie finds out she's pregnant. It isn't exactly a secret, as Sophie is very bad at secrets and anyone can tell as soon as you look at her. She smiles way too often when she's got something she wants to say, her loopy Russian eyebrows arching up her wide forehead. Once the terror starts to fade, once we're definitely sure we're going through with it, we begin telling everyone, people we don't even like, people who only moments before were total strangers. We are both in our late twenties and done daydreaming and ready to behave like adults. I quit the underground art magazine where I have been working and get a boring 9-to-5 as a designer at a glossy journal—one whose quiet layouts are dedicated to the anonymous world of wood—while Sophie, who is some fancy artist's assistant, is finally given decent medical insurance. Of course, her parents offer to help us move into a nicer apartment, but we say we are all right, and thank them anyway. It feels like we will be okay. It feels like we are holding hands everywhere we are going.

The only problem is that Sophie doesn't act like she's pregnant. When I ask her when she plans on slowing down, when it is she's going to begin to act like she's having a baby, she just looks at me funny and shrugs, rolling her eyes, and then tells me to kiss off. Her hair is long and dark and she has a beauty mark just above her lip, and when she shrugs it makes you feel small and stupid for ever troubling her about anything. When I come home at night, she is usually not there. She is out, at some noisy gallery opening with her boss, Marisol—the

Russian artist who does enormous paintings of angry female genitalia—or she is dancing with her younger cousin, who's just moved here from Minsk to become a model. Everything Sophie wears, from her tight T-shirts, which reveal her lovely midriff, to her knock-off designer jeans, so tight you don't need any kind of imagination to see what's going on there, all of it stays exactly the same.

Sophie says she'll quit smoking but not drinking. She says her boss Marisol never quit drinking when she was pregnant. Not more than thirty seconds later the phone rings, and even before Sophie hands it to me I know who it is. "I drank all the time when I was pregnant," Marisol hisses, her voice as deep as some Russian general's. "Who do you think knows more about having babies, you or me?"

I go into the Gold Star, this bar around the corner from us, and tell them that if they serve Sophie there will be serious consequences. I ask my friend who was a police officer last year for Halloween to escort me, in hopes that they will be fooled by his plastic-looking badge. I go to the bodega at the end of the block and tell the guys there not to sell Sophie any more alcohol. They look at me and laugh and then give me some free lottery tickets because they feel bad for me.

A week later, Sophie talks to a woman she has just met on the subway and decides she does not want to chance it. She decides it is time to finally quit drinking. We put a number of half-empty liquor bottles in a box and leave them on the corner and in the morning it is like magic when we find that they have been emptied.

When I look at her now, it doesn't even seem like she's pregnant. She just looks very sure of herself, like she knows something you don't know, like she might keep you guessing about that something forever. The only thing that does seem to change is our music. Sophie sells all of our old records and says she only wants to hear bands from the British Invasion. She has bought the collected recordings of Nick Drake. "No more French dance music, no more hardcore," she says. No more post-core, no more new-new wave. That night, we lie in bed together and listen to "The Thoughts of Mary Jane." I stare at Sophie's body, tiny freckles appearing in places I have never noticed before. I try to count them all but there are just too many and she has become too beautiful and staring at her is now like staring at a star moments before it supernovas, destroying just about everything.

* * *

Sophie surprises me by getting a number of used baby books—books that tell you the fetus is now the exact size of your fingernail or that its ears have finished developing. We read them together at night and I ask Sophie if she has talked to the baby today.

"No way," she says as if I am crazy. "Are you crazy?"

She actually asks me this.

But I know why she doesn't talk to it. She is afraid something bad is going to happen if she starts, like she will jinx herself maybe. I tell her I think we ought to at least make the kid feel welcome and then I lie down and place my lips against her belly and tell the baby we are really excited and can't wait to meet it. I sing a song to it, something from the Beatles, and Sophie rolls her eyes. In secret, I feel so sensitive I think I might start crying.

"Why don't you ever sing to *me* anymore?" Sophie asks.

"Because you've already made your mind up about me," I say.

After the first few weeks, we both start to refer to the baby as "the bun." I ask, "How is the bun doing today?" or Sophie says, "Look at this crib we should get for the bun." It feels good to have this joke just between us. I even get a little baby-size T-shirt made that says *The Bun* right across the middle.

"It's cute," Sophie says. "But my kid isn't ever going to wear something that corny."

I am surprised, but we still get to have sex, which is something I was afraid we wouldn't be able to do. It feels weird to me, not doing it with a rubber now, because I have been trained by my older brothers since even before I understood sex to never mess around without one. It feels meaningful, having sex like this, like we are for real, like we are in a movie about true love.

When her mother calls, bellowing in her Russian accent, I try to be decent. When she asks me when Sophie and I are going to get married, I say goodbye politely and then I quickly hand the phone to Sophie.

* * *

At work, I do the layouts, full-page spreads exploring the variations of Norwegian, oak, cherry, maple. Against my will, I begin to understand the notion of grain, of knots, of bark, of sapwood and heartwood. I ignore the random looks of despair on my coworkers' faces. I ignore the pathetic flicker of the fluorescent lights overhead. I ignore the man in the cubicle next to me who spends his days dreaming of a Korean mail-order bride. I do my best, working without thinking, trying to be selfless, behaving the way I imagine an expectant father should.

In our closet, Sophie has a collection of all the saddest things in the world. It is part of an art installation she has been planning for years, which we both know will probably never happen. On the weekends, Sophie drags me to all kinds of garage sales, yard sales, estate sales; it is her thing, looking for other people's diaries, answering machine tapes, journals, letters, anything that tells someone else's tragic story. She has boxes and boxes of that kind of junk, everything from war letters to miserable-looking family photo albums of people she has never met. When we first started going out, I asked her, "Why do you collect all this junk?" and she told me it was her way of understanding that life was one continuous tragedy. We were sitting on her small bed and I was just noticing the smell of her hair when she opened up a photo album from the '70s and showed me a photograph of a girl who was maybe eight or nine at a zoo, standing beside a beautiful, velvety fawn. In the photograph, the girl was crying and holding her left hand. "It bit me," Sophie whispered, pointing to a small white scar on the knuckle of her left hand. She kissed it and placed her knuckle against my lips. I felt like I understood something about her then, something that was both incredibly attractive and incredibly sad. I had never met anyone as sure of the imminent end of the world before, and for some reason I found it very reassuring.

We wait for the baby together now, sorting through some of Sophie's collected tragedies. We listen to the dozens of answering machine tapes she has collected, one of which goes like this: *"I just wish you knew what you mean to me. You're like a forest. You make me feel larger than life. You make me feel invincible. When I'm with*

you, I can do anything. Please, please, please, please call me back. I'm sorry for what I said to you. You're just so much smarter than me. If you don't call me, then I'll know what your answer is. But my flight is at 11. I hope to God you change your mind. You're not going to change your mind, though, are you? Jesus . . . that's exactly what I love about you."

We lie on the floor and listen to these tapes, over and over again, before placing all but one of the boxes in the trash, making room in the apartment for the crib Sophie has picked out already.

When we first met, people introduced Sophie to me as Natasha Rostova: I had just so happened to have read *War and Peace* when I was an undergrad, or at least parts of it, so I knew it was a joke. You can imagine what I thought later when I found out her real name. What I thought was that Sophie was a snob, someone who walked around with French novels in her purse, which she did. She had on a black turtleneck and an orange skirt—it was at a small gallery show which I went to against my will, because everyone I knew then was trying to become famous for doing nothing. Guys who had been sketching dirty pictures in the corner of their math homework suddenly wanted to be considered serious artists. I thought Sophie was part of that crowd. The first things I noticed about her were her eyes, which were violet, then I noticed that she had cut her own bangs; they zigzagged in an imperfect dark line across her forehead. I got introduced to her that night through a friend and was surprised when she gave out her number so quickly.

When I asked her what her real name was on our second date, she told me it was a secret she would keep until death. We ended up sitting on my fire escape, staring up at the moon, pretending like we were the only ones looking. A couple of days later, we had done it twice already and were already walking around the city holding hands. That's when she told me her name was Sophie. She made me promise not to tell anyone because she said she was an escaped Russian princess. I believed that for a little while, a few weeks maybe, because I had never met a girl like her before and so I thought it was completely possible she might be escaped Russian royalty. By then, it didn't really matter though. We were head over heels, and going out every night with each other, and then

she moved into my tiny place without even asking, which is not how these things go usually.

Sophie had been pregnant once before, when she was nineteen, but decided she wasn't ready at the time and so she had an abortion. She told me about this a week after she had moved in with me and we both ended up crying. I looked in her violet eyes which were cobwebbed with black mascara and told her I didn't think it was such a big deal; I knew a lot of girls, including both of my sisters, who had gone through the same thing. That night, when we had sex, I was afraid I was going to get her pregnant, even though I was wearing a rubber. I decided I never wanted to put her through that again and even after she told me I didn't need to wear a rubber anymore, I say it was okay. I said it was no big deal. But after a few weeks, we fooled around once or twice without one, and then *poof:* a baby.

Sophie calls me from work every day at 11 o'clock to tell me she how she is feeling. Eleven o'clock is when her boss at the gallery usually goes outside to smoke. Today Sophie says she wishes she were a deer. When I ask her why, she says it's because she feels as big as an elephant.

At lunch, I walk across the street to the park to eat alone. Sitting on a park bench, I notice a group of kids waiting for the bus at the corner. They are in school clothes and have backpacks. For some reason it puzzles me. I wonder, *Is summer already over? Has school started already?* and then I realize it is the beginning of September. The baby is coming in six months. That is it. The number sounds unbelievably small to me. I look up and watch the school kids joke and shove one another. A girl with a pink hair clip finds herself in a headlock within the arms of a chubby boy. The boy grabs her book bag, then turns her loose. Holding the bag over her head, he opens it. She screams, though secretly I can tell she is happy for the attention. The boy pulls out a pink notebook, spilling the rest of the bag's contents on the curb. The girl screams again, this time not so happy. The boy flips the notebook open and begins to read out loud, shouting something so all the other kids at the bus stop can hear. The girl is desperate now and puts her hand over the boy's mouth. It's obvious they are trying to figure out if they are maybe in

love. The boy plays keep-away with the pink notebook, the girl chasing him with loopy giggles. Finally the bus arrives, drawing up to the bus stop. The girl grabs her book bag, packs up her spilled books and pens, then, ignoring the boy, she climbs aboard the bus. The boy gets angry for some reason, maybe because he is being ignored. He grabs his own bag, then throws the pink notebook in the trash can near the corner. He runs back, climbing aboard the bus just in time. From behind the bus windows, I can see the girl slapping the boy's head. The driver is shouting at them.

As the bus pulls away, it looks as if the young couple are smiling madly at each other. When I finish my lunch, I stand, look around to be sure no one is watching, and then I walk over to the garbage can. The pink notebook is lying on top. It is unopened. On the cover, in silver marker, it says, *Observations: by Rafaela*. I pick it up and begin to flip through it. Each entry is carefully dated and mentions the author's mood in one simple word: *June 5, Angry*, or, *July 28, Depressed*. Beneath the headings are detailed entries, thoughts, poems, drawings of horses with wings being impaled, sketches of enchanted castles on fire, and a number of unsent letters like, *Dear Mom, why are you such a bitch to me?* and, *Judy, I know you think you're something special but you are not*. On the back cover, the girl has written in large, bold letters: *It doesn't ever happen the way you think it will*. I close the notebook and decide this is something that Sophie would love. I carry it inside the building, close to my chest, hiding the cover.

When I make it back to the office, I put the pink notebook in my briefcase. I look up at the clock on the wall and see that I am late. The stranger in the cubicle next to mine is giving me a dirty look, pointing at his watch, asking me when he can expect the birch layout to be finished. I tell him soon, very soon, then hurry to begin designing a spread where strange white trees cross one another in perfect silence and harmony. The title of the piece is this, sadly: *Birch-watching*.

It is 4 o'clock when Sophie calls again.

I pick up the phone at the corner of my desk and ask her what's up and I can tell she's upset for some reason. She whispers something so soft that I'm sure I've heard it all wrong: "I think I have to go to the hospital," is what I think she

says. I press the phone harder against my ear, trying to understand. I know that something must have happened to someone we know, that someone we love has died, that there's been an accident of some kind, her mother or aunt, my dad maybe.

But then Sophie says it again: "I think I have to go to the hospital. I'm having some bleeding."

"Okay," I say, "I'll be right there."

"Okay."

"Okay, I'll go . . ." I say, but already she has hung up.

I do not tell anyone I am leaving the office. The birch trees in the layout I am supposed to design will remain only faded black lines against snow. It takes forever to get to the gallery through the afternoon traffic. When I pull up in our ruined little car, Sophie is outside waiting for me. She looks terrified and really lovely. There is the small bump at her middle. Sophie is tall and usually looks like a stringbean to me. Now she is like a snake who has swallowed something—a lopsided watermelon maybe. When she gets into the car, she is silent. I drive us toward the hospital as carefully as I can. I do not think I have ever driven this carefully in all my life. I am like an aging driving-school instructor. I go ten miles an hour less than the official speed limit. I do not know why I drive so slow: Cars are behind us honking and beeping. It suddenly feels like we are both made of glass—that if I make a turn too quickly, we might fall apart. As we make our way toward the emergency room, I consider the look of absolute terror on Sophie's face. I watch the shape her mouth makes, the size of her eyes, wondering what, if anything, it might all mean.

A nurse in triage refuses to look us in the face. As soon as Sophie begins to explain her symptoms, the nurse folds her bottom lip in, her gaze no longer meeting ours. The nurse has curly red hair and has seen it all, probably. She has already made up her mind about us and the rest of the world and everything. With her age-spotted hands, she jots down the appropriate information. Then she adds, "I want to warn you, this doesn't sound good." Sophie gets her temperature taken. I find this particularly strange, that something as ancient and childlike as a thermometer is somehow going to save us from what we most fear. We are told

everything else looks okay. We are then told to wait, which we try to do, calmly.

"It's probably no big deal," Sophie says. "We're probably just overreacting."

I nod, unsure of what to say.

"I'm so hungry I'm losing my marbles. I didn't have time to eat lunch today," she says.

"I can get you something out of the vending machine. What do you want?"

"Surprise me."

"Okay."

I stand and walk across the emergency room to the two vending machines. The rest of the waiting room is nearly empty at this hour of the afternoon. It smells like artificial pine trees. The fluorescent lights are tricky: Everything beneath them immediately becomes blue and sad. A Mexican family sits together, waiting for news about their grandmother. An epic gladiator movie, dubbed into English, plays on the emergency room's two TVs. I actually begin watching it: Hercules and Jason are searching for the Golden Fleece. I know everything will work out for them because it is on TV. I put some change into the vending machine and get Sophie two packages of Pop-Tarts, then sit beside her. She tears the packages open and quickly gobbles up the dry pastries. I stare at her, surprised, and she frowns and says, "So what? I was hungry."

Another nurse, a young Asian woman with painted turquoise fingernails, calls Sophie's name. We stand up, confused, like we have just won something.

We are led toward a small yellow examination room. I take this as a bad sign for some reason, that we are being put in here alone, because someone, some doctor, has already noted our tragedy. Outside the door of the small room, a prisoner is awaiting medical treatment. He is handcuffed to a silver gurney. A police officer waits beside him reading a dirty magazine.

"I was shot," the prisoner explains as we pass. "Twice. In the leg."

"And you were lucky," the cop says.

We step inside the examination room. Sophie climbs onto the hospital bed. The nurse gives Sophie two hospital gowns to put on, then disappears. The gowns are gray-blue and ugly. They have been designed in the color palette of a corpse. I help Sophie tie the knots in back.

"We could just walk out right now," Sophie mumbles to me.

I cannot tell if she is trying to make a joke.

"We could just pretend everything is okay," she whispers again.

"That's probably not such a great idea."

"No . . . Hey," she says, "are you scared?"

"No. Are you?"

"No," she says, then a moment later, "Yes."

"Me too."

The nurse returns and asks Sophie why she is here. Sophie explains she is bleeding a little. The nurse tries to find the baby's heartbeat using a fetal heart monitor, a tiny blue device which she holds in the palm of her hand.

"Sometimes this doesn't work, so don't get worried," she says.

She searches and searches, pressing the pad against Sophie's bare belly.

There's nothing. We get scared. I begin to feel tears in my eyes. Sophie and I look at each other, then away very quickly.

"Like I said, this thing never works," the nurse explains, then disappears behind the door again. We don't see her for another hour. When she enters, it is like she has never met us before. She tells us the doctor will be with us in a moment and closes the door.

The ER doctor actually comes in right after that. Sophie and I roll our eyes at each other. He looks like he might be a guitar player in a college jam band. He looks like he is nineteen. He looks like people call him "Bro" or "Weasel." His shoulder-length hair and youngish face make me even more worried. He talks to us but I don't hear a word he says. Finally, I understand that he's ordered an ultrasound. He asks if he can do anything else for us.

"Please, we just want to know, if you could, please don't keep us waiting," Sophie says. "Either way, we just . . ."

"I'll do everything I can," he replies, and suddenly, for some reason, I feel like he means it.

An elderly black man with a deck of cards in his front shirt pocket wheels Sophie down the hall, into an elevator, and then to the basement of the hospital. I follow them down another long hallway to the lab, where I am told to go sit in

another waiting room. I do not argue. I think that if I do what I'm told everything will work out okay. I give Sophie a kiss on the forehead and momentarily watch her vanish into a room at the end of the hallway.

On the TV in the ultrasound waiting room, a court show is playing. I can't watch it. The other people in the room argue with the people on the TV. I watch the glass door, waiting for the attendant. I realize I have my coat and Sophie's purse in my lap. I feel awkward with the purse there, like it's obvious how wrong things are because I have my girlfriend's purse, sitting there like that, in my lap. Ten minutes go by. A half hour. When the attendant returns, nodding at me, I hurry out.

"What happened?" I ask. I look at Sophie, then at him.

"The doctor has to read the results," the attendant says. "Don't worry, it'll be all right."

"How long will that take?" Sophie asks.

"I don't know," he says, and I begin to follow them both down the hallway again. He pushes Sophie's hospital bed into the elevator and back into the emergency room. I say thanks and after he leaves, I kiss Sophie's hand.

The ER doctor knocks on the door of the room. For some reason I find this funny, the fact that he knocks like we now own the place. He enters and says he's still waiting on the ultrasound results. He says he thinks he should do a pelvic exam in the meantime. Sophie and I roll our eyes at each other again.

I get out of the way. I don't want to see what's going to happen. I do and I don't. I think about maybe stepping out into the hall, but instead I stand beside Sophie, holding her hand tightly. The young doctor asks Sophie to slide down toward the end of the table. He is wearing rubber gloves which make his hands seem enormous.

He says, "If the cervix is open, then we know it's a missed abortion."

"A what?" Sophie asks.

"A missed abortion."

"Is that the same as a miscarriage?" she asks.

"Yes."

"Can we please call it a miscarriage then?"

"Okay," he says.

His face suddenly becomes serious. He continues searching around and then stops.

"The cervix is closed."

I almost start crying. Then I do. I cry and cry, hopelessly weeping because I don't know what the doctor means.

"Is that good or bad?" I ask.

He nods but does not say yes.

"There's a lot of blood. We'll have to see what the ultrasound says," he finally mutters.

We begin to hope that this is all going to be one of those kinds of stories, something you tell to prove how much you love someone. *"Once we were on a camping trip and Sophie got lost and I remembered that she always confused north with south and so I began hiking south and of course . . ."* a story just like that.

As we wait, I hold Sophie's hand. It seems like the only thing I can do now. We are both speechless. Words have become small and see-through and frightening. We listen to the sounds of the ER, to the prisoner outside the door singing in Spanish. Sophie holds her face against my chest and we wait and we wait and we wait.

The results from the ultrasound finally arrive an hour later. The young doctor enters the room, pushes his long hair behind his ear, and says, "I have some bad news . . ." but I do not hear the rest of the sentence because everything starts to ring. I do not ever remember crying like this in front of a stranger before. In the blue-gray hospital gown, her face screwed up in grief, Sophie looks like she is dying. I try to hug her, to hold her, but she is lying down and it is hard to get my arms around her. She presses herself against my chest and I begin to feel her tears on my shirt and neck. The young doctor is still talking. He is saying something about how one-quarter to one-third of all pregnancies end this way: that it is no one's fault, that we did not do anything wrong. We don't believe him. We search and search for the one awful thought we momentarily had and secretly blame ourselves and each other for everything. What hurts is to find out we are not as special as we had always believed.

We are just past twelve weeks and so we have already told everybody that Sophie is pregnant; people at our jobs we don't really know, people we think we despise. In the emergency room, while we wait for Sophie to be discharged, we imagine having The Most Awkward Conversation of All Time with all the different strangers in our lives.

"It won't be so bad," I say. "We got pregnant once. We just have to try again."

I sound stupid and I know it but I can't stop myself from talking, from wanting to explain everything away. Sophie gives me a dirty look and we fall away into silence.

We go home. On the way, we stop for maxi-pads. In the aisle of the pharmacy, Sophie announces that she has to leave. She is bleeding on herself. She asks me to pick something out. I get one of each kind of maxi-pad, from light to super-absorbent, and then we hurry back home. I know I have gotten the wrong kind of maxi-pad but it doesn't matter. Everything is wrong today.

We lie in bed all day crying. We call our parents and cry to them. We try to talk to each other about it but the bad feeling is here to stay for a while at least. When Sophie is speaking to her mother on the telephone, I go around the house looking for anything that might remind us of what we have lost. I put the children's books we have bought, toys, clothes, in a closet. I stare at the pile of stuffed animals and feel like I need to apologize to them, too, for some reason.

I notice Sophie sitting over her cardboard box of tragedies. Without a word, she yanks off her plastic emergency room bracelet and places it inside, then puts the top back on and shoves it into the corner.

When we finally go to sleep, we are too tired to say goodnight. I lie there feeling as if I have lost both arms and legs. Like something more important than my heart has been stolen from me. What can be more important than your heart? I don't know. Whatever it is, it is now missing.

When I get to work the next morning, I stare at the angry Post-it note the boss has left on my computer, then I crumple it up. I think about storming into his office and laying into him, telling him all the awful details, but I don't. I sit at my desk

and stare up at the fluorescent lights. I see the pink notebook, the one from the trash, lying in my open briefcase. It looks like something from a hundred years ago. I flip through its pages, drawings done in pen and pencil, fiery forests, tigers eating children with wings. It all seems small and sad and insignificant. I don't know how to deal with how much has changed, I don't know how to make sense of what has happened in only one day.

By the time Sophie's birthday comes around a week later, neither one of us feels like celebrating. We decide to postpone it. Then it's October, then it's November, and we are still sad and undecided about everything. We agree that it would be better to celebrate Sophie's birthday now, though, before January comes around, before the year has officially ended, which is why we go to the movies.

At the movies, I get the tickets, I ask Sophie if she wants popcorn, she says no, I give her a dirty look, I ask her if she wants popcorn again, she says no again, then we go inside the theater. A couple of Puerto Rican kids—teenagers—whistle at Sophie when she stumbles into the darkness. I eyeball them hard but all I get is a bunch of Mickey Mouse giggles. I wonder if there's a problem with the clothes I'm wearing, my jacket, my shoes. Do I come across as a chump? As a target? Maybe. Ten years ago it would have been me laughing in the back row. Now I ignore it and chalk it up to a lame haircut I got two weeks ago.

Before us, the previews flicker along the rectangular screen, the announcer overly excited. We look for seats and find the only open ones, somewhere near the middle of the theater, along the right side, two rows in front of where some other kids, all high school age, have their feet up on the seats. They start laughing when we make the stupid decision to sit near them. We do our best to ignore what they say. In the dark, their voices are like the sound of a radio playing in a car as it passes by you, only a word or two makes it to our ears. One of them says something about Sophie's coat, which is blue with gray fur, a ratty thrift store number. It's a coat from when she was an art history major. It does look a little stupid, but so what?

In front of us, the previews have finished and the opening credits for the movie have begun to play. We hold hands and hope the kids will shut up and

watch the film, but now I'm not even watching it. I am sitting there like an idiot, just waiting for something bad to happen.

We don't usually go to this particular movie theater because it's always pretty sad. The floor is sticky with spilled pop and the seats are almost always broken. I look up and notice that the movie has started. In it, a man and woman are arguing. The movie is black-and-white, subtitled. Now they are kissing, and the kids behind us are hooting and whistling, and as the couple onscreen begins to undress, Sophie leans over and says she wants to leave.

We make it to the parking lot without saying another word.

"Why did you want to leave?" I ask.

"I didn't want to see that movie anyway."

"Okay."

"We shouldn't have even bothered," she mumbles, pulling on her seat belt.

I don't know what to say to that, so I don't say anything for a while. All I come up with is, "I don't know why you're mad at me. I didn't do anything."

"I don't know why I'm mad at you either, but I am," she says.

We drive home defeated, momentarily, by just about everything. The city glitters past us with its sharp edges, reminding us of how tiny, how weak, how totally unimportant we are. When we get back to the apartment, we don't know whose neighborhood it is anymore: Everything looks suspicious and bombed-out. Everything looks like a movie set of an ugly block. There is graffiti all over the place, tags upon tags. We don't care really. We're only staying here another year. We still feel angry at each other about something, though. When we unlock the front door that night, it doesn't sound like the end of an argument. It doesn't sound like an apology.

Sophie decides she has had enough and goes to take a bath. From the bedroom, I listen to the faucet running, the sound of her stepping into the tub, the soft splash of her moving beneath the water. I knock on the door. She doesn't answer. I knock once more, still no answer. I touch the doorknob and find it is unlocked. I step inside, close the door behind me, and without thinking, I start to undress, before Sophie can begin to argue. Our tub is small—it barely fits one person—so I sit behind her and put my arms around her neck. I realize we have not been

naked together for what feels like a long time, a couple of months now maybe. It feels weird and sad and exciting. Sophie turns around and puts some shampoo in my hair. She starts working it in using her fingertips, smiling at me. Silently, I begin to wonder if we will ever find anything funny again. I think about the pink notebook from the girl at the bus stop, which has been sitting in my briefcase for almost two months now. I think about how much time will have to pass before I can show it to her, how much longer it will be before we will be able to laugh about all kinds of stupid things. After she washes the soap out of my hair, Sophie turns and looks at me. I cannot tell if she is actually smiling but it seems pretty convincing, the single dimple appearing on her left cheek.

"Hello," I say.

"Hello," is what she says back to me.

the ARCHITECTURE of the MOON

illustration by
Souther Salazar

By Monday the moon has stopped glowing. One moment it is the singularly most important shape in the nighttime sky, and then it is gone, a blurry afterimage burning beneath everyone's eyelids, and then it is only a question, only a flash, and then nothing, only a memory. Once the moon is no longer shining in its place, the rest of the stars quickly fade. And then, without the moon and stars, each and every kind of lightbulb loses its inspiration and soon begins to fail. Finally, there is only darkness, a complete and total absence of light as soon as the sun disappears every night. Tragically, the public finds itself getting lost each evening. Those who are lost must sleep in their cars, in doorways, or on strangers' lawns. In the darkness, they wander around until they are tired, then lie down wherever they are, like brave little orphans. At night, it seems the buildings themselves have begun to move around. Street signs exchange positions. At night, avenues and boulevards become cul-de-sacs. Without the moon or the stars or streetlamps to keep things in place, people realize the speed at which the world is moving. The effect, as you can imagine, is rather dizzying.

Every evening, Thomas stares through his telescope at the absolutely black sky, squinting at the phantomless night, waiting for his father's telephone call. The remainder of a few candles light his room. It seems the glow of the flame is the only light that still works properly. It is true that Thomas does not have a job anymore; once he was an illustrator for a magazine about nightlife in the city, but then people began to get lost in the dark and so, of course, the magazine quickly folded. Thomas has noticed that since the moon has gone dark, his hair has begun to grow rapidly. In dark waves, it hangs messily above his ears. Thomas spends his time drawing pictures of what the moon used to look like. He attempts sketch after sketch while he waits for his father's call each evening. Thomas's father works nights; he is an accountant at a large insurance company. The insurance companies have been doing quite well—because of the general chaos and calamity—and so they have found it necessary to extend their business hours. Every evening after work, Thomas's father will spend much time hopelessly wandering around the vacant city, his long white face wrinkled in a frown, searching aimlessly for where he has parked his car, then, after hours of that, he will drive in widening loops,

looking for the hidden location of his house. Often times, he will give up and wait until morning, sleeping in his car alone. Or he may pick up someone else who is lost and offer them a ride, but after many tense hours, this other person will often be unable to locate their home as well, and so Thomas's father and this stranger will pull over and try to rest; an awkward unfamiliarity will make it quite difficult to sleep. Out of this unnamed nervousness, and to avoid hearing the other person breathing, Thomas's father will often leave the car's engine running. But as it turns out, there are thousands of people who find themselves stranded like this each and every night.

Usually around midnight, Thomas's telephone will begin to ring. Tonight, Thomas adjusts his telescope, searching through the impossibly unclear shapes orbiting the darkness downtown for the tall, slanted figure of his father, dragging a brown, sturdy-looking briefcase at his side, but there is nothing. In the viewfinder of the telescope, there are many different kinds of blackness—some resembling the kind of darkness that occurs when you place your hands over your eyes, a certain kind of darkness that is partly cloudy, and some that are all pins and needles—but there is nothing resembling a man.

"Hello?" Thomas answers.

"Thomas?" His father's voice is higher and sounds more confused than normal.

"How are you tonight, Dad?"

"I'm well, son. I'm in a parking garage right now, I think. I don't know where I am exactly. I keep driving around and around but I can't find the exit. Is it possible they forgot to build an exit?"

"I don't think so, Dad."

"It has to be somewhere. I've been at it for about three hours now. I just keep driving in circles."

"Is anyone with you?"

"No. There are a number of other cars driving around too, doing the same thing. None of us can find the exit to this thing."

"Do you want me to try and find you with the telescope?"

"No, I'm okay. I guess I was just getting very lonely. The radio keeps playing the same songs over again. I just wanted to be sure I wasn't dreaming."

"Well, Dad, I'll talk with you as long as you like."

"Thank you, Thomas."

"So tell me about your day, Dad. Did anything good happen?"

"I had a large bowl of soup for dinner. It was delicious."

"That sounds good."

"And how was your day, Thomas?"

Thomas looks around at the wrecked nest of his apartment. There are reams of crushed paper strewn everywhere. There are illustrations of what the artist imagines the moon used to look like when it was full, hanging above a delicate mountain. There is a drawing of a couple, a man and woman, kissing, their hair lit by magical moonlight. There is a picture of the citizens of some imaginary city pointing up at the wondrous beauty of a half-moon, their eyes dancing with pleasure.

"I spent the day drawing mostly."

"And the evening?" his father asks.

"I spent most of the night looking through the telescope."

"And what did you see?"

"I saw a lady with a dog walking along the street. She must live in the apartment building across from mine. I thought it was too late to be walking her dog, because it was just around twilight, and the woman began to shout as the sun went down and she made it back to her apartment building just in time. But her dog wasn't with her. It had gotten lost, I guess. She cried from her window for a few hours but the dog hasn't come back yet."

"That's too bad."

"I know. Even the animals have been getting confused. The pigeons outside my window don't leave the telephone wires anymore. They're getting awfully skinny."

"It is all a mess," Thomas's father says.

"Are you having any luck finding the exit, Dad?"

"I'm following a station wagon now. It seems to know where it's going."

"Okay, we can keep talking until you find your way out."

"I appreciate it. There's about ten cars behind me now. We're all lost, I guess."

"Can you see a sign anywhere?"

"Wait a moment, yes, there, there it is. It was there the whole time, Thomas. I got lucky following this gentleman with the station wagon. If your mother calls, tell her I'll be home very soon."

"Okay, if you get lost again, don't be afraid to phone me."

"I will, Thomas. Thank you."

Thomas looks out the telescope once more. What appears to be a large silver skyscraper suddenly becomes an abandoned factory. In the autumnal darkness, twin smokestacks begin to bellow out gray smoke. Thomas places the telephone beside his bed waiting for it to ring again. When it does begin to chime a half hour later, twice, then stops, Thomas knows his father has made it home okay. From the corner of his eye, he glances up at the sky again, sure he will catch the moon sneaking guiltily across the firmament, but no, like always, there is nothing.

Thomas makes drawings of the moon and sells them to people who are nostalgic for how the sky used to be. His specialty is drawings of the moon rising in the nighttime air above an imaginary city. Already Thomas has forgotten certain critical details of his subject. He remembers the moon having a number of windows, like portholes, directly along its center. In other drawings, the moon is shaped more like an egg; it balances obliquely between a number of silvery clouds, a thin crack running along its middle. In others, the moon has grown some visible rivers and lakes.

Thomas, as he works, will often set down his pencils and place his right eye against the viewfinder of the telescope, trying to spot the moon—to see if what he is imagining is accurate—but there will be only the deepening darkness of the empty night collapsing around him. He will then go back to his drawing, unsure, trying to remember if the moon used to have wings.

When Thomas's father calls the next evening, he sounds quite frantic. His voice is pitched and uneven. Thomas can hear his father's nervous footsteps echoing against the black pavement.

"Thomas?"

"Yes?"

"I don't where I am. I'm walking somewhere. I haven't been able to find my car yet."

"Just take your time, Dad. We'll figure it out together."

"I've been walking for hours. I think I'm almost out of breath."

"Where are you now, Dad? Describe what's around you."

"I seem to be walking beside a river of some kind."

"Are you on a bridge?"

"I might be."

"What color is the bridge?"

"I can't tell. It might be blue. Or green."

Thomas opens up a color-coded map of the city, tracing his finger along the river, searching for a bridge. In the darkness, with only the flicker of the candle's light, he is unable to tell what is blue and what is green.

"I'm not sure if there are any blue or green bridges, Dad."

"Maybe it isn't a bridge. No, it's an escalator. I was wrong. I am on an escalator."

"Do you know where your car is parked?"

"I do. I went there, but what I thought was the parking lot is some kind of building now. I'm sure if I keep circling around I'll find it. Go on and tell me about your day, Thomas. That will keep me from feeling so worried."

Thomas looks around his tiny room.

"I worked on a new drawing today, Dad. Of the moon, when it was under the ocean, just before it would rise. There are a number of boats in the drawing being rocked by the enormous waves, and seabirds circling around it."

"I don't think the moon used to do that, Thomas."

"I'm almost positive. I'm almost sure I remember it did."

"It might have been a dream."

"It might have."

"Did you do anything else today?" Thomas's father asks. Thomas thinks he can hear his father's anxious breath. It sounds like a soft clock ticking.

"Oh yes, I watched the girl in the apartment across from mine this evening."

"And?" His father's voice suddenly seems to twinkle.

"And she went out to go look for her dog. I was afraid she wasn't going to make it back in time, but she did. When she came back, she had the dog's collar but the dog was still missing."

"Oh, that's too bad."

"She spent some time calling for it, but it didn't come."

"I think I'm all right now, Thomas. I think I've found the parking lot. No, no, it's the wrong one. But there's a number of people here wandering around. If I can't find my car, I can always ask one of these other people for a ride."

"Dad, are you sure?"

"Thomas, don't worry. If I get into any trouble, I'll give you a call."

Thomas hangs up the phone and sets it down beside his bed. When he wakes up in the middle of the night, he realizes the phone has not rung yet. Quickly, he dials his father's number. His father answers, his voice very soft, very quiet.

"Dad, are you okay?"

"Thomas?"

"Yes?"

"I'm sleeping in an elevator right now. There's a few other people here. None of us could find our cars tonight."

"Are you okay there, Dad?"

"I think so, Thomas. I'll give you a call in the morning."

"Goodnight, Dad."

"Goodnight."

Thomas places the phone back in its receiver and checks the telescope once again. What appears to be the moon for a moment is only the conflicted white face of the woman from the building across the way. She has her window open and is shouting for her dog. Her face glows brilliantly with the lines of recent tears. Thomas finds his sketchbook and does a hurried drawing of the moon with the woman's forlorn face.

By the end of the month, a sad turn of events has begun to take place. Those

people who find themselves lost at night, those who wander the streets helplessly searching for their cars, those who are fortunate enough to eventually find their cars but who drive about searching for their homes, only to pull over, falling asleep behind the familiar safety of their steering wheels, have begun to vanish. When the sun comes up, these lost people are all inexplicably gone. Their automobiles are parked in awkward places, pointed in the opposite direction of usual traffic. Their clothes are left strewn about, only afterthoughts now, and in the morning, those people who work during the day find these ownerless garments in the oddest of places: in closets, beneath desks, in stairwells, in the middle of busy intersections. It is suggested that this has something to do with the moon going dark, with its silent, unknown particles, or possibly with X-rays, but the cause remains very imprecise. All that is known is that there is something wrong with the nighttime now. Once you fall asleep anywhere outside of your home, anywhere beneath the shadowed moon, its unseen, sulfurous rays may do you mortal harm.

Thomas begins to worry seriously about his father. One day, instead of drawing pictures of the moon, he decides he will try to make a detailed map of the city. Using the telescope, he finds his father's office building—a flat, featureless, rectangular skyscraper—and begins to sketch everything surrounding it, depicting the busy city streets in a few quick, quavering lines. One by one, he marks the trees, the lampposts, the intersections, the signs, then with more detail, a piece of trash, a garbage can, stubs of cigarettes. By the time his father calls that evening, he has all but finished a map of a large part of the center of the city.

"Thomas, you're never going to believe it, but I'm lost again. I'm in my car and driving past what looks to be a forest."

"A forest?" Thomas traces his finger along his map and taps it twice.

"No. It's a park, Dad. Go to the next intersection and take a right."

"And now there's a fountain of some kind."

"What does the fountain look like?"

"Well, there's a statue. It might be a man. Or a woman. I can't tell."

"Does the statue have a trumpet?"

"No, I don't think so. It has a sword of some kind."

Thomas searches the spotty lines for the statue with a sword and finds his father's exact position. He instructs his father to take the next right.

"It's working, it's working, Thomas. I'll be home in no time."

"Good, we'll just keep following the map."

"You are quite smart, my boy. What a brilliant idea! What a brilliant plan!"

His father's voice sounds gilded with joy. Turn by turn, Thomas places his finger along the sketched city streets, imagining his father traveling there safely, somewhere at the tip of his forefinger where his heartbeat beats. Within an hour, his father has returned home. From the receiver of the telephone, Thomas thinks he can hear his mother clapping, then shouting happily, a sound he thought he had already forgotten.

By the following Monday, even this plan too begins to fail. For the moon, and the people, and the world in its darkness, seem quite intent to stay lost. At night, whole city blocks begin to exchange places with their neighbors. Buildings turn around, their façades shrugging into the shadows like grieving widows. In the clouded dark, more and more people start to vanish. Where do these people go? Their clothes form small mountains of debris all about the city streets. Unaware of the unfolding complexity of this disaster, Thomas continues to work on his city atlas, sketching out his map in excruciating detail. During the day, as the sun—unremitting, glorious, as welcome as a favored child—glows brightly in the autumn sky, Thomas places his eye against the viewfinder of the telescope, adding a line of birds along a telephone wire, a crooked lamppost, an empty soda pop can lying along a curb. That evening, however, when his father calls, the map does not work. It seems, in the dark, everything is upside down.

"You're sure you're standing beside a rose garden?" Thomas asks.

"I'm very sure, Thomas."

There is a long pause. Thomas traces his finger along the map, finding the rose garden is some twenty blocks from where he thinks it should be.

"Are you having difficulty finding it, son?"

"I'm afraid I must have made some mistake, Dad. Tell me what else you see."

"I don't know. It's very dark. I think I might be standing beside a museum of some kind. There are two bronze lions out front."

"Don't go into the museum. You'll only get lost."

"I think it might be too late. I can't even see what's behind me. I'm sitting down for a moment. My feet are hurting me terribly, Thomas. And the air. It feels sharp. My lungs are very tired. It feels like they're glowing."

Thomas places his eye against the viewfinder of the telescope, searching for a glimmer, a blush, a faintness of light, but there is only the blackness, like a curtain sewn from a burlap sack, blackness crossed with blackness crossed with blackness.

"I don't feel so well, Thomas," his father whispers. "I feel light-headed. Like I'm floating. I would just like to lie down and go to sleep."

"Don't lie down, Dad."

But then there is only the static of the telephone line. In a moment, Thomas thinks he can hear his father snoring. It sounds like a watch spring unwinding. Thomas listens to his father sleeping for a few moments, then he begins to whisper loudly: "Dad, you have to get up! I have the map right here. We'll find your car, I promise."

"Okay, Thomas," his father says. Thomas can hear his father yawning, pulling himself to his feet with a groan.

"Tell me where are you now, Dad."

"I don't know, Thomas. Everything is very blue. It looks like a dream of some kind. It's really pretty. Oh, and there are trees. The trees are very white. It looks like they are made of crystals. I am walking. There is a whole forest of these beautiful trees."

Thomas searches the map, squinting as hard as he can, though he knows there is no place anywhere in the city that looks like what his father is describing. He glances through the telescope, then down at the map, then stands, throwing open the window. Outside, it is very quiet. From across the street, he can hear the woman with the dog still crying. She calls its name once, then twice, then begins sobbing again. Thomas glances about for a marker, for a sign, for a star, something, anything to help guide him. But everything is dark now. The woman

across the street has suddenly gone silent. She closes her window up tightly.

Thomas places the phone against his ear and asks: "What do you see now, Dad? Where are you?"

"All of the houses look the same. One after the other. They're all white and square. They look very lovely. But the doors don't look right. The doors are shaped like stars. I think these houses belong to the stars maybe."

"Don't give up, Dad."

"I'm getting very tired, Thomas. I think I might lie down."

"If you lie down, there could be trouble."

"I'm very sleepy, Thomas."

"We'll talk all night if we need to."

"Okay, Thomas, okay."

"Okay, where are you now, Dad?"

"I'm walking past what looks like a factory."

"What kind of factory?"

"I don't know, Thomas, I can't tell. Everything is so blue."

"Describe what you are seeing, Dad."

"There's a large rectangle, then another, then another. There are three smokestacks. The smokestacks, they are pouring out white smoke. The smoke, it's not smoke, it's stardust. It's glowing. It's blue and then it becomes black. Do you have any idea where I might be, Thomas?"

"I don't know, Dad." He holds the map very near his face. In the candlelight, it's almost impossible to see anything. The lines are only lines. Beneath his sketch of the city, Thomas thinks he can see an imprint of the moon hiding.

"Thomas?"

"Yes?"

"I'm afraid I might be on the moon."

Thomas can hear his father's nervous breath echoing within the plastic earpiece of the phone. He imagines the face his father must be making, the worried lines around his eyes and mouth, gaped with wrinkles, he imagines the other sounds of the empty night congregating all around his father's head, the way his hand might now be gripping the telephone with an arthritic claw, the boxy briefcase

swinging back and forth as he moves nervously along. Thomas tries to think of something that might help. He imagines his words, his voice saying something great, something wise, he imagines his map becoming clear, but all that exists between him and his father now is distant silence. He only has to figure out where this factory is, if it is indeed on the moon, and how he might lead his father back from there. He only has to figure out where his father might now be walking, where his next step should be, and why the moon is acting this way. Thomas closes his eyes, imagining his father's shape crossing quietly beneath a cloud of white crystal trees. Finally he opens his eyes and says, "I'm right here, Dad. Now tell me: What do you see?"

The Unabomber and my Brother

illustration by
Cody Hudson

1

The Unabomber and my brother both grew up in Evergreen Park, Illinois. They do not know each other. The Unabomber's name is Ted Kaczynski. My older brother's name is Alan. They are both American males of Polish descent. They have both been betrayed by their own brothers. They both suffer from serious mental illness. One of them is now in prison; the other is in and out of group homes on an regular basis. One of them fears the techno-industrial age and what that means; the other thinks cloudy thoughts about leopards and cheetahs. They both have dark eyes and dark hair: Only one of them still has a beard.

2

The Unabomber went to Sherman Elementary on 52nd Street until fifth grade. In fifth grade, the Unabomber took some tests which apparently revealed that he was a genius of some kind. He was allowed to skip the sixth grade altogether and enroll directly in the seventh grade at Evergreen Park Central.

When Alan was in fifth grade, he attended Queen of Martyrs on 103rd Street, which is where I also went. I was in the third grade. A few months after the school year began, Alan had to have an operation. He had been born with a herniated intestine, and because of it, his belly button was a balloon of flesh about the size of a ping-pong ball—our parents refused to have it operated on until Alan was older. If you ever mentioned Alan's deformity, like, say, in front of the other kids on the street, Alan would box your ears until one of them bled. He would actually try and cripple you. It did not take long before I realized mentioning his hernia was a bad idea, the very worst idea ever. Alan, because of this slight deformity, had to wear a T-shirt whenever we went swimming at the public pool. I would paddle about in the shallow water and watch him floating there in the deep end, waiting for some loudmouth to make fun of him, to point at the bulbous shape of his strange-looking belly button—obvious beneath the translucent T-shirt—but no one ever did. Alan had a look about him, something about the shape of his jaw and the narrowness of his dark eyes, that frightened just about everyone. When it was adult swim, even though Alan was only in fifth grade, the lifeguards, only a few years older than him, were too afraid to tell him that he had to leave the pool. Because of this, because in fifth grade he had already developed sizable muscles and fronds of dark chest hair, I soon began to both idolize and hate him. By the end of fifth grade, my parents agreed to have the hernia removed, and though the operation was successful, Alan's angry temperament would not change.

3

The Unabomber claims his IQ was, in seventh grade, in the 160–170 range. He has said that skipping the sixth grade was an important turning point in his life. When he began seventh grade, the older children made fun of him and so he never once felt like he belonged: a critical event in a lifelong history of loneliness and alienation.

a critical event in a lifelong history
of loneliness and alienation

In seventh grade, my older brother Alan was tested for learning disabilities. He would eat whatever other kids put in front of him: bits of paper, erasers, a piece of wire from someone's spiral notebook. One of the only things that interested him were Scholastic picture books about jungle cats—lions, tigers, and, most particularly, leopards. He would spend each and every day in seventh grade carving leopards into the wooden top of his desk. His grades were consistent with what you might expect from someone who did something like that. At school, Alan was also very good at breaking things—chairs, desks, other people's pencils. But it turned out that Alan did not have a learning disability: He was actually, on paper at least, smarter than almost everyone else in his class. There was just something about school Alan couldn't stand: He believed he had been born a few hundred years too late. He believed that he would have been much happier being born a barbarian. The only books I ever saw him read were picture books about predatory cats, except for the one about Attila the Hun, which he left in our upstairs bathroom, always open to the same page, resting atop the white toilet tank. It took him a year or two to actually finish that book. He had stolen it from our school library; the librarian, Mrs. Moss, a red-haired maven who I secretly adored, was always cold to me because of it. Once, Alan sat on the toilet while I took a bath and tried to explain to me what he most loved about the Attila the Hun book. He said he thought that he would have been pretty good at killing Romans. He thought that being born now, here, in Evergreen Park, had been completely unfair. This frustration, this constant aggravation, was, I believe, the reason he continuously tortured me.

Alan, by seventh grade, had devised a system of physical abuse that rivaled the brutal torments of the early Mongols. His tortures had been uninspired during our early, formative years—the usual ear-flick, the full and half nelson, the crotch-punch—but by seventh grade his brutal imagination bloomed in full. When he would tackle me, then sit on top of my head and exhaust flatulence directly onto my face, when he would smack both of my ears at the same time so that a faint ringing could be heard for days, when he would pin my shoulders to the floor with his knees and spit into my mouth—forced open by his enormous hands—I knew he was right. There was no appropriate word to describe his predilection for inflicting this kind of harm, other than a certain, outdated kind of brilliance.

4

The Unabomber went to Evergreen Park Community High School: He finished his education there two full years early, as a sophomore.

In his sophomore year, my brother Alan got a girl from Evergreen Park High School pregnant. I found this out when he asked to borrow two hundred dollars from me. It was just after dinner one night, and while I was finishing up my geometry homework, Alan knocked on my bedroom door and stepped inside before I even permitted him to enter. Alan looked like he had a fever or something—his forehead was ringed with sweat—and, more than anything, what struck me was how scared he seemed. The mustache he was trying to grow glistened with perspiration. That was the year Alan started working out, I think. He had bought a weight bench at a garage sale and would spend hours down in the basement, pumping iron and listening to Journey. He had gotten pretty muscular and pretty scary pretty quick. But on his face at that moment was an expression of fear and doubt, an expression he had so often forced me to wear while he held me under the unforgiving, chlorinated water of the public pool or while I struggled in the throes of one of his Neanderthal headlocks. In Alan's eyes that night was the quiet look of someone else, someone unfamiliar, someone much weaker.

Alan did not actually ask me if he could borrow the money. He said, "I need two hundred dollars," and then pointed at my piggy bank with one large finger.

"What for?" I asked, instinctively pulling the wizard-shaped bank into a safe cradle against my chest. In that moment I wondered why Alan didn't have money of his own when he was almost two full years older than me. Why, when I was fourteen and he was sixteen, was he asking to borrow money from me, money I had worked for two years saving up—washing dishes at a Greek restaurant on Friday and Saturday nights, cutting lawns during the spring, summer, and fall, shoveling walkways during the winter—money that totaled just a little more than two hundred dollars, which was going toward the priceless *Fantastic Four* #48, the first appearance of the Silver Surfer, a comic book that sat behind the counter at the comic book store on 95th Street, safe behind plastic, promised to be in mint condition, with the price tag of $275? Why wasn't my older brother embarrassed

to have to come groveling to his younger, more fastidious brother—a situation which the younger brother, in that moment, wondered how to best exploit? What kind of older brother/younger brother dynamic was this? Good questions, all of them. You will have to ask Alan yourself if you want any answers.

Because Alan simply repeated, "I need that money now."

"I'm not just going to give it to you," I told him. "I have to know you're gonna repay me."

"You'll get it back," he said.

"Well, I have to know what it's going toward."

"I told you, I need it."

"Well, you can't have it. Not unless you tell me what it's for."

In that next moment, I saw something else in my brother's face I could barely recognize. It looked like he was going to cry—his eyes were small and watery, his chin lowered, his mouth became a crooked line framing an unspoken question. He closed the bedroom door and sat down on the bed, lowering his face into his large, inhuman-sized hands. Then he began to moan, like some unknown wild animal, like something waiting to be put to death. He made a sound unlike any I had ever heard before, the sound of crushing, total defeat.

"I just need it," he repeated, and then, before I could ask again, he said, "It's for a girl I know."

"A girl?" Something turned in me then, something small and superior and jealous.

"I did it, okay? I got a girl pregnant. I need the money to take care of it," he murmured, his face still buried behind his clenched fists.

"What?" I whispered. "You what?"

But Alan didn't answer. He just said, "I need that two hundred dollars right now," then stood, towering over me. Were we not young Catholics then? Didn't we both escort our mother to church each and every week? What kind of favor was this to ask a brother, younger by nearly two years, someone who preferred the company of the characters of Tolkien and H.G. Wells? I decided I ought to take the moral high ground in this moment, though I didn't know that was what I was doing at the time. It was how all the adults behaved who I admired—superheroes,

parents on situation comedies, math teachers, wizards in serialized novels. Alan looked at me, his face large and menacing, his lips still quivering like he was going to cry, though by then I knew he wouldn't.

"You got a girl pregnant?" I whispered, and he nodded once, then said: "Are you going to give me the money or not?"

I couldn't actually believe it, or I could, but not that he was telling me—me, of all people. In my mind, and I don't know why exactly, I thought getting a girl pregnant, someone you weren't married to, someone you didn't actually love— love in the strictest, most traditional Judeo-Christian fantasy novel sense—was just about the worst thing you could do. I told him this. I told him that I thought he was turning out to be a real asshole. He told me he thought I was not a big shot just because I was in honors classes now. I told him I did think I was a big shot. I told him that one day soon this big shot was going to save up enough money to buy a car and drive far away from Evergreen Park and only come back one day to see it burn. I have no idea why I thought my neighborhood would one day be in flames. It was an ongoing fantasy, however, which I helplessly clung to for years and years afterwards.

"Just give me the money," he said, quickly losing his patience.

"On one condition," I told him.

"What?"

I know he could have ripped the piggy bank out of my hands if he really wanted to. But instead, he stood there, glaring down at me, waiting for an answer.

"I want to see her," I told him.

"Who?"

"The girl."

"What?" His face screwed up in a knot of total disbelief. This was an expression I was more familiar with—one where his heavy eyebrows threatened to climb the thick ledge of his forehead. It was an expression he wore all the time—watching any television program that wasn't a cartoon, trying to teach me how to shoot a free throw, staring at me from across the dinner table with disgust while I told my parents about the goings-on of the Science and Math Club.

"I want to see her," I repeated.

I do not know now why I wanted to see what this girl looked like, only that, at that moment, it was something I know I needed to do. Maybe it was only spite, something that harsh and small and simple. Maybe I thought it would be a grave humiliation equal to the thousands and thousands of embarrassments he had thrust upon me. Maybe, just maybe, I thought that if I could force my brother to let me see the girl he had accidentally impregnated, if I could disgrace him in such an obvious way, then somehow we would temporarily be even.

"No way," he said, suddenly sure of himself once again.

"Then you can't have the money."

"You little shit. I could break both your hands right now."

"All I have to do is call for Mom. That's all I have to do."

"Why do you even care?" he hissed, exasperated. "What do you want to see her for?"

"That's the only condition I have."

He sat back down on the bed, then a few seconds later stood up and said, "You could've been cool about this. You could have but you had to . . . you had to try and be a dick."

"One condition," I repeated, looking down at the carpeted floor. "That's all I have."

He stood by the bedroom door and asked, "Why the fuck are you doing this to me?"

"I'm not doing anything to you," I mumbled, imagining myself as someone older, someone much more wise. "You did this to yourself."

"This is the reason nobody likes you," he said blankly, then closed the door behind him.

One hour later, as I stared at the conglomeration of numbers and shapes on my dull math homework, playing the argument over and over in my head, Alan opened the door without asking and said, "Okay, dickweed, let's go."

Alan had inherited a crummy Ford Escort from our uncle, a diabetic who lost both his legs to the disease. Because Alan was older, the car automatically became his. I tried to argue that this was a terrible mistake, that by grades or by merit the car ought to have been mine, even though I was only fourteen at the

time. My parents, kind enough to hear me out, still disagreed. The car, like almost everything in the world, would be Alan's first.

We backed out of the driveway and turned down 99th Street, Alan silent, a worn-out Doors cassette playing loudly on the stereo. I listened in amazement; the vulgar, sexual psychedelic thrum of the Doors frightened me for some reason. It was music that belonged to my brother and other kids with peach-fuzz mustaches, kids who wore their dads' army jackets, kids who laughed at me because my brother had told them I still collected action figures, which I did, action figures which were bound in their bright cardboard backing, never to be opened or touched. I stared out the passenger's side window of the Escort then, imagining the dotty face of the poor girl he had abused, the face of some street urchin from the illustrated comics of Charles Dickens. The familiar corners and blocks flew past, as I dreamed of the girl's quiet, upturned face—her willowy victim's body trembling beneath my brother's hulking shape. I knew he did not love her. I knew she did not love him. I knew he had lied to her to get her to give in. I would glance at the girl's shamed face and see what brute strength, what twenty-inch biceps, what vigorous male charm had taken and ruined. And I would finally stop envying all my brother ever had.

When we reached Kedzie Avenue, Alan switched the radio off, and without looking at me, said, "You don't talk to her, you understand? You stand there like the little dickweed you are and you don't say a word."

I nodded, then resumed staring out the window. I didn't say anything when he took a left on Kedzie, then sped past the White Hen convenience store, past our childhood doctor's office, past the tiny barber shop where we both got our hair cut. Just before 95th Street, Alan silently pulled into the parking lot of Dairy Queen, shut off the engine, and nodded, motioning with his eyes toward the red-and-white rectangular building, a giant plastic soft-serve ice cream cone rising from its angular roof. Alan threw open the driver's side door, then walked toward the glass windows, not glancing back to see if I was following. I was. But without certainty. I had lost my nerve. I was afraid the girl, whoever she was, would look at me and laugh, that because she was a girl, and because she had done what she had done with Alan, she would somehow be able to see me for what I was, a

miserable, unhappy wretch, who at the age of fifteen pretended to see movies he had actually never seen, pretended to understand books he could barely read, who wished more than anything to be as strong, to be as sure of himself, to be as truly appealing as his older brother, a brute who did not deserve what had been given to him. I stood by the curb, my back to the glass windows of the Dairy Queen, terrified to look the girl in the face. But I could see that Alan was talking to her now, a tiny, unremarkable girl with blond hair, wearing the red-and-white hat of the Dairy Queen establishment. They were whispering something to each other and they were quietly holding hands. I glanced again and was surprised to see that the girl was wearing glasses. I had never pictured Alan ever going for a girl with glasses.

My brother turned to me and said something, but I shrugged it off and hurried back to the car just then, quickly slamming the passenger door behind me. From my seat, I could see my brother still standing there, talking to a shadow behind a pane of opaque glass, and what was in his eyes, what was in his face, was unlike anything I had ever glimpsed before anywhere—not on television, or in film, in comic books, or in the expressions of my parents or teachers. From the gentle way his mouth parted as he spoke, from the slightness of his eyes, from the way he held one of the girl's fingers in his large hand, grasping it as if it was the most precious thing in the world, I knew then that he was truly in love. I knew then how I would never hold hands with a girl in that way, not any time soon, or maybe not ever. I sat there in the passenger seat and momentarily accepted that it had been my fault that I had become so miserable.

Later that evening, I gave Alan the two hundred dollars he had asked for. He paid it back to me in full the following week. By then, he had begun using and selling drugs pretty regularly.

5

The Unabomber went to Harvard when he was seventeen years old.

When my brother was seventeen and I was fifteen, we wrestled on the front lawn the day before Christmas Eve. He had made both my mother and father cry, telling them he would kill himself if they would not let him enlist in the army.

I could no longer stand the look of his face. His eyes were dark and electric, his face lean and sharp. While he had his back to me, standing on our front porch smoking, shouting at my parents that he was through with them and through with God and through with everything, I jumped onto his back. He got me in a headlock before I remembered that he would always, always be stronger than me.

Just a few weeks earlier, Alan had been expelled from St. Rita's for being intoxicated in school. He had taken a number of Seconals and brought a pair of nunchuks to his biology class, which he was desperately failing. I don't know what he had planned to do with the nunchuks, because he collapsed beside his desk before anything happened, lying there on the tile floor, unhappily smiling.

6

The Unabomber graduated from Harvard and went on to get his PhD in mathematics at the University of Michigan. His specialty was geometric function theory; he earned his degree by solving a single math problem his professors could not solve. He was then hired as an assistant professor in the mathematics department of the University of California at Berkeley.

Alan didn't ever go to college. He did try to get his GED at Moraine Valley Community College, but after one semester he decided "it's a lot of dumb kids acting like smart assholes" and so he quit. He thought that all of his teachers had it out for him. He truly believed there was an actual secret network of some kind—a network which all teachers in the world shared; he believed that his previous teachers from high school had asked his current teachers at community college to try their best to fail him.

Alan and I had pretty much stopped speaking to each other by then.

I was finishing up my senior year in high school and I didn't want to consider Alan's problems too. Alan was twenty and had become totally erratic. He had lost a lot of weight and was skinny and always sweaty. He had punched a number of holes in his bedroom walls—eleven altogether. He tried to cover these holes up with posters of jungle cats or torn pages from *National Geographic*. He began to use drugs more and more frequently—drugs like PCP and cocaine. He would

pcp & angel dust

come to dinner only wearing dirty white underwear. He would be high when I found him staring at the television at all hours. He refused to get a job or leave the house. Finally, my parents decided that Alan needed to find a place of his own. He got so upset at the suggestion that he began sobbing right at the dinner table. He threw his plate on the floor and ran upstairs to his room where he locked the door. He would not open it for the next two days, not until my mother promised that he did not have to move out.

Looking back now, it is clear to all of us that this is when Alan first began getting sick. But it was so hard to tell—his symptoms and his personality had silently begun to overlap, and no one could get close enough to see what was actually happening.

<div align="center">

7

</div>

After leaving the University of California at Berkeley, without explanation, the Unabomber's first explosive device was sent to a Northwestern University professor named Buckley Crist in May of 1978. The device, hidden within a brown paper package, was left in a parking lot with Crist's return address written on it. The package was found and promptly brought to Crist. When Crist received the package, he noticed that the address was not written in his own handwriting and so he contacted a Northwestern University campus policeman by the name of Terry Marker. Marker opened the package and it immediately exploded.

Alan had finally got a job working at MenuMart supermarket on 95th Street; he would bag groceries and corral the shopping carts which were left stranded all around the parking lot. His hair was long and dark brown and shaggy. He had grown a scruffy beard and now his fingernails were always black and dirty. At work, he would often get in trouble for saying odd things to the customers as he placed their purchases within the safe confines of their paper or plastic bags. Alan had become obsessed with the idea of God. He believed God was present in nature, that He resided within the trees and animals and moving rivers and streams of the natural world, and that modern progress, which obstructed or destroyed the natural world, was actually killing God. He would say these things to the supermarket customers as he held their grapefruits, their Sloppy Joe mix,

their loaves of bread, in his dirty white hands. He might then tell them everything he knew about jungle cats. "The leopard is the smallest member of the great cats and most closely resembles its cousin, the jaguar. Male leopards only actually weigh between eighty and 150 pounds. I believe the leopard is one of God's finest creations and proof that He exists," Alan would stutter. The customers of the MenuMart did not exactly appreciate or understand his comments, though his manager did state that Alan was the most efficient bagboy he had ever hired.

One day, after Alan had been working at the supermarket for a number of months, a young woman and her two children were waiting in line to pay for their groceries. Alan was working the same checkout line, bagging, when he happened to see the mother slap her tiny son on his wrist. Alan grabbed the woman by the arm and began screaming at her. He refused to let her go until she apologized to both of her children. The woman became hysterical, which only made Alan more and more upset. The local police were quietly telephoned. They promptly arrived and Alan was arrested.

While Alan was being held in jail—waiting for his court appearance which had been scheduled for the following morning—he stole a paperclip from the public defender and cut a large gash in his right forearm. He claims he was not trying to commit suicide. He says that he was angry and only trying to get that anger out. A psychologist was appointed to his case and quickly diagnosed Alan with Residual Schizophrenia, but then changed his diagnosis to Severe Bipolar Disorder II after a three-hour interview.

Alan was only twenty-one. I was nineteen, a sophomore in college, away at school. I took a bus home right away and found both my parents sitting there in the dark, completely shocked. I tried to ask them what had happened but they were unable to speak. They just stared at the telephone, waiting for Alan to call them to say what was going to happen. Something important in them had been broken. Something precious had been impossibly fractured. None of us had any idea what to say or do. We sat at the dinner table silently, the television set the only sound in the room.

8

In 1979, on a routine flight from Chicago to Washington, D.C., smoke began to

rise from the rear cargo hold of an American Airlines flight; fearing the worst, the pilot made an emergency landing. It was then discovered that the Unabomber had placed an explosive device within the airplane's cargo hold and that a poorly wired timing device was the only thing that had kept the plane from being instantly destroyed.

After his arrest, Alan was quickly remanded to our parents' care. I was not much interested in getting involved; the sight of Alan, standing before the judge in a borrowed blue suit, terrified me. The suit was from the uncle who had died from complications due to diabetes. It made Alan look like a cadaver. I wanted to pretend that what had happened to him had not actually happened: I immediately went back to school, but then, for some reason, I stopped going to my classes. I partook of as many illegal substances as I could. I became self-centered and intolerable. I was sure that if Alan—who had always been stronger, tougher, better at dealing with the inherent difficulties of life—had gotten sick, then there would be no hope for me. I waited for something appalling, something overpowering and sharp to suddenly explode inside of me. I would lie in bed at night and hear my own heartbeat, imagining it was the sound of some kind of clock, something warning me of the precious few moments I had left before everything became sad and unfamiliar.

Back at home with Alan, my parents were also a little terrified. Alan had just begun the initial round of what was to become a long, unpredictable course of pharmacological therapy. First, he was put on a series of typical, then atypical, antipsychotic medications, then mood stabilizers, then anticonvulsants, each of which proved unsuccessful, until finally the right medication and the right dosage were achieved, nullifying his symptoms but leaving him listless, almost catatonic. (Alan's latest prescription drug is lamotrigine. He has gained considerable weight because of this med, which is a real dilemma, since diabetes runs in the family, though he has little choice but to continue taking the medication, knowing that, sooner or later, his obesity will present severe complications.)

The first time I came back from college and saw Alan, I was in complete disbelief. It had been only a month or two after his arrest but his face was enormous now, completely round, covered in coarse brown and white hair. He

ate an entire box of powdered donuts while I tried to talk to him. He was mostly silent, staring down at his hands, which were covered in white powdered sugar. When he finished eating, he stumbled back to his bed without muttering another word, then collapsed on top of his sheets. I stood there outside his bedroom door watching him sleep, wondering how much time remained before he lost control again, before he did something violent, before he hurt some other stranger, or worse, my mother or father. I knew that after their deaths, it would be up to me to take care of him. I wondered how much time remained before his problems took over again.

One night while I was back from college on a semester break, my parents went grocery shopping, leaving me alone with Alan at home for the first time since his symptoms had begun to develop. I didn't know what to say to him then. The medications hadn't been successful in stabilizing his mood and so I felt like he was a stranger, like he had become someone distant, someone unrecognizable. As we were watching television, it began to rain. For some reason, the sound of the rain made him incredibly anxious; he put his head on my shoulder and said he was afraid. He told me that the rain terrified him now. I think it was the first time Alan ever admitted he was frightened about anything to me, or at least the only time I could ever remember. I put my hand on his shoulder and told him that there was nothing to be afraid of. I told him it was only the rain. He told me he knew that God lived inside the rain. He thought God wanted to tell him something, but that he was too afraid to hear it. I tried to tell him there was nothing to worry about. I told him I was there with him and I wasn't going to let anything happen. Alan asked me if I could hear God speaking. I said I thought so. We turned down the volume on the television and listened to the rain together. Each drop hit the windowpane behind us, each some sort of secret message: It was one of the few moments I could remember where Alan and I got along, where we weren't fighting about something. I figured that Alan wasn't really Alan anymore, that maybe the meds or the disease had made him someone else, someone more timid, someone I actually felt close to. I kept hoping that this would be it, that this would be as bad as it would ever get.

9

After the events involving American Airlines flight 444, the FBI developed the code name UNABOM (**UN**iversity and **A**irline **BOM**ber) and began pursuing the Unabomber's case. In the end, Theodore Kaczynski was charged with the unlawful detonation of sixteen explosives.

Alan has been arrested three more times since the first incident. The second was for attempted assault, the third for attempted assault, and the last one was for shoplifting. In the Chicago Ridge Shopping Mall a few years ago, just before his thirty-fifth birthday, Alan tried to steal a telescope. He took the display model under his arm and walked out through the front entrance. It was during a highly manic phase. He had suddenly become obsessed with astronomy, specifically the shapes of animals like Ursa Major and Leo the Lion in the sky. Again, he believed there was some connection between God and nature, this time in the animal patterns of celestial lights. As Alan hurried out with the telescope under his arm, a security guard spotted him and detained him in the parking lot, and then the local police were called, and soon enough Alan was arrested a fourth time. He was observed and re-diagnosed by a state physician as having a personality disorder, and then that diagnosis was overturned by a second court-appointed doctor at this third trial when his Severe Bipolar Disorder II diagnosis was reinstated. Because of his ongoing medical condition and because he is generally very quiet, very shy, the judges in court are always unwilling to sentence Alan too harshly. They will threaten to send him to a state institution but will once again remand him to my parents' custody, unsure what else to do. I will go to court with my father and my brother, also unsure what we should be doing to help him.

We do not tell my mother when Alan gets arrested. My father and I do whatever we can to keep the stress of Alan's condition from wrecking her any more than it already has. The truth is that she's the biggest victim, the one who's really been destroyed by this. She's the one I'm most worried about. She's the one who now, at the age of sixty-four, cares for him every day, a grown man who is as unsure and as volatile as an impulsive child. She's the one he yells at. She's the one who he begs, asking to borrow the car for an hour and when he returns, of course, he has wrecked it. She's the one who, most often, has to be

industrial society and its future

alone with him. Her gray hair is always uncombed now. Her hands always look like they are shaking.

10

In 1995, the Unabomber demanded that his 35,000-word manifesto be published. The manifesto, *Industrial Society and Its Future,* claims that the "Industrial Revolution and its consequences have been a disaster for the human race. They have greatly increased the life-expectancy of those of us who live in 'advanced' countries, but they have destabilized society, have made life unfulfilling, have subjected human beings to indignities, have led to widespread psychological suffering (in the Third World to physical suffering as well) and have inflicted severe damage on the natural world."

I think now how much I used to envy Alan. I envied everything about him, everything: the way he looked—tall, well-built, handsome—the way he could talk to anyone, his strength, his charm, his sense of humor, how sincere he could be, sitting there in church, staring down at his hands at the times when I thought he might be actually praying. And now. And now. Now I am lucky if, when I see him, he is a fraction of himself. Now he will be on some new severe medication which will make his voice sound tired and slow. "I wrecked the car again yesterday," he might say. "It's these new meds. I keep falling asleep. I blacked out while I was driving. I wrecked Mom's station wagon. I'm not sure what happened. I hit a couple of parked cars. I actually hit six of them. I sideswiped them all. I'm okay, though. Don't worry." Or sometimes, sometimes he will leave a long message on my voicemail, something like: "This is Alan. I want to talk to you about something important. I want to talk to you about leopards. Do you know anything about leopards? They're amazing creatures, Pete. Amazing. Think about this: A leopard can run almost forty miles per hour. It can leap more than twenty feet horizontally, and ten feet vertically. It's also a very good swimmer, Pete. Leopards are probably the greatest animal ever born to this planet. And now they're being hunted for their skins all over Africa and Asia. They're killing them, Pete. They look out at the world with the eyes of God, Pete, and we're killing them."

Alan has tried writing some of this stuff down. He made a book for me a few

years ago for my birthday, with drawings he had done. Because of the meds, his drawings are loose and wobbly and look like they've been scribbled by a child. My favorite one shows a litter of leopard cubs; all of them have long black eyelashes and they are sleeping high in a jungle tree in a blue basinet, with a string of *zzzzzzzz*'s rising from their tired pink mouths. For some reason, a few of the baby leopards have wings, like angels, I guess. This is a perfect portrait of who Alan is now, I think. On the back cover of the little book he made, there is his name, *Alan*, again and again in what appears to be different handwriting. I asked Alan what it was all about and he said it was just practice. He said he had begun to forget who he was and so was practicing writing his name to try to help him remember.

11

When the Unabomber's manifesto was finally published in the *New York Times* and the *Washington Post* on September 19, 1995, the man's younger brother, David, immediately recognized his older brother's writing style and notified the authorities.

I do feel like I have betrayed my brother. I do not know what to do for him. I do not know how to help him anymore. Not too long ago when I was visiting my parents for Thanksgiving, I was happy to see that Alan had shaved his beard. He looked like he was trying to take care of himself. The first couple of days went well. But then, for some reason, he decided to stop taking his medication because he did not like how slow it made him feel. My mother tried to talk him into taking the meds but he wouldn't. He said he felt like he couldn't enjoy himself and he was sick of not enjoying himself. Things were okay for a couple of days, but by the end of the week, the day after Thanksgiving, Alan began to have a reoccurrence of his symptoms. He started yelling at my parents before he finally stormed out of the house.

About two blocks away, a woman named Theresa Howard was unloading her groceries from her car. Her daughter Amanda, a toddler, was in the passenger seat of their large black SUV, waiting to be unbuckled. For a variety of reasons, Alan has always been suspicious of black cars, especially SUVs. Something about

their size intimidates him. He walked up to the car and immediately began to attack the parked vehicle. He pounded on the tinted windows with his large fists. He hit Mrs. Howard in the face a number of times, perhaps up to seven. She says she tried to keep Alan away from her daughter by scratching at his face. Mrs. Howard then found her cell phone and called the police. By the time the authorities arrived, Alan had crawled under the car and was unwilling to speak. One of the police officers had to use a stun gun to incapacitate him. The woman, Mrs. Howard, knew my mother from church and so she decided not to press charges. The damage to her vehicle was limited to a broken window and a side mirror, which my father paid to have replaced, but something had changed in my dad. He said he had stopped being able to trust that Alan could take care of himself. He said he could not trust that Alan would not hurt himself or someone else.

A few days later, my mother and father decided we needed to place Alan in an institution, at least until his symptoms stabilized. My father says it was the hardest thing he ever had to do in his life. My part was pretty simple: I was the one who had to drive my brother. What I did then was probably the worst thing I have done to anybody: I told Alan we were going for a ride, and when he asked where, I told them that a new zoo had been opened and that we were going to go visit it. I suddenly remembered who he was, that he was my older brother, and that what I was going to do to him—put him in the care of vigilant though unfamiliar strangers—was the thing Alan most feared. It was about a half hour drive to the facility, south down the interstate; Alan seemed content to play with the radio and watch the other cars fly past. I kept thinking of what I should be saying to him, how I should be preparing him, but I couldn't speak. When I saw the exit for the facility, I almost drove past it. I had the idea that we could just keep driving, that I could take care of him and things might be okay, but then, as I've done again and again in my life, I took the easy way out. I exited on 159th Street and drove the few miles down the pastoral highway to the enormous gray facility. By the time we were at the gates, I think Alan knew what was happening, but he didn't bother to resist. He didn't make a sound. I drove up to the main entrance and two orderlies in gray-and-white uniforms helped Alan from the car. My parents

were there already, filling out the paperwork. It was the first institution Alan had ever been in, even though he had been diagnosed with Severe Bipolar Disorder II nearly ten years earlier. For some reason, my parents were proud of this, that they had tried for so long to help him on their own, that, unlike me, they thought with love and understanding they would be able to cure him. But by then I guess we had all given up. I don't think my brother will ever turn back into who he was; I don't even know if I want him to anymore. I don't know what I'd say to him if he did. *How are you? Do you remember us? What have you been thinking all this time? Where have you been?*

12

The Unabomber is now serving a life sentence without the possibility of parole in ADX Florence, the federal supermax prison in Florence, Colorado. He is prisoner number 04475-046. He can be written at:

Theodore John Kaczynski
04475-046
U.S. Penitentiary Max
P.O. Box 8500
Florence, CO 81226-8500

After my brother had spent four months in the facility near my parents' house, my father changed his mind and signed him out. With the facility's help, Alan was placed in a group home on the north side of the city. He has been in and out of group homes and low-income housing for the last five years. The phone number I last had for him no longer works. I keep reminding myself to ask my mom for his new number, but I haven't. Every so often, every week or so, Alan will call my mom to check in. If he forgets to call, she automatically assumes the worst, that he is in jail or dead. Sooner or later he will call though. He will say he has been too depressed to talk to anybody.

To be honest, the last time I saw Alan was seven months ago. At that point, he had gotten a part-time job at a shoe store, reshelving the merchandise. He was shaving and taking a bath every day. His face almost looked the way it did when

he was a teenager, when there was the subtle expression of both confidence and mischief in his darkly handsome eyes. When I think of him now, though, I don't picture his face the way it is. What I see is from a memory, from a moment when he must have been eleven or twelve years old and we were both in our backyard and it was summertime and I was drawing in a coloring book and he was there in the green grass and he didn't know I was watching him. He was crawling around on all fours; he was practicing being a lion or a tiger or more probably a leopard and he was growling to himself, stalking the shadow of a bird, and he didn't see me staring at him and I think my mother was there, looking at us from an upstairs window, watching us both and gently smiling, and what I remember most is that all of us were happy then with who we were at that moment; at that moment, all of us were quietly happy.

ART SCHOOL IS BORING SO

illustration by
Steph Davidson

Art school is boring so Audrey wears a space helmet around: It is kind of pretentious but so what.

A secret: Audrey does not know any Velvet Underground songs but still she wears their T-shirt. It is black and Audrey's hair is black. She is very short with big brown eyes, what boys would call cute, but she doesn't think of herself as being pretty because she was a geek in high school.

Of course, Audrey has an idea for a new zine: It will be called *Poop Fest*. She isn't completely sure what it will be about yet. Something about celebrities and the shape of their poop.

Look: Audrey is in her apartment window right now standing like a mannequin with the space helmet on. In the room beside hers, someone is doing it with someone else, someone who is out-of-control horny. That someone is Isobel, her slutbag roommate. It seems like Isobel is always in her room with her artfag boyfriend, doing what girls and boys are sometimes known to do.

With her camera: Audrey is trying to be sneaky. She is taking pictures of her old Japanese neighbors, who are slowly, slowly walking down the hallway of the apartment building, the two of them slight and holding hands. The old man has large black glasses and the old woman a white scarf around her neck. Audrey thinks the old couple is the most beautiful thing she has ever seen and decides that somehow she is going to use them for a zine she is thinking of doing. She takes a picture of a tree losing its leaves and decides that this might work for the cover.

Another secret: Audrey has no idea what to do for her final project for Composition II class. There are two weeks left in the spring semester and all she can think about is how everyone is in love with someone, but she is not in love with anyone. She considers this at the laundromat as she watches her roommate, Isobel, doing her laundry: Isobel is tall and thin and a dancer, with short blond hair. There are nude photos of Isobel online, photos Isobel has put up herself. Audrey notices that it is the fourth time this month Isobel has washed her sheets, and there, there spinning like a phantom in the washing machine, are her boyfriend's dirty purple briefs.

What Audrey is studying in art school: photography—though she got an F in her Photography I class.

On the phone: Audrey tells her mother she wishes she was in love with someone. Her mother laughs and says, "So do I, honey, so do I. If you can think of anyone you can set me up with, I'm open to ideas."

"Gross," is what Audrey says in return.

The basic idea for her zine *Poop Fest*: drawings of different celebrities' poop

with different comments. Tom Cruise, Julia Roberts, Macaulay Culkin, what kind of poop each of them would have, things like that.

Another secret: Audrey is thinking about doing a zine all about her roommate Isobel, and how she is always in her room doing it loudly with her artfag boyfriend, which is the reason Audrey is in her room dressed up as a spaceman every night: She cannot lie in bed and listen to them because then she gets all turned on and then angry and then sad. Maybe she'll write down all the stupid horny things they say in bed, or no, maybe she won't, because she has a million other things she should be doing, argh.

Audrey's favorite musicians: Gang of Four. Or maybe Serge Gainsbourg. For the moment, at least.

What Audrey hates: Of course, Audrey has recently decided that she hates the world. Like everyone else in art school, she hates U.S. imperialism. She hates mass production but she secretly likes Britney Spears. She hates the way she looks: pretty but too Caucasian and too tiny. She hates her black hair. She hates the way the thrift store clothes fit her body: badly. She hates that no one thinks her pink roller skates are funny. She hates all the white leather belts she sees people wearing but wears one anyway. She hates that all modern art has to be explained. She hates the kind of drawings she makes because she cannot draw people's faces. She hates that her parents are rich and she hates that she hates them for being rich. She hates the kids in her art classes who are sometimes pretentious and sometimes totally brilliant. She hates that she has not done anything she is proud of since the spaceman outfit she made last semester, which no one really noticed anyway, but hey.

What Audrey loves: Henry Darger, the movie *The Goonies*, her nose and eyebrows, which she is right to think are attractive, and the singer Olivia Newton John. That is all. Everything else has already been done a million times.

At art school: Audrey is totally hot for Hot Eric. He is in a band called American Video Game. They do covers of Atari 2600 songs. Audrey does not like Hobbit-Haircut Eric, who has the same haircut as all the other guys at art school. It is exactly the same as the guys from The Strokes and the fact that everyone has that haircut makes Audrey very hateful.

Of course: Audrey works at a corporate copy chain named Top Copy. Of course, Audrey does not do her job well. She wears her Yoko Ono sunglasses indoors and a lot of silver bracelets and eye makeup, which she has been warned is "totally unprofessional." She is supposed to clean the bathroom but she refuses to.

Does Audrey ever sing made-up songs? The answer is yes. Here's one: "*Asian lady / in your apartment / why do you wear gloves / why do you wear gloves?*"

At work: Audrey makes drawings of the people who come in. There is Mr. Elephant-Face with Brown Tie. Mr. Potato-Nose with a Cane. Mrs. Facelift with Saddlebag-Boobs. She has at least a thousand different ideas for zines she could do: One might be about Hall & Oates, one could be about sea horses, one about how she is starting to like soul music, and one all about fireworks. The problem is, well, she just hasn't had time to start any of them.

Of course: Audrey hates hearing the sounds of her roommate Isobel and her boyfriend alone together. It is like they are trying to be quiet, which is worse, because it is all so obvious: duh. The sound of the Bright Eyes record, the same record almost every day, every night, of the bed under duress, of the most intimate, the most longed-for kind of laughter, of the most exquisite and most wonderful shuffling of limbs. Audrey covers her ears, screaming, jumping out of bed. She pulls the space helmet over her head and stands in the window like a mannequin, holding her hands above her heart, moaning loudly.

At work: Audrey tries to trim her nails with the paper cutter. Hobbit-Haircut Eric comes into the copy shop with a video camera. The red light on it flashes brightly.

"I want you to be in my movie," he says. Like always, his hobbit-hair looks hobbit-awful.

"No way," she says, covering her face. "I'm not going to be in any dumb movie."

"Come on, you're perfect for the part."

"What's the part?"

"A girl who works at a copy shop who is secretly in love with a young filmmaker."

196

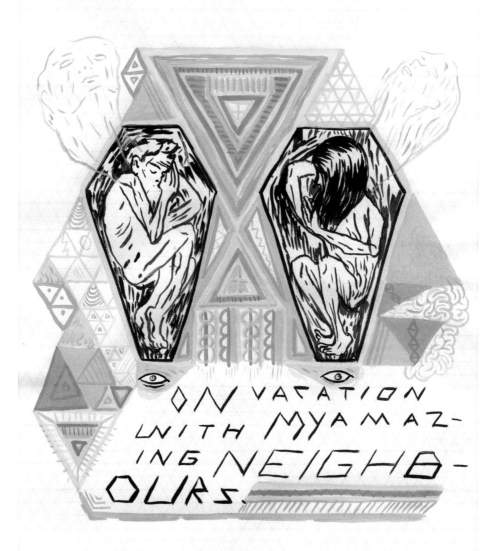

ON VACATION WITH MY AMAZ-ING NEIGHB-OURS.

"Yeah, thanks but no thanks."

"Come on. You're perfect for it. You are totally beautiful."

Audrey blushes when he says that. She hurries behind the counter and pretends to be busy copying something.

A mystery occurs in Audrey's life: In the apartment next door, the two old Japanese people die suddenly, both on the same day. Audrey and Isobel stand in their doorway and watch the two gray vinyl bags being wheeled from their neighbors' place down the hallway. A police officer writes down the girls' names but never calls. Some service comes and cleans out their neighbors' place and leaves all of their personal effects in front of the building in the trash. Audrey inspects the strange objects carefully: Inside the black plastic bags, there are the old man's neckties, beautifully modern with small blue diamonds, men's shoes, the same pair, dozens of them, a small paper lantern, two dainty white gloves, and many, many books of photographs of the couple, as youngsters in love, standing in front of a volcano, middle-aged and proud before the Washington Monument, old and shuffling in front of a blue-capped mountain. Audrey decides she will use the photos for her zine, which she has now decided to call *On Vacation with My Amazing Neighbors.* In the zine, she imagines what their conversations would have been like and where they might have traveled. One story in the zine is going to be called, "My neighbors and I Go Grocery Shopping."

At the copy shop: Audrey helps a girl in junior high to plagiarize what is supposed to be a research paper. Audrey gives the girl a new title, "The Scarlet Letter Is Unfair to Women, Duh." Audrey tells the girl what to write and even what words to change. When another customer, a young man wearing a backwards baseball hat, tells her that he is having a problem with the self-serve copier, Audrey covers her ears and disappears into the back and does not return.

At night: Audrey waits until Isobel and Edward are both on the couch, in the dark, whispering. She pulls the space helmet over her head and lurches from her room, then stands in the doorway, pretending to be drifting aloft in space. The young artfags look at her silently, then go back to watching the TV.

"Do you want some popcorn?" Isobel asks.

"Okay," Audrey says, taking a seat beside them. She leaves the space helmet

on and reaches beneath the foggy blue plastic, slipping the popcorn in her mouth, squinting.

"Can you even see with that thing on?" Isobel asks.

"I can totally see fine," she says. "In the future, people are going to be wearing these things all the time."

"Not likely," Edward says, smiling to himself. "Not with this president. We're not even going to make it to 2006."

"Well, I know, I'm from the future," Audrey says. "And this is how people dress."

"Well, if you're from the future, can you tell me if I am going to have enough for rent next week?" Isobel asks, grinning.

Audrey the spaceman presses some imaginary buttons on her space helmet and declares, "All signs point toward no."

"What about Edward?" Isobel asks. "What's going to happen to him?"

"The future predicts terrible things for Edward: I see him standing in the hallway checking himself out in the mirror. He will suck in his gut and then curse loudly. He will go on living here even though he does not pay any rent."

Everybody is quiet then, going back to watching TV.

Another secret: Audrey has only had sex once and she is not sure if they even did it right. It was with a faggy goth boy back in her junior year of high school and it went so badly that Audrey has begun to give up on the idea of having sex ever again. Okay, get this: While they were doing it, the goth boy came on her belly. She laid there like she had been shot, which she had in a way. Thinking about that, Audrey decides to do her Comp II paper on famous people who are celibate: Morrissey from The Smiths, the Pope, Michael Stipe from REM. In the paper, she argues that people who are not worried about always having sex have time to do more things. When she writes this, she suddenly realizes she has yet to finish any of her art projects or any of her zines. So she starts to write about herself and her roommate and how awful it is having to hear them all the time when no one in the world notices how smart and lovely she is and she even goes into how awful the first time she had sex was. When she turns the paper in, she does not know if it is the best or the worst thing she has ever done, but it is all

honest and all true and not just some art school act and so she really hopes her teacher will love it.

Audrey also has another job, her own business, which she has invented: She is like a clown, but not a clown. She entertains at birthday parties, for children who are terrified of clowns, but typically she ends up frightening the kids anyway. As you might guess, the business is not going so well. She spends most Saturdays at the mall passing out handmade flyers, and when she does get a job, it usually goes pretty terribly.

"But you're not a clown," is what most of the children say.

"I know, it's okay," she responds. "We're still going to dance and play games." She will be wearing a plastic tiara and a pink tutu and will try to get the kids to have fun, but most of the time they just sit there and stare. Usually, it ends with the parent paying her before she is done with her routine, which includes a rendition of "If You're Happy and You Know It." When parents remark with disapproval, Audrey refuses to apologize.

On Saturday, Audrey is called to "do a party." When she shows up, no one is home. It takes her a few minutes to realize she has been duped: It must have been a crank call. She tears the tiara out of her hair and throws it on the porch steps beside her magic wand. Fuck it. She is done being a clown, she decides, as she pulls away.

At work: The girl in junior high comes back in for more help with her research paper. On the Internet, Audrey helps her find an entire research paper which she borrows liberally from. "Isn't this cheating?" the girl asks. The girl has a purple duck barrette in her hair. "Isn't this like stealing?"

Audrey stares down at the girl and frowns. "There is no such thing as an original idea anymore. Everything is a total rip-off and a total letdown. It's all like postmodern art." Audrey feels both very old and very sad when she says this. Apparently, this is all she has learned in art school so far.

At work: Audrey is staring out the window when Hobbit-Haircut Eric comes in again with his video camera. He stands in front of her but does not say a word. He simply stands there, filming.

"You are like the world's biggest creep," Audrey says.

"This is going to be my masterpiece," Eric whispers, nodding. *"Portrait of an Unsuspecting Beauty."*

Audrey begins to blush again and covers her face quickly.

"Wait, let me get a shot of you blushing," he says.

"I'm not blushing."

"You are totally blushing."

"I'm not blushing."

Eric pushes her hands away, and when he does, setting one of his own on her wrist, lowering the camera from his face, she gets scared and excited that they will kiss. But they do not. He places the camera against his eye again and begins shooting and Audrey is left to wonder if she maybe, maybe she might like him.

On the phone: Audrey tells her mother she got a B on her final Composition paper. Her mother says, "I think that's wonderful, honey."

"But I'm still not in love with anyone," Audrey says.

"Neither am I," her mother says. "Neither is anybody."

At work: Audrey decides to stay late. Her slutbag roommate Isobel asked if it would be okay for her and Edward to celebrate their three-month anniversary in the apartment, alone, and Audrey, sighing, agreed. It is fine, though. Audrey is working on her new zine: She has just cut and pasted a photo of herself with her old Japanese neighbors shopping at the grocery store. In the background, the old neighbors wave happily, as Audrey glues her own head in place, the three of them colorful, disjointed, happy. She looks up at the clock and decides she has given her roommate plenty of time to do whatever gross thing they are going to do. She smiles, staring at the glued photos. She thinks maybe she will finish it tomorrow. Or maybe not, who knows? she thinks.

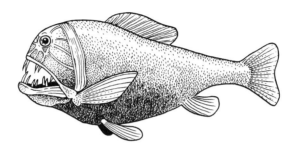

Oceanland

illustration by
Anders Nilsen

Oceanland is in bad shape. Oceanland looks awful. All the marine life appears old and molten and dizzy: The tropical fish are colorless and swollen and the dolphins bump into each other as if they're cross-eyed. Most of the stingrays do not swim anymore and all look a little senile. Barry blames his younger brother Jack, who is supposed to be in charge of the place. He stands before the Hall of Invertebrates, the most impressive exhibit in the crumbling marine park, the glass walls rising like a ruined cathedral, as he looks at the assortment of starfish: The five-legged echinoderms were, as he remembers them from his youth, one of his favorites, always bright red and yellow-pink. But now the starfish look how Barry feels: brittle and gray, their bodies disfigured, each of them missing several limbs.

Across from the starfish are the moray eels, their jaws clasping and unclasping

as they breathe, searching about desperately for something to eat. Barry watches as the eels spot him and then disappear into the caves beneath the plastic-looking reef. The eel heads bob about as they hiss a steady stream of air bubbles as a warning. Barry leans in close and begins to apologize. He gently whispers, "I know you would like to bite my hand right now. I know you would like to hurt me. If we were in the ocean, you would be faster than me. You would definitely kill me. I am sorry you cannot injure me right now. But look, there are some shrimp to eat." The eels seem to turn their attention to the dwindling school of shrimp in the murky floor of the tank. "Have a good day," he says, and slowly walks away to find his brother Jack.

As Barry walks, he stops before several more exhibits, disappointed at the forlorn-looking animals and the exhibits in disrepair. He apologizes to the walrus, who appears to be sobbing. "This is no place for someone as gentle as you," he says, pressing his forehead against the glass.

Barry continues on and soon notices that the marine park is entirely empty. He looks down at his watch, worried. *It's after 9:00. Where are all the ticket takers? Where are the gift shop employees? Look. It's 9:13 and the beluga whales have not been fed and the seagulls look bloody and the front gates should be open and where is Jack?*

Barry turns a corner behind the colossal plastic squid and suddenly finds Jack, who is hiding behind the abandoned mollusk exhibit and getting high. In a dirty gray wetsuit, which is unzipped to his waist, his knotty chest hair blooming above his pronounced pectorals, a tiny white shell necklace loose around his neck, Jack takes an impossibly long drag, grinning wildly. Barry watches, marveling at how long his younger brother can keep the smoke trapped inside his lungs. As a boy, Jack would always win when they would dive to the deep end of Dolphin Cove, trying to see who could hold their breath the longest. Jack, with his red hair and freckles, would plunge to the bottom and grab ahold of the silver water filter, grasping the vents with his fingers. He would be fearless, pulling himself down, crossing his legs, and sitting Indian-style at the bottom of the pool: He could hold that position for up to four or five minutes, just drifting there, eyes closed, the most serene smirk you could imagine resting on his little red face. Barry could

never go over a minute: Older, wiser, made anxious by their father, he would always open his eyes first, terrified that his younger brother had drowned.

Barry marches over to his younger brother and realizes Jack is in much better shape than him. His arms are well-muscled as is his chest. Barry takes notice of this and taps his brother on his back, saying, "Jack, I would like to have an impromptu meeting."

Jack lets out two enormous lungs full of smoke and smiles. "Let's do it," he says. "What's on your mind?"

Barry is trying not to act like the older brother here: He has to remind himself he is not in charge. He has been gone for eight years. He is not the general manager. While he's been away, working as a very successful if underappreciated CPA, and also developing an enormous, meteorite-sized ulcer, his little brother Jack has been here, running the place with their grizzled father, learning how to operate Oceanland. Jack, younger by four years, is now Barry's boss. It is this sad fact that has been eating at Barry since he moved back. This, and all the wounded-looking animals, and Marcia walking around their apartment with no clothes on, and, well, many, many other things actually.

Barry stares down at his feet and asks, "It's like 9 a.m., Jack. Why are you getting high?"

"Barry, there are a couple of things I think you should know about me."

"Okay."

Jack exhales, blowing a puffy cloud of smoke out through his nose. He flexes, the pectorals in his chest turning to fleshy stone.

"One: In the last couple of years, I have become one of the greatest living guitar players of all time. And I'm not bragging. I can do the guitar solo to almost any Allman Brothers song note for note. I mean, you should hear some of the songs I've written myself. There is this one I'm calling 'Angel with a Devil on Her Shoulder' and it has probably the most infectious riff that you ever heard. I mean, if you hear it, you can't get it out of your head. You'd need like surgery or psychotherapy to forget it."

Barry looks down at his feet again. This time he sees his younger brother is shoeless.

"Two, second, segundo: I sometimes enjoy a mild narcotic in the morning to take the edge off. Being in charge comes with certain pressures and I don't need these certain pressures clouding up my workday."

Barry grips the spot between his eyes and sighs.

"Okay, third, and maybe most importantly: Because Dad is no longer running the show here, we now have a very comfortable, relaxed work environment. We have drinks together after the park closes on Thursday. We all head over to BJ's Grill and I let the employees drink whatever they want for free. It's kind of a radical concept and I haven't seen the numbers from it yet, but I think it's really great for everyone's morale. I know some of these new radical ideas might be hard for you to adjust to, coming from the corporate world. But the thing is, I'll tell you what I told Dad when he asked me to take over: I don't want any part of it if I can't do it my way. And my way is to have fun with it."

Barry turns and stares at the tranquil waterfall rising just beyond the front gates. The water should be blue but it is green and brackish and full of algae.

"Jack, listen, it's way after 9 and the gates aren't open yet."

"Barry, listen, I didn't hire you to worry. I hired you for your amazing bookkeeping skills. And also because you're my only older brother and I know you needed someone to throw you a line. So listen, okay: The gates will open when the gates open. What is this place called? Oceanland? Am I correct? The ocean doesn't run by man's clock. It has its own schedule, which we would be fools to try and interfere with. Does that make sense? We're running on the ocean's schedule, if that's okay. So if we're done here, I've got a family marine park to maintain."

Barry nods and stares as his younger brother staggers off: He watches as Jack stops to frown beside a pool of hyperventilating hammerhead sharks, sparking them to life with an electrified prod. Barry feels like crying but knows he will not.

The last time Barry cried he was fourteen and leading a guided tour around Oceanland. His father suddenly appeared and cut him off mid-sentence, then grabbed him by his knobby ear in front of the worried-looking tourists. Shoving Barry's face hard against a Plexiglas tank, his father began shouting: Barry had

forgotten to feed the eels and three of them were now floating along the surface, greasy-looking and gray. Barry, embarrassed and guilty, picked himself up and ran through the park, past the gawking strangers and brightly lit exhibits, past the souvenir shop and Breaktide Falls. He leaped and dove headfirst into Dolphin Cove, kicking to the bottom as hard as he could. He grabbed the cold steel vent as Mandy and Sarah, the trained dolphins, bobbed around him like ghosts, and he began to cry uncontrollably, the salt of his tears mingling with the salt of the sea. He cried for what felt like hours, then surfaced and changed clothes, not telling anyone else about what had happened.

Barry has not cried, not once, since that day.

Barry stares at the exhibit of dull-looking manta rays and feels a sadness deeper than he thinks he should. A young boy is jabbing at them with his finger, grinning with awful delight. An old man keeps trying to poke one of the rays in the eyes. Barry, getting upset, gives the old man a dirty look, which the guy ignores. Barry peers down at the rays and sees that they are all frightened and covered entirely in scars: Large parts of their skin are sandpaper rough and darkened from being

touched by so many kids and adults. Barry knows this is why a manta ray will die—being pet to death. Another group of tourists draw close to the ray exhibit and Barry quickly hangs the bright yellow sign, the one with the cartoon shark speaking in a cartoon bubble that says, *Sorry, folks, this exhibit is closed. Try back again later today.*

A boy, holding his mother's hand, begins to pout, as Barry apologizes.

"Sorry, but the manta rays are not feeling so well."

"But we drove an hour to see them."

"They just need a break is all."

"Well, this place is awful," she announces. "I don't see how you stay in business." The mother and son march off toward the Porpoise Portal, which is stocked mostly with dolphins. Barry turns and stares down at the manta rays and whispers, "It's okay. You guys have the rest of the day to yourselves."

While Barry is inspecting the pH of the deep sea tank, an activity which is not one of his official accounting duties, his wife calls.

"*Barry,*" the marine park's loudspeaker shrieks, "*your wife is on line one.*" Barry, slightly embarrassed, hurries toward the closest park phone, which is hidden behind a plastic panel shaped like a conch shell.

"Hello?" he asks anxiously.

"Hi, honey. How's work?"

"Marcia, honey, I thought we talked about you calling here. It's kind of . . . I don't know . . . it's kind of unprofessional."

"Nobody notices things like that but you, Barry."

"No, that's not true. People notice things."

"I don't think anybody cares about things like that, honey."

"I just don't feel comfortable here yet. I just feel like everyone is still watching me."

"Okay."

"So?" Barry asks. "What's going on at home?"

"I'm bored. So, well, I was hoping you could tell me if you know if there's anything fun to do in town today. Like maybe you could tell me where I could go, some stores or something."

"What?"

"I was hoping you could tell me if there's anything fun to do. I'm bored. Like where can I go if I want to take a walk? I don't know the neighborhood yet, so I don't know. And, well, I guess I also kind of wanted to just talk to you."

"Marcia, honey, you can't just call me and ask that. It's got to be serious. It's got to be an emergency."

"Fine."

"Fine. I'll talk to you later."

"Fine."

"Goodbye."

Barry hangs up the phone and scurries off, past a young couple arguing about the price of admission. He looks over his shoulder. A young boy in a blue cap is tapping on the thick Plexiglas of Porpoise Portal, driving the poor mammals inside crazy.

On the way to the administration building, Barry notices a dark-haired girl in an aqua-colored Oceanland shirt standing perched above the tiger shark tank, staring down into the restless gray water. Barry stops and watches for a moment as the girl dangles a black shoe over the edge of the tank. Barry gulps down some air as he pulls himself up the metal stairway, calling out to the girl, who looks up, her heavily blackened eyes wide with surprise.

"What are you doing?" he asks.

"Um, nothing. Looking at the sharks."

"You looked like you were going to jump in."

"I was just watching," the girl says, the dark hair falling into her eyes.

"Where in the park do you work?" Barry asks.

"Concessions."

"Well, you shouldn't be up here anyway. This area is for the animal handlers only."

"It was unlocked."

"That doesn't matter. You could have gotten hurt or you could have hurt the animals."

"I was just looking at them. It's no big deal."

"Well, I think you should return to your work station."

"Whatever. Fine."

Barry watches the girl walk off, disappearing into the throng of disappointed families and elderly pickpockets. He closes the gate, then checks the lock to be sure it is secure.

Barry decides he has had enough. He does not want to do this but he will: because he loves Oceanland and, even more than that, he loves the animals, all of them, each and every one, the dolphins, the mollusks, the crabs, the skates and rays, the sharks, the sponges, the eels, the jellyfish, the anemones. He hurries to his father's office in the two-story administration building, which is, at the moment, unoccupied. Barry is mad; he feels he should be righteously indignant. He thinks of the starfish, of the underfed eels, of the walrus and manta rays. He thinks of seeing the great purple octopus floating dead in its tank this morning, a group of schoolchildren standing there horrified, pointing, one of the little tykes already crying.

Barry charges off, finding his father standing before the great white shark, the park's most popular exhibit.

"An adult great white shark can smell one drop of blood in a twenty-five gallon tank from as far as a quarter-mile away," the old man mumbles.

Barry knows the speech all too well: He had to memorize it and repeat it to

hundreds and hundreds of tourists every summer, starting when he was twelve.

"How's she doing?" Barry asks.

"Not so good," the man says. "All of her teeth have fallen out for some reason."

"Some kind of algae?"

"Probably."

Barry watches as the enormous shark cruises past.

"Dad," Barry whispers, placing his hand on the man's arched back.

"Jack runs the show."

"Pardon me?"

The old man's face does not move or flinch. "If this is about Jack, and this place, I want no part of it. Jack runs the show. That's what I told you when you came back."

"Yes, I understand that, Dad, but why?"

"Why? Why? Because I said so."

"But why? He's doing a really terrible job."

"Because Jack was around. Because he wanted to learn the business. Because he put in the time required to learn what Oceanland means to me."

"But Dad. Really. Half the animals . . . I mean, take a look around this place. It looks, well, it looks like hell."

The old man turns, adjusting his large tinted sunglasses. He peers at Barry as if they have never met: He holds out a hand tentatively, tapping Barry's shoulder once before turning back.

"You always thought you were better than us, Barry. I never liked that about you."

Barry frowns. He turns and watches the gigantic fish zoom past like a sparkling torpedo through the murk.

Before he can utter another word, the old man says it again: "You always thought you were better than this place. So now Jack is running the show."

Because Barry did not win a trophy at the company banquet, because he believed he was better than the rest of his coworkers at Hildebrant Manufacturing,

because he'd had enough of the mediocre world of corporate accounting, he quit his job.

It began when his accounting staff and budget had been drastically cut. Barry had soldiered on, finding a way to declare a portion of the company's losses as a corporate donation, saving Mr. Hildebrant hundreds of thousands of dollars. But then they took his office and fired Roberta—his elderly secretary—and the two junior accountants. And even though they came to him with the obvious proof of clumsy financial fraud, Barry had gone to work every day and always did the best he could. He believed doing his best was important, the most important thing a person could do, even if it was only accounting. In the small unlit suite, one room which all three accountants had to share, Barry put up a photograph of Reggie Jackson, the same one he had in his room as a kid. The suite seemed like a punishment, like a sure sign that Hildebrant was doomed, but Barry bravely carried on, saving the company with a few daring accounting maneuvers.

But when, at the company banquet at the end of that desperate year, Mr. Hildebrant, his starchy collar choking his awful, wrinkled neck, offered trophy after trophy to Distribution, Human Resources, and Development, completely neglecting the Accounting department, Barry, more furious than drunk, got up and began shouting. He kicked over his chair as he stood and yelled, "We got screwed! We all got screwed!"

On the way home from the awards ceremony, terribly embarrassed, Barry

began to tremble, thinking of what would happen to him come Monday. Soon, he felt like he should cry but knew he could not: He had been unable to cry since that awful day when he was fourteen. Barry, driving alone, wanting to cry but unable, squinted to see and then, predictably, drove his wife's new car into a telephone pole, and then a tree. He left the automobile there, staggering home on foot. When Marcia looked up from her pillow, Barry was sitting on the corner of the bed, moaning, his forehead bleeding. He told her he would have killed himself if he had bought a better insurance policy, but, always financially conservative, he had been too cheap.

Barry sits despondently beside the jellyfish pool: It is one of the least popular attractions because the jellyfish are often invisible. People usually glance at the cloudy water and simply keep walking. But sometimes at night, when the moon is full, the tiny creatures will begin to glow, radiating with an amazing iridescent light. As a child, Barry remembers how, after the park closed, he would sneak down to the end of this row of exhibits and lean over the metal railing, watching as, like stars, the pool would begin to sparkle and sing, the tiny lights flashing in time. When he was alone like that, he believed they were talking to him. He believed they were trying to tell him secrets: secrets about God and the universe and nature and human beings. Sometimes, while they were glowing, making sure he was alone, he would fold his hands and begin to pray silently.

At the moment, the jellyfish are only gray globs of tentacles floating in the water. Barry stares at them for a while before he realizes Jack is standing beside him. Jack is getting high again. He offers the joint to Barry, who just stares at it. He can see the smudge of his brother's spit along its narrow end. He closes his eyes, sighs, then takes the joint and inhales deeply. He hands it back to Jack and exhales, coughing violently.

"I knew you'd be over here. You're the only person in the world who likes jellyfish."

"I guess," Barry says. "Is it cool to get high here out in the open like this?"

Jack grins. "I don't know. I mean, I'm the boss now and Dad, well, he never comes down this way. It's too far from the office."

Jack passes the joint back. Barry takes another hit. He coughs once again.

"I haven't smoked weed in a long time. It's making my head hurt."

"I get this stuff from a guy in Acapulco. I love it," Jack says. "It makes me feel like going swimming. Remember we used to swim here, when the park was closed?"

Barry nods. "Yeah. The dolphins would always nudge our crotches."

"Yeah. These new dolphins, they won't even let you swim with them. They'll bite you. They're from the fucking Amazon and are very fucking snobby about it."

"Oh," Barry says. He listens to the whirl of the jellyfish pool's filter before Jack speaks up again.

"I talked to Dad. He said you told him you thought I was doing a terrible job."

"I didn't tell him that. I just said . . . I just said this place seems pretty disorganized."

"It is," Jack says, nodding. "I feel like I have no idea what I'm doing most of the time. Which is okay. I mean, it's the animals, you know, they're the ones who make me worried. I can give a shit about the rest of it, like the paperwork and payroll and all."

"But why don't you want me to help? I'm good at organization and planning, all those things. I really enjoy that kind of stuff."

"Yeah, I know. You were always good at it so Dad always put you in charge so I never had to do it. But I want to see if I can do this on my own, you know? I mean, it's like a once-in-a-lifetime opportunity. I want to see if I can figure this thing out without anyone else's help."

"But this place is falling apart, Jack."

"It's okay. I feel pretty confident that I'll be able to fix it. If you're gonna work here, you're going to have to let me do this on my own. I can't have you looking over my shoulder and checking the pH of the tanks and shit."

"I don't know if I can do that."

"Well, then I don't know if I can have you working here," Jack says.

Barry stares out over the jellyfish reef. The marine park is empty once again

as families hide from the noontime sun beneath the shaded umbrellas of the concession court. The animals, unhealthy, underfed, and neglected in their cages, enjoy a moment of silence, a reprieve from shouting and electrified prods and brats tapping on the glass. Barry turns and looks at his brother leaning against the light blue railing.

"Jack, I want you to know something."

"Yeah?"

"I don't think I'm better than you," he whispers. "I want you to know that."

"Yeah, you do," Jack says. "You're just no good at hiding it."

Barry spends the rest of the afternoon stoned, walking around Oceanland. For a winter afternoon, the crowds are pretty lousy. So Barry ambles about, pressing his forehead against the cold glass tank of the Porpoise Portal, screeching silently to the dolphins, telling them he knows they are in the wrong display. Some kids are tapping on the glass and Barry turns, inconceivably angry. He grabs one of the kids by the arms and shouts, "How would you like it if I tapped on your head all day? How would you like it?" The kid, terrified, dashes off,

calling for his mother. Barry frowns, then hides behind the blackened coral reef.

On his way back to the administration building, the girl with dark eyes, the one who was standing listlessly above the tiger shark tank, leaves her concession booth and moves beside him.

"I wanted to thank you," she says, staring down at her black shoes. "For this afternoon."

Barry nods. "Okay," he says. "Sure."

"But it doesn't really matter. I'm still going to kill myself tomorrow."

"What?"

"I'm still going to kill myself tomorrow."

"You are?"

"Yes."

"Why?"

"Because the world is mediocre. Everything is shit."

"That's why you're going to kill yourself? Because the world is shit?"

"Yes. And my boyfriend is fucking some hoodrat."

"Oh. Well, I don't think you should kill yourself because of that."

"You don't even know me. I mean, it might be the best thing in the world for me."

"It's probably not."

"Well, it might be. So, well, thanks again for trying anyway."

"Sure," Barry says, frowning. The girl nods and scurries away, blurring into the haze of the late afternoon crowd. Barry stands, staring for a while longer, wondering if he should be worried for the girl: He decides he *is* worried and walks by the concession court trying to find her. But she is already gone and when Barry tries to describe her to the other surly teens operating their greasy concession booths, they just look at him.

After work, Barry sighs as he walks into the tiny apartment. He finds his wife walking around nude again. Marcia is thin, a beautiful woman who is as narrow as a rail, with dark hair and large, hauntingly brown eyes. Barry stops at the door,

holding the apartment keys in his hands. Marcia is watering the plants: a few ferns, a peace lily, a gloomy-looking hydrangea that refuses to die. The windows are wide open, the shades completely parted, and Marcia is completely naked, which is her new mode of moving about the world.

"How was work, dear?" she asks, without looking up.

"It was fine. Listen, I thought we talked about this."

"What is that, dear?"

"Jesus, Marcia, would you please put some clothes on?"

"No. I will not. I am completely comfortable with my body and not ashamed of walking around my house like this. I don't see why you're so uptight."

"Well, could you at least shut the windows or something?"

"Barry," his wife says, finally looking up. Her eyes are a flash of meanness, dark and soft and lovely. "There is exactly one hour each day when this awful apartment gets sun. If it makes you feel bad seeing me like this, maybe you should start working out again. If you are not happy with yourself, you need to make yourself happy. I am not here to make you happy. Now, what do you want for dinner? All we have is fish."

Barry stares at his wife for a moment, then turns, still holding the keys in his hands. He exits, closes the apartment door, and walks down the hallway, wanting to die. When he steps out into the parking lot, seven or eight kids, boys with binoculars, one with a telescope, are watching his wife parade around the apartment naked. Barry does not say a word. He climbs into his car and tears out of the lot, wishing something good would come on the radio as the soundtrack to his terrible exit. But there is nothing except static and the sound of seagulls crying in the distance.

He drives around for almost an hour, giving up on trying to find a station that will play a song he knows or wants to hear. He tours around Breakrock, the town he grew up in and promised himself he would never drag himself back to, past the marina with its barnacle-encrusted cigarette boats, past the beaches with their plastic-surgery grandmothers in string bikinis, past the strip of half-empty diners with their flashing neon signs and nautical names: The Clamshell, The Pearl, The Sand Dune. Outside the car's window, it's just starting to get dark.

Along the tourist traps, just past the private lagoons and exclusive resort beaches, a fireworks show is starting. Barry pulls over and watches for a moment. He starts up the car and heads over to Jack's, a one-story stucco rental. Before Barry kills the car, he can already hear his young brother wailing on guitar. Jack is playing along to some record, Barry isn't sure what, and the sounds coming from his brother's enormous Marshall half-stack are like white-hot wires turning and twisting in the sky. Barry sits in his car and listens, remembering how awful Jack used to be on guitar, but now, now he sounds like a genius.

He never knew. He never knew his brother was good at anything. Barry leans back and closes his eyes and feels awful for ever hating Jack.

Barry drives around for a while more and then finds a pay phone to call his wife, listening to the sad drone of the unanswered ring.

"Please pick up. Come on, honey, please pick up."

Miraculously, she does.

"Hello?"

"Marcia?"

"Yes."

"Honey, I'm calling to let you know I'm all right."

"Great."

"I've been driving around."

"Wonderful."

"Honey, I want you to know something."

"What?"

"I am sorry."

"What?"

"I am sorry."

"For what?"

"I'm sorry I quit my job without talking to you about it. I'm sorry I dragged you down here and made you leave your job too. I'm sorry we have a crappy place to live now."

"Barry," his wife whispers, "where are you?"

"At a pay phone."

"Barry, I'm going to tell you something, okay?"

"Okay."

"You are the smartest, hardest-working person I know."

"Okay."

"But you are also the most miserable."

"Okay."

"So you have to figure out how to be happy in a world that isn't as good as you think it should be. You need to be less hard on yourself and less hard on Jack and less hard on everybody."

"Okay."

"And you have to decide whether you are going to be happy or whether you are going to be miserable. If you want to be miserable, please do not come back home. You are making me crazy."

"I don't want to make you crazy."

"Well, you are."

"Well, I'm sorry."

"Well, that's fine, but you need to figure some things out. You need to

figure out that being the best all the time doesn't always mean that much."

"I think it does."

"Goodnight, Barry," Marcia says, and hangs up the phone.

Barry sleeps in his car that night, in Oceanland's parking lot, and when the sun comes up, he is startled by someone's rotund face in the window above him. It is a family of overweight vacationers, all of them with big round faces, all of them whispering and pointing. Barry opens the passenger's side door and climbs to his feet, then stumbles through the front gate. He pauses before the moray eel exhibit. He tells them they look ferocious today. He tells them they look like they could do some serious damage with those teeth. He strolls around the park and apologizes to all of the animals, all of them, before heading to his office to do some serious accounting.

About an hour later, as Barry is walking into the administration building to audit the filtration accounts, a woman somewhere begins to scream. Barry follows the high-pitched shriek and sees the dark-eyed girl, the one from the day before, standing on the metal edge of the great white shark tank. A crowd has gathered. Parents shield the eyes of their chubby children. A group of French tourists begin to point and hiss.

"Oh Jesus," Barry mutters, and then he is running, pushing past the gawking crowd as fast as he can. The girl is looking right at him when she closes her eyes and jumps in. Barry feels the elevator inside his heart plummet down a great fiery shaft. He stands there open-mouthed for a moment, before he springs into action, hurdling the safety bar, kicking off his shoes, and diving in headfirst. The shark darts past in a grayish blur, thumping Barry with its nose. He suddenly remembers the shark has lost its teeth. He suddenly remembers how to breathe. He bursts to the surface, sucks in a mouth of water, then dives down again, grabbing the girl beneath her arms. She is fighting him. He feels the shark dart by once more, its dorsal fins cutting past his legs. The girl is biting his arm, her soft breasts pressing against his chest. Barry howls and kicks, shoving the girl to the edge of the tank, pulling his legs up and out of the water. The girl is still fighting. He holds her down, sitting on top of her as she tries to drag herself back into the

water. Somewhere, some insane tourist is taking pictures: Flashbulbs flash and people are clapping. The girl, her black makeup now runny, stares up at Barry, crying.

"You ruined it," she mutters, spitting up saltwater. "You ruined everything."

"I'm sorry," he whispers.

"Why couldn't you just mind your own fucking business, huh? Why couldn't you just mind your own fucking business?"

"I'm sorry," Barry mumbles back. "I'm sorry."

Barry does not try to find his brother to report the tragedy. Instead, he staggers through the marine park, pushing past a retired couple arguing about the price of a disposable camera. On and on, darting through a group of teenagers who are dangling dangerously over the edge of the sea snake tank, past a universe of silent, exhausted, and bored families, until finally he sneaks into the employee entrance of Dolphin Cove, which, of course, like almost all of the exhibits at Oceanland, is permanently but *Temporarily Closed*. The dolphins have been moved, the tank is now only rippling white waves. The water in the pool is bright and silver and inviting, though the lining of the tank is coated green and gray with some indefinable algae. Barry does not care. He kicks off his shoes, pulls off his shirt, doffs his slacks, and dives into the water, the sharpness, the coolness, the

gravity pulling him under. His white briefs become translucent as he cuts across the water, swimming as hard and as fast as he can. Some children are watching, turning from the coral reef exhibit, pointing at the lone man paddling about the dolphin pool.

Barry makes it to the center of the tank and, after gulping a great breath of air, dives down, kicking furiously, until he can reach out and grab the vent, gripping the metal with his fingers, his lungs pounding, his ears screaming, closing his eyes, counting off the seconds he can stay under, his heart saying, *We have tried so hard and still we fail, we have tried so hard and still it is all shit*, his heart ready to explode, his heart ready to burst from his chest like a beautiful red balloon, before finally, alone at the bottom of the pool, *It's okay, it's okay,* he thinks, and suddenly he begins crying.

GET WELL, SEYMOUR!

illustration by
Paul Hornschemeier

The girl playing badminton is the one. But I don't want to believe it. It is because her legs are so shapely and long and, in their stunning whiteness, betray a winter spent indoors. Her ankles are well-sculpted, her knees pinkly glowing, and there is something about her slender wrists that suggests the modest charms of aristocracy. I don't care much about the rest of her. It is the shape of her shadow, the way she stands there bored in the shade of the cruise ship's upper decks in a green skirt with white tennis socks pulled past her shins; I watch her lean over as she traces something with the edge of her racket, some invisible word or shape in the air. She is daydreaming and the picture she makes in the middle of the ocean liner is one of absolute splendor. I hear the sound of her laughter as the shuttlecock flies her way, her laugh which is not the kind of haughty one you'd expect from a girl who looks the way she does, and suddenly I've lost my nerve. I'm no longer red-faced or angry. I forget the direction in which I was walking as soon as I see her standing there, all ease and assurance on the badminton court. I feel the ocean breeze on my face and follow the shape of the shuttlecock as it's hit back and forth over the wind-blown net and then I begin to wonder how long she has practiced looking so blithe, so poised, so wonderfully self-assured.

"Are you sure that's her?" I ask, turning to face my sister.

Alexandria nods her head. My younger sister's face is a collision of odd shapes and silver wire. From her sturdy wire-rimmed glasses to her glimmering metal braces, Alexandria's features seem both mismatched and regrettable. She is shaped exactly like a pear. When she gets upset, her voice begins to whistle uncontrollably. "Oh, that's her, all right," Alexandria says, the metallic glimmer in her lisp high-pitched as she squints knowingly. One of her eyebrows dives below her bifocals lens and is magnified one hundred times to my great terror, as she makes an angry expression. "Well, what are you going to say to her?"

"I don't know exactly," I mutter, which at the moment is the absolute truth.

"You don't know? I thought you said you knew exactly how to handle someone like that."

"Well, she looks kind of busy," I murmur. I direct my attention back toward the girl in question. She is now whispering to another blond girl beside her, a younger sibling most probably, and just then the shuttlecock veers over the girl's head. She laughs—a kind of obvious laugh directed at her audience in the deck chairs before her, meant to demonstrate how much fun she is having—before swinging wildly at the birdie. The shuttlecock tumbles out of her reach and bounces in the soft artificial grass. When she bends over to retrieve it, without a thought, in a graceful and automatic gesture, she places her left hand at the back of her skirt, demurely keeping it in place. I suddenly feel the heat of the tropical sun traveling upon my cheeks. The girl snatches the birdie in her left hand and gives it a solid whack with the racket—serving it high over the net—and it drops daintily at her opponent's feet. Pleased with herself, the girl takes a small bow, neatly leaning forward from the waist as someone in the nearby deck chairs claps. When the girl rises, she looks up at Alexandria and then over at me. I watch as she goes through the momentary, involuntary calculations—trying to identify us, trying to remember if perhaps we have recently been introduced—and failing to see us as social equals, she happily goes back to the contest.

"Well?" Alexandria asks.

"We'll wait. We'll wait until dinner," I whisper. "When her parents will be there."

Alexandria nods, giving the girl one final, snotty look, before we both turn our backs and stalk below to our cabin.

It is February, and as such, we are on vacation, though we have not seen our parents in many days. They are once again in love, as both of them have exclaimed multiple times already. There is an inordinate amount of love-pecking, giggles, and hand-holding. We prefer to enjoy a leisurely existence aboard the cruise ship without them as they, more often than not, only leave us regretting their company. They do not come out of their cabin anymore anyway. There is room service on the ship and so they have been taking their meals at odd hours. We know of their habits only by the discarded silver trays left piled up in front of their door, charge slips signed blindly with black ink in my father's name.

The rest of the ship is old people with money and spoiled brats with regal-sounding last names. I am reminded again and again that I do not belong here. I am a freshman in college at Princeton. I am a Political Science major. I am seriously considering a minor in World Philosophy. I embarked on this loathsome little journey at my mother and father's desperate request—both of them claimed that it had been almost five years since we had all taken a vacation together—but now it is clear that they invited me along merely as a ploy, and that their invitation was only to ensure that Alexandria, who is twelve years old this month, would have an adult chaperone while they were busy re-exploring the odious physical aspects of their successful marriage. To that, I would have said thanks but no thanks, yet we have just passed Cancun and already it is too late.

I have brought a bundle of books with me, fortunately, and although I do enjoy the briny smell of the ocean and the tremendous profundity of the unfettered sky, it is in the solitude of enjoying Plato and Hegel that I find myself most pleasantly restored. It has been almost impossible to catch up on any reading, however, with Alexandria as an amusing distraction and constant ward. We have made a game of the last few days and I am happy to admit how agreeable I find her company, as she has matured rapidly and is unlike any other twelve-year-old I have ever known. Her interests in science and mathematics are quite astounding. She has begun collecting feathers from the variety of seaborne birds that hover about

the upper decks, carefully cataloguing them in a journal devoted to her ongoing projects. She is also quite fond of crossword puzzles. She is unafraid of seeking out words she does not know in my college thesaurus. I only wish Alexandria was not so quick to tears and had a better social sense. At school, away at college the last few months, learning when to offer an opinion and when—even though you might have a very detailed knowledge of a particular subject—you choose to appear diffident, is a skill I have had some difficulty grasping. I am often at odds with my dorm-mate Brice, who believes I want to remain a virgin for all eternity. "Don't quote ancient Greeks so often," has been one of his vital instructions. "And stop talking like you're somebody's rich grandfather," is another one, just as important apparently.

On the portside deck, in a pair of lounge chairs, later that very afternoon, Alexandria asks me why I use the vocabulary I do. "If you're composing a symphony," I say, "you want to have access to as many different instruments as you can. Consider that. Also, in ancient Greece and as late as the nineteenth century in England, men would often settle their disputes through engaged verbal clashes. I would prefer to handle my own trials with a sharp tongue and a quick wit, than have to resort to violence. And also," I add, "I don't believe in talking more simply just to put other people at ease."

Alexandria rolls her eyes and I pretend to ignore her. She returns her attention to the crossword puzzle folded in her lap and asks, "What's a seven-letter word for *lonely?*"

"*Dejected,*" I answer quickly.

"That's eight letters," she says. "It has to start with an *F.*"

"*Forlorn,*" I say, sure of its merit.

"That actually works." She happily jots the word down in the black-and-white squares. "None of the other kids I know like doing crosswords. But I think they're great."

"Well, I used to love to do them when I was your age."

"When you were my age, did you ever wonder why everyone laughed at you?"

I sit up and look my sister in her rounded, uneven face. "When do they laugh?" I ask.

"All the time."

"For instance?"

"Like at school and at parties and things. Whenever I raise my hand or talk or whatever."

"Wait a moment—you go to parties?"

"Mom makes me."

"But you get invited to parties?"

"Everybody does. It's a rule all of the parents have."

"I see."

"I just wish I was in college already," Alexandria says. "I wish I could study whatever I wanted and not have to worry about whether people liked me."

"It will happen soon. Someday you will find yourself surrounded by people with the exact same interests as you, and you will never feel out of place again," I say, already wary of the incredible lie I am telling.

At dinner that evening, Alexandria and I stand in line, glancing about the busy dining room for our prim antagonist. I turn and notice that Alexandria has two crystal bowls of chocolate pudding in her hands. Apparently, she has been eating only dessert since both my parents have vanished. We find a table off to the side of the enormous dining room where we can silently observe the goings-on of our shipmates without being noticed ourselves. We stare out at the crowded lines of wrinkled divorcées waiting in line at the buffet, searching for the girl's familiar, untroubled face. I am trying my best to identify the kind of fish I am eating when Alexandria elbows me in the side harshly. "There she is," she whispers.

And it is true. I look up and spot the girl sitting pensively at a large circular table. Her parents—old-money types with East Coast features, the large eyebrows, the polite ears, the patrician noses, the gaping mouths—sit on either side of her. Her other siblings are seated around them, laughing, ordering drinks, all of them seeming completely at ease; the father, having shoved the cloth napkin into the front of his shirt collar to jokingly suggest the severity of his hunger, quickly removes it when his wife gives him a stern glance.

"And she's with her parents," Alexandria adds, not without pleasure.

"So she is," I say, and then again, "So she is."

"Will you just look at her? She thinks she's so perfect. And look, look at her mother."

The girl's mother, bedecked in garish diamond earrings and a double diamond pendant, is as lovely as her daughter, if not more so. She looks like an actress, like someone who has never had to speak louder than a whisper.

"Where do you think they're from?" Alexandria asks.

"Massachusetts. Or Connecticut," I venture. "Connecticut, most probably."

"How can you tell?"

"The way the father combs his hair. Everybody from Massachusetts combs their hair like that at school. Parted down the middle with no sideburns."

"Look how tan the dad is. Maybe he's a politician of some kind. Maybe he's a senator."

"He's no senator," I say. "He sells stocks and bonds. Or he is a golf pro. Or he manages a chain of health clubs."

"Look at how that girl holds her fork. Like she think she's a princess or something."

"Yes, or something."

"So are you going to go over there or not?" Alexandria asks, her feathery voice now becoming urgent.

"I don't know. Do you still want me to?"

"Yes," she says without equivocation, the single word a hiss of tongue and teeth and braces.

"And you're sure she's the one who said it?"

"I already told you," she hisses again, this time losing her patience. "She pointed at me when I was in the changing room and called me *Baby Huey*. Then she started laughing."

I silently watch my sister's eyes fill up with tears.

"If you're going to chicken out, I'll just go tell Mom and Dad and let them handle it," she whispers.

"No, no, there's no need to do that. I just don't want to go over there and make a fool of myself, if, well, if you happen to be mistaken."

"She's definitely the one. She said it to that other girl. And then they both started laughing."

"And you're sure you heard what you think you did?"

"Yes," she says almost without a sound, her face going red. Does she even understand the origin of the insult, I wonder? Is it possible she only heard what she did because of how terribly she feels about the odd shape of her body? It doesn't matter now. Her oblong face is red and her tears appear gigantic behind her unbecoming bifocals. I decide I really must do something.

"Okay, try and stop crying," I say, holding her hand. I glance back at the other table. The girl is finishing her dessert with great aplomb while her younger sibling is sitting with her arms crossed, pouting, staring down at her food with an expression of disdain. It is obvious that they are spoiled. Each child already has the permanent crease around the mouth one gets from perpetual frowning. I do not like the look of them, any of them really, with their formal ties and dress shirts, the mother with her heavy makeup and jewelry. These are not the precincts of Rome or Paris. This is not the hidden port of Morocco. This is a cruise ship, a *cruise ship*, and not some famous ocean voyage. Who are they to put on airs? Who is that girl to think she can be hurtful to a fellow human without any consequences? I feel the anger rising in me again as I set down my knife and fork.

"All right," I say, "I'm going over there."

"You are?" Alexandria's smile seems to appear from nowhere.

"Yes. Are you done eating?"

"Yes."

As a testament, there are the two empty pudding bowls and a number of dots of chocolate along Alexandria's lips and teeth.

"All right. I want you to go back to the cabin. If you see Mom and Dad, tell them I went for a walk around the decks."

"But why can't I go over there with you?"

I turn to look at my sister—a rose that has not bloomed, an eternal duckling. Her enormous glasses shine with the perpetual viciousness of hope.

"Because I don't want you to be part of this. Now go."

Alexandria nods without another word and pulls herself to her feet. As she

passes the table where the girl in question is seated, she lingers, doing her best to offer them all a dirty look. Unfortunately, Alexandria's dirty look is almost impossible to recognize, the cocked eyebrow obscured by the frame of her glasses, the upturned lip made unnoticeable by her unruly, glimmering teeth. She passes the table and hurries out through the swinging dining room door, and as she goes, I realize so does most of my nerve. But I have made my younger sister a promise. I stand, gathering my courage, and step toward the large circular table. I do not hurry. I take as much time as is humanly possible to cross the dining room, which only a few hours from now will be converted into a dance club. By the time I am close, the girl and her younger sister are already excusing themselves, and then they have disappeared somewhere behind the doors leading to the lower decks. I pause, wondering what my next move ought to be. I try not to flare my nostrils as I pass the rest of her family, two brothers—who might be twins—engaged in feral sword play with dull butter knives, the mother looking drunken and sedate, the father monstrously stabbing at his giant teeth with a golden toothpick. When I look over, I see the spot where the girl had been sitting at the table. There, on her plate, are a number of words spelled out in what appears to be ketchup, a single phrase which reads, *G—el—Seymour*, but suddenly my view is blocked and I am unable to read the entire message. For some reason what I discover surprises me, and I crash into the swinging doors before I collect myself and stumble out.

So why am I such a coward, someone may ask? Why am I afraid of a girl who just so happens to be pretty? Why, when I possess a knowledge of some of the finest, most exact words in the English dictionary, do these same expressions so often disappoint me? I roam the upper decks of the ship for a long time, pondering these uncertainties. I am frantically avoiding a return to our tiny cabin where I will have to explain to my younger sister why I have failed, why I do not love her enough to do this one small selfless thing, why I appear to be so knowledgeable and wise and contented, with a new haircut and extensive vocabulary, when really, deep down, I am as unsure as I have ever been, which is precisely when I collide with the exact person I have been too afraid to face.

At the end of a curving hallway, I bump into the girl in question as I open

the door to a narrow stairway: She is there busily scratching something into the flaking white paint of the bulkhead with a black ballpoint pen. I trip over her foot, barely catching myself against the cold metallic railing. I am so surprised that she is there before me, standing alone, that I am unable to do anything at first but thoughtlessly apologize.

"If you'll beg my pardon," I stammer. "It was all my fault."

"You really should look where you're going," she says, without heat or anger. She is just as embarrassed as I am. She quickly adjusts her left gold-colored flip-flop, which has come off in the struggle.

"I'm sorry, I was only . . ." and then I reach for something, anything, to momentarily detain her. "Do you happen to know where the observatory deck is by any chance?"

The girl carefully brushes her fingers against her bangs in a gesture that reveals exactly how lovely she is. "I don't know," she says wearing a meek smile, a smile that reveals an astonishing dogtooth jutting above her pink bottom lip. "I haven't been there yet."

"I don't think we've been introduced," I say, extending a hand. She takes it bashfully and seems to smile in an entirely different way this time, with the faint timidity of a thoughtful blush. She is eighteen or nineteen years old, I guess. She is in a blue skirt with a sporty sailor top. She is on vacation with her family and exactly as bored as I am. Why couldn't we be friends? I immediately begin to imagine busy afternoons of shuffleboard and snorkeling, of meeting her parents and younger siblings, of introducing her to Alexandria to smooth over what has just been one unfortunate mistake. Intent on making her acquaintance, I decide to continue with the standard introductions as confidently as I can.

"I'm Josh," I offer a little too quietly.

"Sabine," she says, and the name, when it is sounded, is like a tiny bird passing through the wind. The way she says her name makes me doubt almost everything about myself. I continue to nod, wondering what I should say next, still shaking the girl's tiny hand. She gently lets go of my palm and fingers, then glances around for the quickest exit, which is a pair of elevators directly behind me.

"It was nice meeting you," she says.

"If I may ask, are you on the ship with your friends? Part of winter break?"

"No. I mean yes, I'm on a break from school. But I'm with my family."

"That's nice."

I see her eyebrows flatten as she nods once more and then begins to move toward the elevators.

"Just going for a stroll then?" I ask, moving along beside her.

"I guess. I was looking for the dance club."

"I think it's in the same place as the dining room. I think they just move the tables away. It's kind of funny to think of it being a dance club, when only a few hours earlier there was a bunch of old people there waiting in line at the buffet."

My remarks are met with a candid indifference.

"Are you in college?" I try.

"No," she says.

"High school?"

She nods. "But I'm going to Vassar next year."

"Wow, that's great. I'm at Princeton right now."

"Cool."

"Yes. If you ever want to talk, about college I mean, it can be a difficult transition to make. I've noticed that—"

"Thanks."

When we climb into the narrow elevator, I watch as she quickly lifts the black pen in her hand to scribble another, nearly indecipherable message. *Get well, Seymour!* it reads. I squint and see the same words, the ones penned in ketchup on her plate, the ones she might have been dotting in the air on the badminton court that very afternoon. When the elevator doors slide open at the next deck, the girl hops out and I follow, still unsure of what I am going to say or do. I catch up with her and ask in a confidential tone: "Who is Seymour, if I may ask?"

"Seymour?"

"You just wrote something. *Get well, Seymour!* it said."

"It's just a joke."

"Oh. I'm afraid I didn't get the joke."

"Seymour is our bird. We had to leave him at home."

"Oh."

"He's an African gray parrot. He's almost a hundred years old. He was my grandfather's; he actually left him to us in his will. My sister Jess and me, we have this game every time we go on vacation. We leave messages for Seymour, because once, when we went to the Bahamas, he got out of his cage and snuck out through the trash chute and broke his wing. He was trying to follow us. We were lucky, though, because the maintenance man found him. But every time we go somewhere, he ends up getting hurt."

"I see."

"He came down with a cold or something before we left. My father said it was just psychosomatic."

"I didn't know that parrots could get colds."

"They can. They're just like people really. The older they get, the more allergies and junk they can have. Once, the last time we went on vacation, we came back and he cried. My mother said Seymour was so happy that he actually started crying."

As we make our way down the corridor to where the sound of out-of-date pop hits blare loudly, I see a line of seniors in bright pastel cruise wear waiting to enter.

"Some dance club," the girl mutters in disappointment, changing her mind. She turns and I follow her once more back toward the elevators. She stops, darting quickly down a narrow hallway, to scribble another quick message in black ink. When the girl is finished with her note, she hurries off once again.

"There's a good place," she says, pointing to a corner where the crown molding creates a perfectly ornate frame. "I can't reach," she says, stretching on tiptoes. "Would you mind?"

I nod, then take the pen from her balmy hand and scribble as quickly as I can, *"Get well, Seymour!"* I add a large, jagged exclamation point as a flourish and hand the pen back to the girl, who nods at the message in appreciation.

"I have an idea," she whispers.

"Yes?"

"Let's go do the whole upper deck. When Jess gets up in the morning, she'll

be totally amazed. We just need to find a pen for you . . . I know. We could ask the ship's concierge."

"That might look suspicious," I say.

"You're right. Look," she says, leaning over, finding a black ballpoint left atop a silver room service tray. "Here you go." Without another word, we make our way down the hallway, the girl stopping every few feet to jot the same message in miniscule letters over and over again. Following her lead, I go for the hard-to-reach spots, inscribing the words along the molding and on top of the doorframes of unsuspecting cabins. We do this for maybe a half hour or more. At one point, it is like a race to see how many either of us can scribble before reaching the end of the hallway. When I look up, both of us are red-faced, and the girl, Sabine, is laughing.

"You kind of remind me of someone I used to know," she says, pointing at me with a grin.

"Someone famous?" I ask.

"No, a friend of mine. He's a year older too. He's at Brown. He took me to a dance once, but we . . ." Her words trail off and I notice that she's blushing. "Do you want to go see what my sister Jess is doing?"

"Okay," I murmur.

I would like to be able to say that in the next moment I immediately think of Alexandria, poor Alexandria, and the promise I have made, and the expression on her face, and the nascent tears brooking her red-rimmed eyes. I would like to say that in the very next moment I look the girl in her perfectly symmetrical eyes, in her perfectly freckled face, and ask her the question I've been too cowardly to ask, if she did indeed point at my little sister and make a rude comment and then begin laughing. But I do not. Instead I follow the shape of Sabine, her outline, her shadow, up into the C deck, then into an enormous pair of staterooms where her family is staying. I meet her mother and father who are not bores, but typical parents, except that her mother is an esteemed law professor and her father runs a string of newspapers. I allow them to teach me the card game Hearts. I find, to my great dismay, that none of the children are actually spoiled. They are polite and incredibly well-mannered and probably the most charming family in the entire

world. The two younger twin brothers do impressions of black-and-white–era movie stars, Groucho Marx and Greta Garbo. The father talks about going on safari in Africa, where he refused to shoot the animals with anything but a high-speed camera.

During the card game, the mother touches my hand like we are already old friends, kindly asking me if I would like to discard. The younger sister utilizes perfect diction. She says a word I have never heard before: *ersatz.* From that moment on, I will think of that night whenever this particular word is used. Sabine, across the table, blinks at me every so often, smiling. I tell them all about my first year at Princeton and no one seems bored.

The family goes so far as to invite me to visit the Belizean port with them the following afternoon. I accept all of this without thought. By the end of the night, Jess, the younger sister, suggests we play a game of flashlight tag, using the lower decks, but her father cautiously intercedes, pointing at his silver watch with a slight frown. I realize then that it is already past midnight and that tomorrow when I see this delightful family, when I am alone with Alexandria, I will have to act like none of us have ever met. If they wave to me as I am sitting beside the pool, I will not be able to wave back. If the father calls my name from across the buffet line, asking me to join them, I will turn, my face red with shame, looking over at my younger sister with her two dishes of chocolate pudding, before escorting her to the most deserted, most remote dining room table.

At the end of that most lovely evening, I make my way back to the elevator, feeling more glum than glum, more lonely than lonely. I see one of Sabine's messages in black ink scribbled on the wood paneling, then another in the hallway on the second deck, then a third along the upper deck's railing. I search my pants pockets for the black pen and hold it in my hand, and for some reason I do not discard it on a stack of room service plates. I examine it and think of the way the girl might have looked with her timid eyes closed, what secrets she might have confided in me some days later. I stand beneath the opaque lighting with the stars gaping down at me, the sound of the great vessel's engines rumbling like an unanswered argument, the noise ringing through the porthole

window as I continue peering down at my feet for many, many, many minutes.

I do not know what to tell my sister. All I am able to think of are extravagant lies in which her poor self-image has been properly saved. When I return to the cabin, many hours later, the lights are out and Alexandria is lying in bed. She immediately sits up and switches on the bedside lamp, her face delicately aglow, her silver smile perfectly brilliant. I turn to her, unable to look, before she asks me to please tell her everything.

ICELAND TODAY

illustration by
Rachell Sumpter

Iceland is located just south of the Arctic Circle, in the North Atlantic Ocean. It is an incredibly attractive and thoroughly exciting island nation. What is most unique about this small republic is that it was one of the last islands uninhabited by humans until it was discovered by immigrants from Scandinavia in the ninth and tenth centuries. The people who live in Iceland are beautifully pale, as if they too are made of ice. Their eyes lack guile and also pigmentation. When they are displeased or unhappy about something, their corneas become as transparent as glass, so that it is possible to actually see what they are feeling. Though their spoken language only contains fifty-two actual words (as the cold prevents them from being more verbally communicative), the Icelandic people are quite proud of their prosperous island country.

Historical Background:

Before its independence, Iceland was, at one time, under the rule of Norway and then Denmark. In the year 928, the revolutionary battle between the people of Iceland and their Danish rulers, known as the Quietest War, was begun. Iceland was then mostly a series of small, unknown fishing villages, many of which had never been mapped. When the Danes returned in the winter of 928 to collect taxes from their conquered Icelandic subjects, they demanded a young Icelander named **Magnus Ragnheiðr** draw a map of his country to expedite their conquest. In an uncanny act of courageous revolt, Magnus Ragnheiðr sketched a false atlas instead, in the hopes of deceiving the bloodthirsty Danish army. As the Danish Vikings trudged through the wintry landscape, searching for rich villages to plunder, they found themselves unprepared for the brutal weather they encountered. One by one, the Danes began to perish. Along the route of this deadly march, Magnus Ragnheiðr had built a number of miniature villages—constructed entirely out of ice, twigs, and snow. Due to the shifting perspective of the voluminous flurries and the rugged winter terrain, the effect of these dioramas was quite convincing. When the Danes drew closer to the minute, false towns, they realized, all too late, the Icelanders' ruse. Following imaginary paths to invented ice villages, the conquering Danes finally discovered that they were lost. The remaining Danish Vikings then turned on one another, before wholly disappearing beneath the silent veil of a truly vicious snowstorm. Today, the celebration of Magnus Ragnheiðr's ingenuity and the noiseless war which he singularly waged is re-enacted each December 1, in a national holiday known only as **Ice, Twig, and Snow Day**.

Soon thereafter, in the year 930, the Icelandic people created the world's oldest functioning legislative assembly, the **Althing**. Magnus Ragnheiðr was its first laplig or secretary. Magnus Ragnheiðr is likewise commemorated on the most valuable Icelandic coin, the **Fjordragnheiðr**, which is roughly equivalent to a United States quarter.

Iceland has since then enjoyed quiet prosperity throughout most of its existence, with the exception of a number of volcanic eruptions, the first occurring in **Askja** in 1875. Askja had been previously thought to be dormant until an avalanche of ice buried the nation's former capital, **Olafur**. Remarkably, most

citizens of the capital were unharmed by the eruption, though their city had been hidden beneath a translucent barrier of impenetrable glacial snow and ice. For nearly eight years, the people of Olafur survived as an independent colony, living quite happily within their glassy fortress. A number of interesting inventions were borne out of this terrific event: Industrious though very tiny horses were bred to navigate the narrow passageways which had been tunneled through the ice. These miniature horses would later be matched with a line of British fox-trotting ponies to create the world's smallest adult horse, the **Icelandic fox-trotting breed**. Of equal importance was the underground city's social customs. Citizens of Olafur often found themselves stooping to pass one another in the cramped passageways and it is now suggested that this was the first place in the world where people had formally begun to **bow** to one another as a sign of respect and welcoming.

In the year 1900, a subsequent eruption of Askja devastated the entire nation of Iceland. The subterranean capital of Olafur was buried once again in a tremendous wave of killing sleet and ice; this time, unfortunately, there were no survivors. The city of Olafur's population was immediately frozen in place. Ice mixed with volcanic ash combined to create a permanent tableau of horror. The ice city of Olafur is now visited by hundreds of thousands of tourists each year. It is possible to see the remarkably human activities that each of these frozen citizens, at the moment of their deaths, were performing—everything from sweeping to sewing to praying to gutting petrified fish.

After the second eruption of Askja, nearly two-thirds of the island nation of Iceland found itself buried in volcanic debris. In the spring of 1901, as the snow and ice began to recede, the still-frozen bodies of several thousand people and animals were discovered in a number of unlikely places—high atop trees, in haylofts, wedged into neighbors' chimneys. One such corpse, a full-grown horse, had been left atop the narrow steeple of St. James Cathedral in **Halsuk**. The horse, now fondly referred to as **Goldie,** was later cast in gold and is, to this day, a Halsuk landmark.

It is also a little known fact that the **world's first spiral staircase** was built sometime during the late nineteenth century in **Reykjavík**, Iceland's current capital; forensic architects believe the year of origination to be 1865 or 1866. In the city of Reykjavík, all staircases are now required to be spiral. Over the years

of their wonderful history, the people of the capital city discovered that spiral staircases make the most lovely entrances and the most enchanting exits, and in 1903 a city law was passed officially mandating their use.

During the next century, there was a large emigration from Iceland to **Canada** and the **United States**, equaling nearly twenty percent of the island's population. Fear of future volcanic eruptions, famine, and economic depression were all common causes of emigration. Intrepid Icelanders, desperate to escape cruel conditions, were known to build small sailing vessels out of suitcases and trunks, with masts assembled from abandoned furniture and other debris. Oftentimes, these tiny makeshift ships, called **Fluevðrs**, would safely reach their destinations, with mainsails expertly crafted out of heavy quilts and winter blankets.

Today, Iceland's literacy rate is among the highest in the world. Icelandic literature is often concerned with topics most other Western Europeans can hardly imagine. Tales of ice fairies and ice princesses abound. Unlike most contemporary works of literature, it is part of the Icelandic tradition that the hero or heroine of the novel—at the end of the work—usually dies by drowning. The most famous and longest Icelandic novel ever written is ***Magnus*** by **Kurt Vullholing**, a seventeen-volume historical retelling of founding father Magnus Ragnheiðr's life story. It includes a detailed appendix of each of Magnus Ragnheiðr's descendents and a thrilling account of his daily health and diet regime, which involved the consumption of an almost unbelievable amount of whale blood.

Iceland's current economy is supported by a prosperous fishing industry, by abounding tourism, and by a thriving, state-subsidized **mannequin industry**. Icelandic mannequins are some of the most detailed and provocative mannequins in the world. Icelandic mannequins are almost immediately recognizable by their nine fingers instead of ten. The final digit on the left hand is always left missing as part of an old Icelandic superstition that prevents these statues from coming to life.

Today, most Icelanders enjoy a relatively safe middle-class existence with all the same trappings of capitalism, commercialism, and consumerism that their mainland European neighbors take pleasure in, though the threat of both earthquakes and volcanic eruptions is a constant.

Location:
Iceland is located in the arctic region, both north and west of the **United Kingdom**.

Geographic Coordinates:
65°00 N, 18°00 W

Area—Comparative:
Iceland is about the size of any large United States airport.

Climatology:
Iceland's weather is generally frigid. It is so cold so often that most Icelandic women tend to wear their hair cut short for fear that their tresses will break off at the root, leaving blond braids in their lovers' large, gloved hands. Most winter months, the freezing temperatures force the Icelandic people to sleep for extended periods of time, closing down schools and businesses for the entire winter season. An Icelandic adult may sleep up to five months per annum, while Icelandic children enjoy up to ten months of rest each year.

Wildlife:
The only native Icelandic mammal is the **arctic fox.** Today, this animal is usually hunted for its soft fur, while its teeth are ground up and mixed with licorice liqueur to create an aphrodisiac.

Other forms of wildlife are the snowy egret, whose numbers have begun to dwindle due to the expansion of a voracious Icelandic salt industry, and the arctic trumpet-billed wood duck, the national bird of Iceland featured in many folk songs and nursery rhymes.

Capital:
The capital of Iceland is Reykjavík. Its longitude and latitude are: 64°08 N, 21°56 W. It is a city made almost entirely out of glass. Each staircase in Reykjavík is spiral in design.

The tallest building in Reykjavík is called the **Gísladóttir.** Its brilliant crystal antennae turn bright blue each evening at precisely the same time, which signals the end of the Reykjavík work day.

The arrival of the new year is the most important event for the people of Reykjavík. They spend large sums of money on fireworks, most of which are set off as midnight approaches. Every year there are a number of unfortunate deaths associated with these enormous firework displays, which adversely affect Reykjavík's typically low crime rate.

Terrain:

The geography of Iceland is mostly plateau interspersed with volcanoes, mountain peaks, and expansive ice fields. Iceland's coast is shaped by a number of bays and **fjords.** A fjord is a narrow inlet, which due to the season and weather patterns may vary greatly in size and depth. Fjords are most useful to Icelanders as a source of minerals like salt and sulfur. At one time, entire mining towns were built along these fjords, and each spring as the snow melted and the ice thawed, the fjords would grow, rising steeply along the banks. In summer, these tiny mining towns would vanish beneath the surface of the water, and would then reappear in the fall. Several buildings and houses were built with two entrances, an elevated entrance for the summer months when the fjords would rise, and one for the winter months at the base of the building, when the fjords would be low. The five most important fjords of Iceland are:

> Hvalfjörður
> Skagafjörður
> Ísafjarðardjúp
> Eyjafjörður
> Húnaflói

Elevation Extremes:

Lowest point: Atlantic Ocean, 0 meters
Highest point: Hvannadalshnukur, 2,110 meters (at Vatnajokull Glacier)

Natural Resources:

Iceland's greatest natural resource is its abundance of fish—chiefly cod and whitefish. Fishing is both the nation's oldest industry and the most financially lucrative, even today. Fish are used for much more than just food. Fish eyes are essential to the Icelandic medical industry in the treatment of skin lesions, while fish oils are used to lubricate intricate machinery. Iceland's other natural resources include a profusion of sea salt, which is deposited along its coasts in enormous drifts, and volcanic gases, which, when properly excavated, are used in the creation of a famous Icelandic soft drink.

Natural Hazards:

As Iceland is fraught with innumerable fault lines and over ten thousand volcanoes, its most dangerous natural hazards are both earthquakes and tumultuous volcanic activity. Iceland's last earthquake was in 1989 and registered a .60 on the Richter scale. After the initial shockwaves, which forced a number of buildings in the capital of Reykjavík to shift dangerously from their foundations, a second earthquake called a "twin" or "echo" of equal, opposing vibrations, immediately returned the same buildings to their original, intact positions.

The most recent volcanic eruption in Iceland took place in 2002, when the **three volcanoes at Laskard** exploded without any forewarning. As the volcanoes were thought to be safely inactive—each crater filled with a vibrant blue lake— their subsequent, coordinated eruptions caused a widespread national disaster. A cloud of bright green smoke hung above the island for a full year afterwards, raining down bits of debris and sulfur on an unsuspecting public. The Icelandic government issued protective safety suits, ingeniously designed with matching helmets, oxygen tanks, and gloves, for all of its citizens' use, young and old alike. As late as 2005, many Icelanders continued to wear the plastic safety clothing, until a formal announcement issued by the government informed them of the Icelandic atmosphere's apparent safety.

Population:

299,388 (July 2008 estimate)

Culture and Customs:

One of the most striking features of Icelandic culture is that men often wear their facial hair in elaborately fashioned mustaches and beards. Each year, in March, a national contest is held for the most original beard in Iceland. Afterwards, the winner is considered a national celebrity and is featured in a number of tourist advertisements for their island country. The women in Iceland usually wear their winter gloves year round and, because of this, their skin is unimaginably supple. When an Icelandic woman removes her gloves in public, male observers will sometimes cry out, *"Dus!"* an Icelandic expression which relays the beautiful shock one experiences from the unfamiliar sight of such loveliness.

Most Icelandic cultural events and customs are based on the terribly quiet joy one feels moments before or after an earthquake or volcanic eruption. Though it may be hard for us to understand, Icelandic people love the complex and often destructive nature of their small island nation. In popular songs, Iceland is usually referred to as "the mistress you wish you never met, but certainly can never forget." Why do these Icelanders love their imperfect little country when it has so often been the source of unending misery? Why choose to live among volcanoes, in desolation, with weather that is almost impossible to endure? Why be forced to contemplate the terror of being buried alive by an earthquake that will certainly destroy everything you hold dear before too long? Why love anything?

Airports of Light

illustration by
kozyndan

One sad story: Paul and his girlfriend Elizabeth are in their compact car arguing when it first happens. When it first happens, they are arguing about who is singing the pop song now playing on the radio. Elizabeth knows she is wrong but hates to admit it because of that stupid look Paul gets on his face, and at the end of the song, when the deejay announces the title and the name of the artist, he nods once and cocks an eyebrow in such a way that makes her roll her eyes and laugh at what a total retard he is. "I was right!" he shouts, grinning. "I am the master! I rule you and the world and everything." Elizabeth stares at him for a moment; his face is not as thin as it used to be, his cheeks are covered in a few

days' growth of blond whiskers, and his jacket has a tear along the elbow. She looks at him as if she is meeting him for the fist time. She decides she is still really in love with him. She turns and stares out the passenger's side window at the city moving past. Suddenly she becomes aware that something is very wrong. She is no longer breathing properly. Her heart has stopped beating. The corpuscles in her veins are somehow failing. Her body tenses, her limbs becoming loose and nearly lifeless, her eyes open wide as she struggles to take in another breath. Paul has not noticed yet. He is still celebrating his small victory. By the time he glances over and turns down the radio, pulling out of traffic, a strange thing has begun to happen. White light—small white lights—have begun to glow in the absolute center of Elizabeth's chest, and her screams, rising from her open mouth, sound far away, like she is falling through clouds.

At the emergency room, tests are run, a doctor from Calcutta is called in, and after some four hours, a diagnosis is made. It turns out that although she is only thirty-three and otherwise generally healthy, Elizabeth has developed a terrible disease. A tiny city has begun to grow in the narrow confines of her precious bloodstream, the miniature buildings and citizens monopolizing the general vicinity surrounding her chest cavity. The doctor from Calcutta, a thin man with a beard and dirty glasses named Dr. Lahksman, orders many, many X-rays. Soon, Paul and Elizabeth discover the strange shape of the malignant formation perfectly matches the map of a modern city from the early part of the twentieth century.

"It doesn't look good," the doctor remarks. "I would say it's maybe 1900, 1910. Listen and you can hear the streetcars."

Paul places his head beside Elizabeth's chest. "My God, there *are* streetcars," he says. "And . . . there seems to be a church service . . . I hear an organ and people singing. No, they're praying . . ."

The doctor nods. "Yes, she's already 1910 or 1915. That's bad."

"What does it mean?" Paul asks.

"The city only has coal now, but soon it will have electricity. Those were the lights you saw. That strange feeling you described." Dr. Lahksman wipes his forehead with a small white handkerchief. "Someone in there must have finally discovered electricity. Soon the lights will come on and not turn off."

Elizabeth's blue eyes close. "What are you saying?" she asks. "That this city . . ."

"Not a city. It's a tumor with the properties of a city," the doctor corrects.

"That this tumor, it can't be operated on?"

"Oh, heavens no," Dr. Lahksman says. "Very soon there will be skyscrapers."

"What?"

"Do you see this?" the doctor asks, holding up an X-ray, his brown finger pointing at a tiny white speck.

Paul squints, Elizabeth leaning in beside him.

"What is that?" Paul asks.

"That, sir, is what I'm guessing will soon be a factory. Do you see the shape there? You can almost make out the smokestacks. At some point very soon, the tumor will certainly become industrialized, yes? Better roads, more poisonous factories, and the advent of skyscrapers, airports, tiny automobiles. When this industrialization happens, when the city becomes that busy, you will die, almost immediately. At this rate now, you have maybe two or three hours, I believe."

Elizabeth lowers her head against Paul's coat and begins to sob. She cries for what feels like a lifetime, and when she looks up, Paul is weeping silently beside her. The doctor has disappeared and the flickering white lights of the emergency room mimic the strange flashing which continues to pulse behind Elizabeth's white blouse. Suddenly, she sits up and begins to whisper something: a song. Paul stares at her as she wipes her eyes and hums a quiet little tune. *"I let a song go out of my heart,"* she mumbles in a soft, melancholy voice.

"What are you singing?" Paul asks her.

"I don't know. I just made it up," she says. "It just came into my head."

He places his ear against her chest again and listens. "No, no, it's a song from in there. It's . . . Duke Ellington maybe. I really can't tell."

"Oh," is all Elizabeth says.

In the hospital room, Paul and Elizabeth hold hands. The flash of the TV, which hums without sound, gives their faces a soft glow. Elizabeth has pulled the blanket up to her throat, clouding the busy flickering of the tiny city lights. Outside it has begun to snow and both of them consider this will be the last either of them will

watch the snow falling together. Everything stupid has become meaningful now. The last cupcake with white frosting she will eat. The last pair of socks she will put on. The last cup of hot chocolate she will drink. The last time she will burn her tongue drinking hot chocolate. The last time she will worry about burning her tongue. The last time she will sneeze. The last time she will have wet hair. The last time she will think about getting old. The last time she will go to sleep. The last time she will dream a dream.

While Elizabeth's IV is being changed, Paul heads outside and returns with a handful of snow. Silently, they sit and stare outside, both of them quietly eating the snow, unable now to say or do anything without thinking of the same terrible, unfair thing.

Later, wearing a sad gray tie, Dr. Lahksman comes to visit. It is well past midnight and Elizabeth has finally fallen asleep. Paul is sitting in an uncomfortable vinyl chair by the window, watching the snow fall, when the doctor steps inside. Paul blinks up at him and does not even bother to smile.

"She is asleep?" the doctor asks, standing at the foot of the hospital bed.

"I think so. She didn't want to go to sleep."

"Yes," the doctor says. "That is understandable."

Paul nods, staring down at his hands. He thinks he would like to murder this doctor, he would like to go out and kill somebody, but then he softens and thinks it is not this doctor's fault. It is no one's fault unless it is everyone's fault and Paul is too tired and too heartsick to consider that.

"You love her, this girl, yes?" the doctor asks.

Paul nods. He is too full of something—grief, guilt, fear, pain, take your pick—to even answer such a silly question with words.

"You do not want to watch her go, do you?"

Paul shakes his head—oh God, he has begun crying. He notices the doctor's eyes are rimmed with tears as well.

"You do not want to watch her go because you love her so much, isn't that true?"

"Yes," Paul mutters. "Please," he gasps through a mouthful of tears, though he knows the answer already, "isn't there anything?"

The doctor takes a step forward, moving into the drowsy light cast by the television. He slowly removes his glasses, folding them into the front pocket of his white smock.

"If you have decided that you cannot watch her go, if you know now you cannot do without her, then there is a way."

Paul feels a start of terror strike the softness of his heart. "I can't watch her go," he says. "I can't."

The doctor nods. He regards Paul once more, measuring some unseen line, some unseen mark on the younger man's face.

"Yes, well, then, there is this," he whispers and, very slowly, lifts his dark hand, the palm placed upward, in which lays something white. Paul stares at it, his eyes worn and clouded with tears—is it a note? A pamphlet? Paul blinks and then steps forward to look at it closer, and sees it is a worn-looking paper ticket, a voucher of some kind. There are smudged letters and numbers, maybe the name of an airline, a departure time perhaps, but he is unable to make out anything specific.

"What is it?" Paul asks, his heart pounding.

"If you want to go with her, you can," the doctor says. "Look," he whispers, pointing at Elizabeth's unsteady chest. "Look here." The doctor gently moves the blue blanket aside and points. Paul leans in close to his girlfriend's chest to see. There, just below her breastbone, faint beneath the thin white material of the hospital gown, are the lights, the many microscopic lights, a perfect pattern blinking on and off together in time. Paul is amazed—concerned and terrified but also amazed—as the doctor places a hand on his shoulder and declares, "Skyscrapers. All along her heart. It won't be long now."

Paul can feel the tears on his face before he recognizes that he is crying again.

The doctor gives Paul's shoulder a supportive squeeze and says, "In a few hours, the first airport will be built in that tiny city. Then another. Then a third. There is a way for you to board an airplane and land there, in that tiny city, but you must hurry. If you wait, if you hesitate, she will be gone before the plane can land. You must not wait. The ticket is yours. It is in your hand."

Paul glances down at the voucher and then up at the doctor's resigned face.

"But what if she wakes up? What if she wakes up and asks where I am?"

"I will tell her everything."

"But what happens when I get on the plane? I mean, what's going to happen?"

"Do not ask any other questions, young man," the doctor warns. "Only go if you are to go."

Paul nods, forgetting his coat, then turns, pulling it on as he dashes through the door and down the hall. *Where is the closest airport?* he wonders. *What is the quickest way there?* He climbs into the compact car and backs over a curb, sliding recklessly out into traffic.

But, of course, the traffic does not oblige him. Everywhere the lanes are full of other automobiles, the snow making the driving very difficult. Paul tries to swerve around a station wagon, but seeing the children inside singing along, clapping, he tries to be patient, waiting for the light to turn green. It does not look good. The highway, the on-ramp, the avenue, all are crammed with choking cars, the lines of their taillights flash, unmoving in the white haze of the snow.

Before long, Paul realizes he has lost too much time, he cannot possible make it. He is too far from the airport and still not very far from the hospital. He begins to drive on the wrong side of the street, hurtling past the traffic. He pulls the battered ticket from his pocket and stares at it. *Has it gotten smaller? Has it begun to fade?* Paul is not sure of anything now.

Eventually, he bolts around a stalled taxicab and into the airport entrance, then leaves the car running in the lanes designated for arrivals. He runs, stopping himself once, looking over his shoulder to see the headlights of his car still glowing. Past the ticket counter and security, he hustles through a long line and down past the blue carpeted gates, matching the number *8A* on his ticket to the numbers which disappear as he moves by them. There are no other passengers, of course, waiting at gate 8A. There is a pretty young lady in a blue uniform, who Paul runs up to, offering his ticket as he struggles to breathe. She smiles, types something, then hands the ticket back to Paul and says, "You just made it, sir. We've already begun boarding."

Paul nods and stares at the open doorway, the gate which leads outside to an enormous white jetliner, and seeing it, seeing the airplane, he stops in his tracks. *None of this makes any sense. How will this work? How can this possibly work? What's going to happen if I get on that plane? What's going to happen to me?* Paul turns and looks at the young lady who is urging him on with her eyebrows, frowning.

"Sir, we're ready to take off. If you're going to board, you need to board now, sir."

Paul keeps staring at her. What does he see? He does not know. He does not see a young lady. He sees something else, something like the shape of a person, but right now he is too panicked to see anyone but Elizabeth, her hands, the shape of her face. Desperate now to be with her, to hold her, to watch her mouth as she laughs, desperate to be anywhere but here, he doubles back. He finds the car still waiting there, the motor running. When he turns to look, the airport begins to fade. The lights along the terminal, along the landing strips, have all gone dark. Paul hurries into the car, pulls off, and finds the traffic more cooperative this time. He rushes back to the hospital, leaving the car in the wrong parking lot, ignoring the parking attendant. By the time the elevator carries him to Elizabeth's floor, she is awake, sitting up in her bed and smiling. She is drinking orange juice through a straw and she winks when Paul bursts in.

"I thought you made a break for it," she says, smiling. Paul forgets for a moment that she is sick. Her smile is so warm, so convincing.

"I'm sorry," he says. "I . . . I didn't make it."

"I know. Dr. Lahksman told me."

"No. I missed it. I missed the plane."

"I know," she says. "It's all right. Don't worry, it's okay." She sets down the plastic cup of juice and smiles wider now, blinking her eyes at him.

"No, it's not okay. It's not okay."

"Paul, it's okay. It's going to be okay. You'll see."

"No," he says. "No, it's not."

She looks at him as if she is going to kiss him but does not. Instead, she takes his hand and places it over her chest, right above her heart. Paul momentarily shudders as he feels something hard, something sharp, the point of something

poking beneath his palm. He glances up questioningly, his eyebrows rounded. She smiles again. "It's a skyscraper," she says, almost proud. "A tall one. It must be like the size of the Empire State Building."

Paul does not remove his hand. He leaves it there, peering at her, nodding.

She closes her eyes, smiling, and says, "It's going to be okay, Paul. You'll see. You have to trust me. It's going to be okay." He nods as she holds his hand against her chest and quietly starts to sing: It's the same song from earlier, the Duke Ellington one. *"I let a song go out of my heart,"* she whispers, placing her head against his shoulder. Together, staring out the window, they watch as the snow begins to fall once again. Paul looks Elizabeth in the eyes and suddenly begins to whisper along.

Winter at the World-Famous Ice Hotel

illustration by
Laura Owens

At midnight, as the mirrored clock in the hallway struck, at a time when other children of that age were already asleep, young Henry, eight years old, recent transplant to the metropolis, lifelong lover of comic books and astronomy, and generally the silent boy ignored by everybody, was the only child still present at the Goldmans' annual non-denominational winter party. His mother, Joyce Vanhoose, a recent divorcée, a former Washington, D.C. publicist for many scandal-afflicted clients, a former art curator whose greatest show was *Hairpieces*

of the White House, which brought President Jefferson's lecherous, powdered wig to the light of the adoring public and was well-received by just about everyone, a former advice columnist, a former "just about everything," with her brand-new nose and matching chin, this Ms. Vanhoose was draped over a strange man on the Goldmans' white leather sofa, and laughing, laughing, laughing wildly.

The man, a near stranger who had strong, dark hair and was wearing a black harlequin mask, held Henry's mother's silver shoe in his hand, right up to his ear, and talked into it. "Hello, hello, is Joyce in?" the man asked, and Henry's mother let out a high-pitched, crackling laugh. She patted her chest, indicating the open window shades of her heart, knowing full well the divorce papers had not yet been signed, but nonetheless languorously inviting the stranger in. "Hello, hello, is Joyce there?" the man asked again.

"Yes, she is," Henry's mother said with a wink.

"Well, how are you this evening? Are you having a nice time?"

"Don't ask me that," Henry's mother said, slapping the strange man's thigh, resting her white hand on his black pants. "Ask me something more personal, something daring."

Henry, staring at his mother carrying on, stood beside the clock, frowning. Here was a boy, a budding astronomer, horribly in love with only the most impossibly distant things. Planets, moon, stars, constellations, galaxies. He regarded his mother with these same feelings. To him, she was just another lone, faraway, luminous object he watched from the confines of earth, which is what she preferred, to be honest. Tacked on the ceiling of the boy's room was the only token of her affection, a lovely blue-and-white poster of the nine planets and their orbits, and in the way other children his age might pray to angels or saints, Henry spoke to these constellations, their round shapes and happy faces peering back at him, the boy glad for their enduring advice. The planetoids would reply with very moral aphorisms, as they were, themselves, handmade decorations of the oldest order of thought. Typical dialogue between Henry and the stars would be:

"I did poorly on a spelling test today."

"Henry, do not forget your father is gone now and your mother is very sad, so you

must try hard to do your best. If you do not do your best, Egyptians will creep into your window at night and murder you while you're asleep."

"A girl at my school pushed me and took my lunch. Then I got in trouble for forging my mom's signature."

"That is too bad, Henry. But you must know how it is very bad to lie. And liars are turned into pillars of salt, inevitably."

"A man followed me to school yesterday."

"Be wary around strangers, Henry. Do not go into their automobiles or vans or they will certainly cut off your head and hands and then you will deserve what you get."

More than with their advice, Henry was quite fascinated with the end of this universe, the annihilation of all these planetoids he had so carefully studied. It was clear, even from an amateur's standpoint, that the solar system was, each and every moment, drawing closer to its own demise. That someday, perhaps not too far off and distant, these spheroids, these lights hanging in the sky, would explode and shower upon one another their milky magnificence, and mankind, as a result, would itself be snuffed out permanently, all in the blink of an eye. It was quite simple, really. Total obliteration was the way these things worked, or so it seemed.

Henry now stood watching, feeling embarrassed as the strange man cooed into the silver shoe and slapped his mother's bare white thigh. Yes, other parents had left hours ago, dragging their broods home, bundled up in white mufflers and gaudy fur overcoats, the Whitmans, the Reynolds, the Friedmans, with their children, gone, all gone. Henry stood at the corner of the parlor, raising himself up and down on his tiptoes, trying to, again and again, maintain his mother's attention by clearing his throat, but no, that ploy did not work either. Joyce was sloshed, blotto, well past her limit, as were the rest of the remaining attendees, most of them lounging on the white pillows, blinking with sappy, blank eyes and cavernous mouths charged with cigarette smoke. A record was playing, a jazz record with a lewd-sounding trumpet that kept insinuating itself, just as the man kept rubbing Henry's mother's soft white shoulders with his unbelievably hairy hands. At the corner of the room, near the hi-fi, was a garish black-and-gold leather ottoman, on which Henry finally took a seat, burying his face in his hands,

moaning audibly, until the front door to the apartment opened with the quick clean sound of the mechanism's surprise.

Henry looked up and saw a flush of white and light blue fur hurry past, a girl in a silver stole, a fluffy hood covering her small head. The girl moved directly through the center of the parlor, almost disappearing down the hallway toward the bedrooms before Mrs. Goldman, with a voice like a wind-up toy clown, clapped and pointed, losing her balance on the sofa as she said: "Oh look, everyone, Silvie's home. Look, here she is. Hello, Silvie, hello, darling." Mrs. Goldman, reaching out to kiss her daughter, knocked Mr. Goldman's highball, spilling it slightly, then whispered, "It's only soda water, Hal," grasped the young girl's face, and kissed it. Mrs. Goldman gently lowered Silvie's hood and planted kisses on each of her cheeks. From the corner of the room, Henry sat up and observed the girl—older, a junior high schooler, her small chin, great brown eyes, and soft brown tresses in a glossy pixie cut—and all at once, he thought he understood the ache of loneliness felt by all of his favorite superheroes.

One particular panel came to Henry's mind: the daring Emerald Falcon in deadly pursuit of a misguided rocket aimed at the heart of the city, flying past a fancy restaurant in a mesmerizing green blur, catching sight of his love interest, Darlene Rogers, star reporter, alone, heartbroken, waiting, the Falcon, having decided on saving the city over saving his heart, now knowing that never would it be anything but hopeless between the two of them.

"But why are you home, darling?" Mr. Goldman asked, mixing his cocktail with his middle finger.

"There was trouble at the Castles'." The girl spoke with a dramatic affectation, like she was rehearsing lines. She inched toward the hallway.

"Trouble?" Mrs. Goldman asked. "What kind?"

"Mr. Castle's secretary called the house very late," Silvie said with a sigh.

A knowing nod circled the room like a musical idea.

"It's no wonder—" some wife started to say, then stopped, a husband pinching an arm quickly.

"Mother," Henry finally said, speaking up, pulling on his mom's stockinged foot, "I'm tired and it's late. May we leave?"

"Just a few minutes more," Ms. Vanhoose said with a delirious smile. "You know we don't get to the city nearly enough and . . ."

"If you're tired, darling, why not go and lie down in the guest room?" Mrs. Goldman said, patting the boy on the head. "Silvie, be a dear and make it up for him."

"*Mother*," Silvie replied, stricken, sipping from her mom's drink.

"I'm not tired enough to sleep," Henry muttered, blinking his eyes. "I'll just wait."

"Oh, be a good girl, Silvie, and entertain poor Henry."

Silvie stamped a little, then pulled off her white stole and dropped it on the floor. "I would have stayed at the Castles' if I knew I was going to be treated like a servant," she hissed.

"Are you hungry, dear?" Mrs. Goldman asked. "How about a little snack?"

"Okay," Henry said.

"Silvie, go make the boy something."

Silvie huffed and turned and Henry followed, entranced by her small silver slippers, slippers that had tiny blue-and-white bows. Silvie practiced as she crossed the room, pitter-pattering along the carpet in quick dance steps.

"Are you a ballerina?" Henry asked.

"Yes," she replied, "everyone I know is. Aren't you?" She switched on the light in the silver-and-white kitchen and yanked the refrigerator door wide open. From the parlor, a grown-up laughed, the sound of it like a fireplace bellows wheezing. Henry leaned back, staring around the corner of the room, and noticed his mother had gone missing.

"Everyone I know who is worth knowing is involved in the world of dance, don't you agree?" Silvie continued.

"I don't know," Henry said. "We've just moved here."

"Oh, I see," she said, very grown-up too, now. "Well, what would you like to eat, dear boy?" Silvie stood on her tiptoes and pirouetted once, then finished with a plié just for show. "There is, of course, snow."

"Snow?"

"Yes, of course. Don't you eat it at your home?"

"No, we don't," Henry said.

"Well, you really must try it." She reached into the freezer and took out a silver container, lifted off the lid, revealing a white frosting of ice, then took two white bowls out of the cupboard and scooped out two large dollops, depositing one in each dish. Henry stared at the bowls on the silvery counter suspiciously.

"That's not ice cream?" Henry asked, blinking, squinting. "Because it looks like ice cream."

"My dear, dear boy, don't be ignorant," Silvie said. "We only eat snow."

The boy began to eat. He stood at the silver counter and heard the front door open and then close, and was reminded of a sound he would never hear again, that of his father coming home. Henry's father, a tall, silent man with soft blue eyes and a dent in his chin, had simply vanished from them without explanation. He had disappeared from their lives, but in a way that was so silent, so without circumstance, that it terrified the boy with its complete lack of warning. One moment the father was sitting in his wooden and leather den, smoking his cherry-wood pipe, and the next he was gone forever. He left on a Wednesday, which upset Henry terribly with its complete lack of order. The father simply opened the door, walked out to the garage, started the new car, which was the latest source of connubial trouble, put his hand against the frosty window, backed out of the drive, and just drove away. It was all as soundless and meaningless as the night coming or going.

The party whirled on, the patrons getting more and more unhappy. The boy soon found that Silvie Goldman, unlike anyone he had ever known, had been given everything she had ever asked for. For example, instead of a bedroom, Silvie Goldman had an igloo. Everything in the room was made of crystal and chiseled glass. Her bed frame was a series of icicles dangling from the ceiling with a frosted white canopy, the carpet was lush and white and furry like how Henry imagined a polar bear skin might be.

"Your room is nice," Henry said, standing in the doorway.

"I know, I designed it myself." Silvie tossed herself on the bed, disappearing into the fluffy whiteness.

"Your mom let you do this?"

"She lets me do whatever I want. And she's taking me to the ICEHOTEL in February."

"Oh," Henry said, nodding.

"Do you know what that is?"

"No."

"It's a hotel in Jukkasjärvi, in Lapland, just above the Arctic Circle. It's made of ice."

"The whole thing?"

"Yes, the whole thing, and my father and mother are taking me. There's also an ice church and a movie theater with an ice screen." Silvie lifted herself off the bed, walked over to her glass bureau, lifted out a white-and-blue postcard, and handed it to Henry.

In the photograph, children bundled up tight in white winter coats were smiling, riding atop a shiny silver sleigh made completely of ice. Behind the children was an amazing silver-and-white structure like a church formed out of gigantic snowflakes. "We're all going in February."

Henry stared at the silver picture and smiled. "It's wonderful," he said, imagining the sound of the sleigh bells ringing. It reminded him of what he imagined when he thought of cities on some other world, some other planet.

"You can come with us, if you like," Silvie said. "You and your mother. I'll tell them I need a new pet and you can be it."

"She'd let me come?"

"But only as my pet."

Henry looked at the postcard again, troubled. "Why doesn't it melt? How come it doesn't break?"

"It's too cold. Everything freezes," she said.

"But doesn't it ever melt?"

"In spring," she said. "But then they start building it all over again."

The boy glanced at the postcard once more and thought of a place so cold that everything could be frozen, that nothing could move, that nothing could ever change, until spring arrived, when the rest of the world would be ready. Then the men, the horses, dragging the great blocks of ice together to rebuild it all over

again. It seemed perfectly wonderful, the idea of it. "I'd like to go there," Henry said.

"Fine, it's settled then," Silvie said and sat beside him, patting his head like a puppy.

As it turned out, one of the adults had stolen Henry's mother's shoe. Some of the men now had red dinner napkins tied around their heads. Henry's mother was arguing with one of them.

"Please give me back my shoe."

"Not without a kiss."

"Don't be unreasonable," she said.

"*You* don't be unreasonable," the man countered, puffing up his red lips. "All I'm asking for is a kiss."

"Just one kiss," Henry's mother said. The man nodded, adjusting his blindfold. When he did, Henry's mother could see a fleshy pink bald spot at the top of his forehead. She closed her eyes and put her lips together tight and hoped this kiss would be wonderful, that it would be magic and fireworks and the kind of kiss that changes everything.

It was not, not even remotely.

At the foot of Silvie's enormous white icicle bed, Henry began to fall asleep. Once or twice, Silvie kicked, already dozing off, her foot covered in sheer white stockings, tapping very gently against his ear, until he was happy she was doing it, the feeling of it soft, accidental, and then she was snoring, and soon his eyes got heavy. He stared up at the glass icicles above his head, hoping, praying Silvie had not been lying about the hotel. If she had lied about him going on the trip, well, that was all right. But the hotel had to be real. It had to be. If there was a hotel made of real ice, a hotel of ice that did not melt, where people could visit and sleep, and then if they could rebuild it, every year, if every year it could be rebuilt, well, then there could be a possibility for anything, a reason to believe that right now was not the end of everything. But he was still very unsure. He turned and folded his head into his arms and felt himself crying for no real reason, then felt

ashamed for being so stupid, such a dumb kid, and he placed his hand on Silvie's foot and almost immediately fell asleep and started dreaming.

Their mothers stood watching them. "They're asleep," Mrs. Goldman said. "Aren't they angels sent from heaven? Aren't they?"

Henry's mother watched her boy's eyes twitch gently as he breathed so heavily. She carefully leaned down and lifted him, Henry still sound asleep, like all the citizens of the world, having no idea he was actually moving.

In the passenger seat of his mother's Saab, Henry awoke with a start. He opened his eyes slowly and saw the glowing white lights of the bridge float on by. In the driver's seat, with her white furry hood pulled up, Henry's mother was silent. Henry stared for a moment, then turned his head. He glanced out over the bridge. It seemed the entire city was made of ice and snow—the silver panes and frosted glass shining like crystals rising into the dark night sky—and that at any moment it might all be gone, and then what? What would happen to them all?

"Can I call Dad? On Christmas?" Henry asked suddenly. "I'd like to tell him something I found out tonight."

"If you like," Henry's mother said. "Yes, okay."

He turned and took a look out the back windows. The city was still there standing. Beneath them, the bridge was steady. At that moment, he felt he was not afraid of anything.

CONTRIBUTORS

Todd Baxter was born in Albuquerque, New Mexico. He is a photographer whose work has been featured in a number of galleries and in a variety of print ads. He now lives in Chicago.
www.baxterphoto.com

Kelsey Brookes was born in 1978. A formally trained scientist who spent years tracking viruses for the U.S. government, he now lives and works in San Diego as a painter. He blames his raw, anxious form of art on the U.S. university system, which refuses to teach its scientists how to draw.
www.kelseybrookes.com

Ivan Brunetti lives and works in Chicago. He is the author of *Misery Loves Comedy* and the ongoing *Schizo* series (both from Fantagraphics Books). His comics and illustrations have appeared in the *New Yorker,* the *Chicago Reader,* and *McSweeney's.* He is currently editing the second volume of *An Anthology of Graphic Fiction, Cartoons, and True Stories* for Yale University Press.
www.ivanbrunetti.com

Charles Burns is an award-winning cartoonist and illustrator who lives in Philadelphia. He is the creator of the Harvey Award–winning graphic novel *Black Hole,* as well as the works *Big Baby* and *Skin Deep.*

Nick Butcher is a painter, poster artist, and musician. He is also a beach comber who lives in Chicago.
www.programmablepress.com

Steph Davidson was born in Toronto, Ontario. She attended the University of Western Ontario for Visual Arts and currently resides in Toronto.
www.prettyempty.com

Evan Hecox is an artist and graphic designer who has become known largely through the subculture of skateboarding, having produced hundreds of skateboard graphics since 1997. He has also emerged as a fine artist and has shown his work in galleries in the United States and abroad, including solo shows in Seattle, Los Angeles, and Tokyo, and group shows in San Francisco, Chicago, New York, Paris, and London. With an approach that has as much in common with photography as it does with drawing, his work deals with the complexity of the urban landscape reinventing the mundane surroundings that might be otherwise overlooked.
www.evanhecox.com

Paul Hornschemeier was born in Cincinnati in 1977 and began self-publishing his experimental comics series, *Sequential,* in college. After graduating and moving to Chicago, he began work on a new series, *Forlorn Funnies,* which produced the graphic novel *Mother, Come Home.* His newest is *The Three Paradoxes.* He currently resides in Chicago.
www.margomitchell.com

Cody Hudson, who works under the name Struggle Inc., is a Chicago-based artist and graphic designer. His paintings have been exhibited throughout the U.S., Europe, and Japan. He enjoys ice fishing, sleeping, reading, and things made of wood.
www.struggleinc.com

Kim Hiorthøy is a Norwegian graphic designer and artist living in Berlin. He has designed many record sleeves for the record labels Rune Grammofon and Smalltown Supersound. He sometimes has a big beard. Smalltown Supersound also releases records of Hiorthøy's own music. Many years ago he used to illustrate children's books.
www.smalltownsupersound.com
www.standardoslo.no

Caroline Hwang is an artist and illustrator who was born in Minnesota and raised in southern California. She currently resides in Brooklyn.
www.carolinehwang.net

kozyndan is a husband-and-wife team who divide their time between making art and working as test subjects on a project to grow gills on human beings for future life underwater. They reside in Los Angeles.
www.kozyndan.com

Geoff McFetridge lives and works in Atwater, California, an independent community of cholos, designers, and bicyclists that exists within the borders of greater Los Angeles. McFetridge's work can be seen via Google.com, championdontstop.com (well, not really), and solitaryarts.com

Anders Nilsen was born in New Hampshire and grew up there and in Minneapolis. He did a year of graduate work at the School of the Art Institute of Chicago, before dropping out to make comics full time. He is the author and artist of *Big Questions*, *Don't Go Where I Can't Follow*, *Dogs and Water*, and *Monologues for the Coming Plague*. He currently lives and works in Chicago.
www.margomitchell.com/thc/an.htm

Laura Owens has exhibited extensively and has had solo exhibitions at Gavin Brown's enterprise, New York; Sadie Coles HQ, London; ACME, Los Angeles; Isabella Gardner Museum, Boston; the Museum of Contemporary Art, Los Angeles; Kunsthalle, Zürich; Camden Art Centre, London; and Bonnefanten Museum, Maastricht. She lives and works in Los Angeles.

Archer Prewitt is a cartoonist by day and a musician by night, touring and recording as a solo artist and with his band, The Sea and Cake. His comic series, *Sof' Boy*, is published by Drawn & Quarterly. He is currently working on a new solo album.
www.myspace.com/archerprewittmusic

Jon Resh is a writer and graphic designer in Chicago whose work includes, among many other collaborations and commissions, a number of cover designs for books by Joe Meno.
www.go-undaunted.com

Jay Ryan lives very, very close to Chicago and spends most of his time drawing and screenprinting concert posters at his shop, The Bird Machine. The remainder of Jay's time is spent splitting logs, riding his bike, and talking to dogs in other people's yards.
www.thebirdmachine.com

Souther Salazar's work first began to circulate in the early '90s, in the form of xeroxed cut-and-paste minicomics and zines made from his bedroom as a young teenager in rural Oakdale, California. He now lives in Los Angeles, where he creates collages, paintings, drawings, and sculptures in dense and frenzied installations that encourage exploration and participation by the viewer. His work has appeared in galleries in New York, Los Angeles, Brazil, and Tokyo, and in publications such as *Kramers Ergot*, *The Drama*, and *Giant Robot*.

Rachell Sumpter currently lives on a remote island in the Pudget Sound. She has contributed art to past McSweeney's publications such as *What Is the What*, Issue 20, Issue 24, and *Here They Come*.
www.rachellsumpter.com

Chris Uphues is an artist living in Brooklyn with his monkey Del. He spends his days drawing, painting, writing, and generally having a good time.

Thank you: Cody Hudson. Without you, this book would not have happened. It's hard to imagine someone so talented being so fun to work with.

Thanks also to: Koren, Lulu, Johnny Temple, Johanna Ingalls, Jon Resh, Dan Sinker, James Vickery, Todd Baxter, and all of the contributing artists for their time and creativity.

JOE MENO is the best-selling author of the novels *Hairstyles of the Damned, The Boy Detective Fails, How the Hula Girl Sings,* and *Tender As Hellfire,* as well as the short story collection *Bluebirds Used to Croon in the Choir.* He was the winner of the 2003 Nelson Algren Award for short fiction and is a professor of creative writing at Columbia College Chicago.

CODY HUDSON is a Chicago-based artist and graphic designer. He collaborated with Joe Meno on the concept of this book as well as the selection of artists featured here.

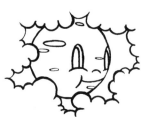